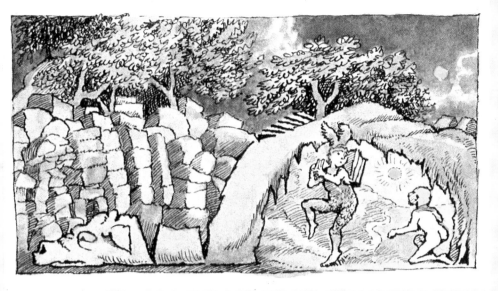

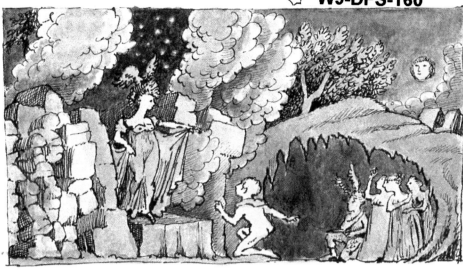

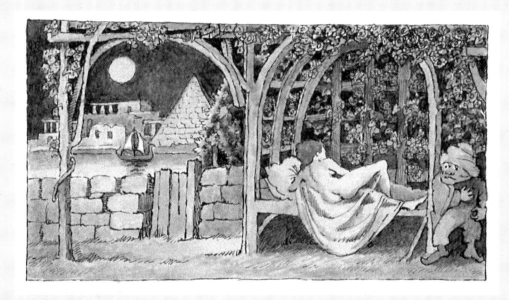

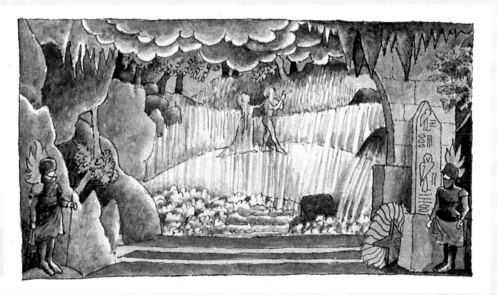

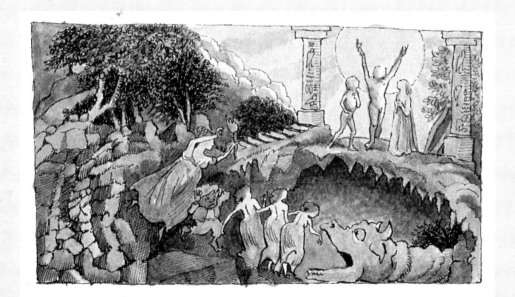

THE ART OF
MAURICE SENDAK

1980 TO THE PRESENT

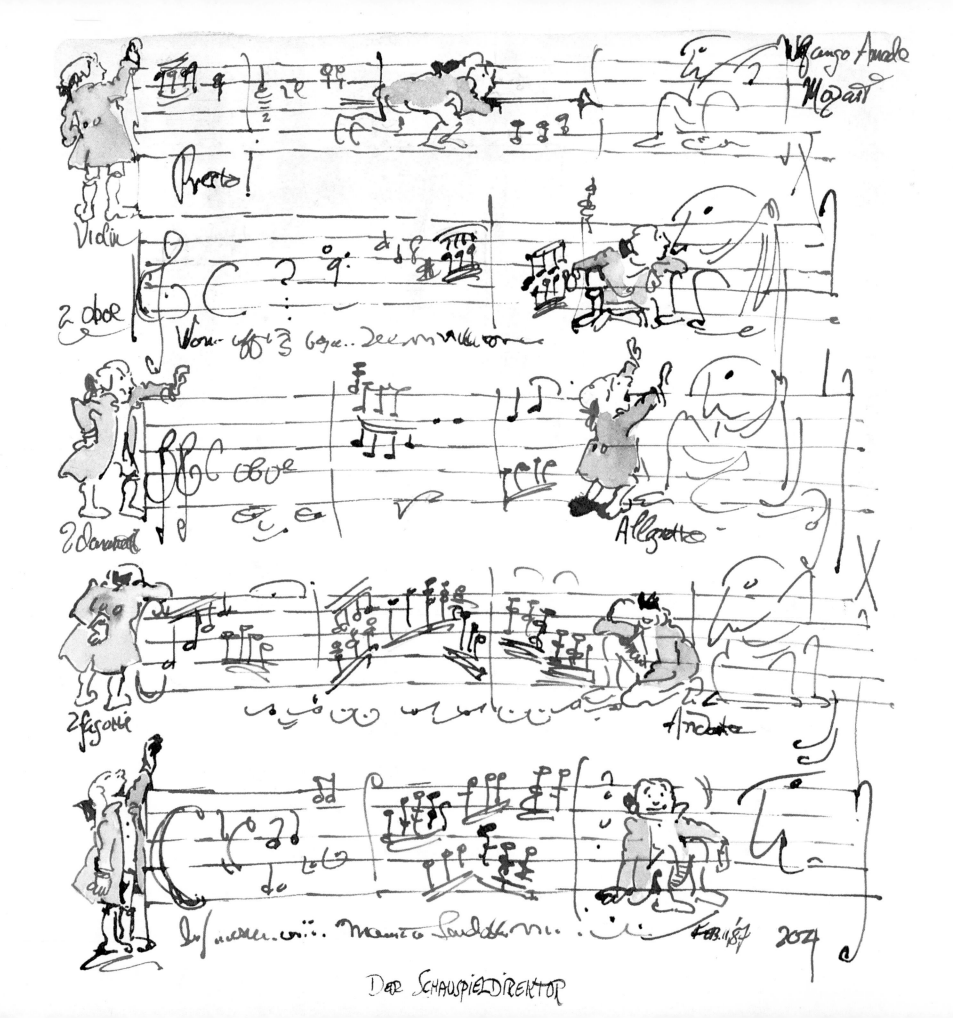

Der Schauspieldirektor

THE ART OF
MAURICE SENDAK

1980 TO THE PRESENT

Text by TONY KUSHNER

Harry N. Abrams, Inc., Publishers

Project Manager: Howard W. Reeves
Editor: Linas Alsenas
Designer: Edward Miller
Production Manager: Stan Redfern
Photography by Harrison Judd

Library of Congress Cataloging-in-Publication Data

Kushner, Tony.
 The art of Maurice Sendak : 1980 to the present / text by Tony Kushner.
 p. cm.
Companion volume to The art of Maurice Sendak by Selma Lanes, pub.
by Harry Abrams in 1981.
Includes bibliographical references and index.
 ISBN 0-8109-4448-0
 1. Sendak, Maurice—Criticism and interpretation. I. Sendak, Maurice.
II. Title.

 NC975.5.S44K87 2003
 741.6'092—dc21

 2003009293

Printed and bound in Mexico
10 9 8 7 6 5 4 3 2 1

Harry N. Abrams, Inc.
100 Fifth Avenue
New York, N.Y. 10011
www.abramsbooks.com

Abrams is a subsidiary of

LA MARTINIÈRE
G R O U P E

Cover: *Outside Over There,* book illustration; endpapers: *The Magic Flute,* opera, storyboard; pages 2, 4, 5,
216–223: Mozart fantasy sketches; pages 1, 3, 6, 7, 9–13: *I Saw Esau: The Schoolchild's Pocket Book,* book
illustrations; p. 224: *Really Rosie,* animated version, character sketch

For Paul Gottlieb, in memoriam—M. S. & T. K.

There would be no opera sets and costumes, no second
career as stage designer, without the encouragement and
special genius of my friend and teacher Frank Corsaro—M. S.

Maurice Sendak is the modern picture book's portal figure. He's unparalleled in developing the picture book's unique possibilities of narrating—to the joy of constant new picture-book illustrators. Furthermore, he is one of the most courageous researchers of the most secret recesses of childhood—to the delight of constant new readers.

Jury citation awarding Maurice Sendak the Swedish government's Astrid Lindgren Memorial Award for Literature in 2003

PROLOGUE, BY WAY OF APOLOGY:

The Art of Maurice Sendak, written by Selma Lanes, was published by Harry N. Abrams, Inc. in 1981, twenty-two years ago. The book is both a biography and a survey of an immensely impressive achievement, a rich array more varied, more ambitious, more sophisticated than that of any other creator of children's literature in American history. I'm not alone in claiming such eminence for Sendak. In an essay marking the fiftieth anniversary of the *New York Times Book Review*'s annual list of the best children's literature, the editor, Eden Ross Lipson, surveyed the names included on the list over the years. "In one case," she wrote, "the work of a single artist encompasses the range of postwar American childhood experience."

Maurice Sendak indisputably dominates the *Book Review*'s list and the public consciousness of children's books in the second half of the twentieth century. His second book [*A Hole Is to Dig*] was on the first list in 1952, and *The Nutcracker*, in 1984, was his twentieth appearance. His work includes some of the great anchors of American experience . . .

Three years ago I received a phone call from Paul Gottlieb, then editor-in-chief of Abrams, asking me to write the text for a companion volume to *The Art of Maurice Sendak*. I refused. I am neither a historian nor a critic. I'm a playwright.

Paul could be, when he needed to be, quite persistent, and finally I put my reservations partially aside and succumbed to his enthusiasm. The result is an unapologetically subjective survey and reading (except here I am, apologizing), a highly selective, personal version of Sendak, neither encompassing nor definitive. I've done little or nothing to transform my stylistic idiosyncracies, or to curb my native generosity with my opinions, so as to more resemble that sere scholar of illustration, stage design, and children's literature, to say nothing of that irreproachable, immaculate prose stylist I still believe they should have hired for the job. If my opinions offend, you should repeat to yourself the wise words found in Sendak and Iona Opie's *I Saw Esau*: "Different people have different 'pinions; / Some like apples, some like inions." Or you may remind yourself of the slipperiness of observation and objective fact by once again diving into *Esau* and cherishing this wisdom: "Truth, truth, nobody's daughter, / Took off her clothes / And jumped into the water."

I knew I wouldn't be able to train my gaze on Maurice Sendak as an object of study, and I haven't. I've been his devoted fan since I was four years old. My admiration has only grown in adulthood. He's been an important influence on my own work. And over the past ten years he and I have become good friends. Objectivity was always out of the question. I offer my impressions, and I invite you, should you grow tired of my company, to ignore what I've written and concentrate on the art: it will tell you everything you need to know.

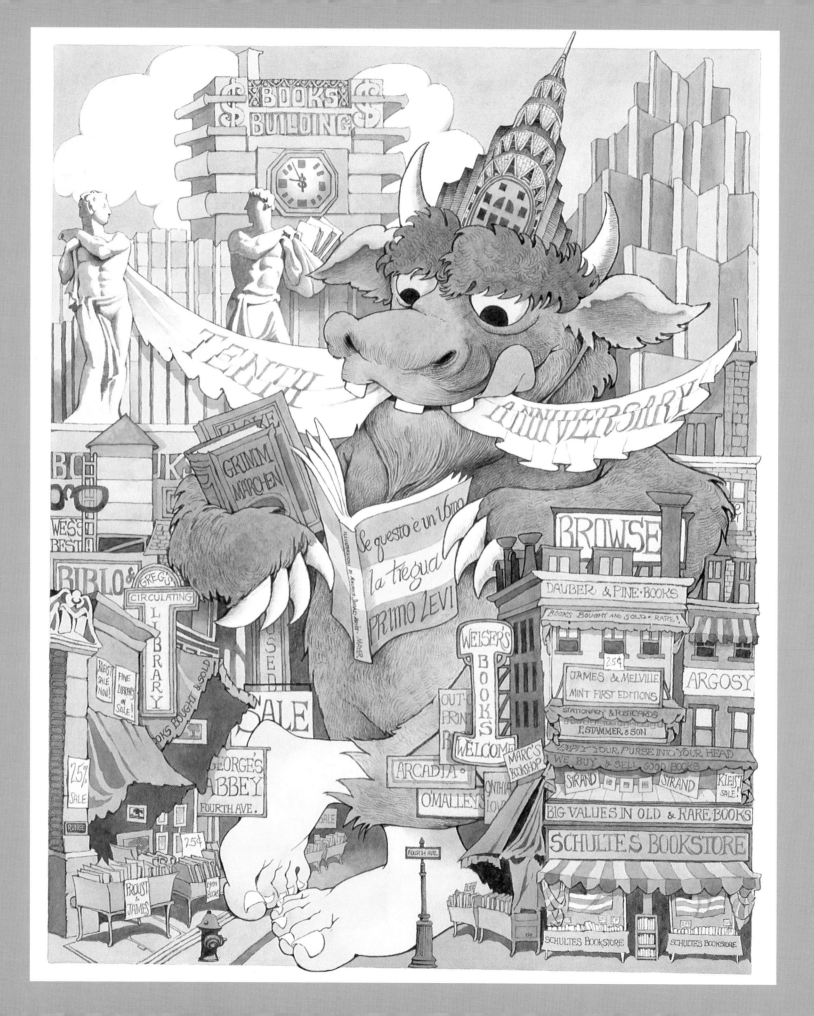

I.

The volume you hold in your hands includes a generous sampling of the illustration and design Sendak has done in the years since the first Abrams book. Before proceeding, a glance backward seems to me advisable, or, at any rate, irresistible.

Throughout the 1950s and early 1960s, Ruth Krauss and Maurice Sendak helped to topsy-turvy and transform the narrative expectations of the picture book with wildly original works like *A Hole Is to Dig, A Very Special House, Open House for Butterflies, I Want to Paint My Bathroom Blue,* and *Charlotte and the White Horse.* Ruth Krauss was a remarkable writer, a poet. Her small books are economical, very smart, funny, and magically full of surprise. She was able to give voice to a child's outsized ardor without sounding treacly. She could turn a word game into a philosophical investigation of cause-and-effect without ever losing sight of the fun. She was a nonsense artist, and like other great practitioners of that indispensable art, she knew how to use nonsense as a means of giddy release and also as resistance training for the logic muscle: One's sense of the world is strengthened after successfully surviving assault by nonsense effectively deployed.

Sendak responded to Krauss, to her free-associative flow and babble, with quicksilver drawings and watercolors. The best books of their collaboration are like extended jazz duets between two brilliant and inspired artists, each tickling, challenging, and encouraging the other to higher and higher flights of apparently spontaneous invention. As is often the case with revolutionary art, with art that changes its medium, the Krauss and Sendak books, nearly a half-century after they first appeared, are able to startle, as if they still contained the excitement, the mischief, the liberated "why not?" delight their author and illustrator felt while making them.

In the illustrations for Elsa Minarek's *Little Bear* series, Sendak created a world balanced between sturdy, bourgeois warmth, a summery coziness, and shadowy ineffability—memory pictures flooded with such feeling that the solidity and security they evoke seem on the verge of dissolving, suffused with susceptibility to time, to evanescence, to loss. With the advent of Sendak, the iron grip that respectable old nanny Jollity had maintained on children's books was loosened. Grace notes of sorrow, chords of ambiguity and ambivalence were sounded; a new seriousness and a profound empathy for the inner life of children accompanied the fresh, delicious exuberance of his art.

The Krauss books and Sesyle Joslin's *What Do You Do, Dear?* and *What Do You Say, Dear?* introduced the indelible, inimitable Sendak kids: eyes often closed, stiff-gaited, top-heavy, and heavy-footed, smilingly sensual, obviously

Opposite: New York Is Book Country, 10th-anniversary poster (1988)

9

bright, theatrically temperamental, self-satisfied tiny egoists vulnerable in bare feet or in their parents' shoes, prone to stomping, dressed and groomed in a style neither American nor European, neither familiar nor unfamiliar. They are immigrants' kids, Brooklyn kids, the most kid-like of any kids ever to march through a children's book, exasperating and delightful as children are and know themselves to be, preposterous and lovely in equal measure. These are the kids described in the best, richest developmental literature, the kids in Piaget and Winnicott, doing the tough work of holding themselves and their world together.

Young children don't amble or saunter, they goose-step. Only Sendak noticed that. They seem to have no knees, the Sendak kids, or more probably they refuse to bend them—it's hard enough work just staying upright, maintaining your center of gravity. And their creator was a child in the age of the European dictators; he's endowed his creations with a lesson learned, namely the use-value of clomping, making an outsized noise. Why are their eyes clamped shut? They're closing out the world, warding off an excess of stimulation or criticism, protecting glorious and even grandiose fantasies within.

The kids at play in Sendak books are also at work. What is often described in his art as "anxiety" is, at least in part, tension born of industry, strenuous effort, sustained endeavor.

D. W. Winnicott writes that the child begins in the womb "not yet a [human] unit in terms of development . . ." but rather in "an unintegrated state," lacking

a wholeness of both space and time. At this time there is no awareness . . . Promoting integration are such factors as instinctual urge or aggressive expression, each of which is preceded by a gathering of the whole self. Awareness becomes possible at such moments, because there is a self to be aware. . . . At later stages exaggerations of self-care can be seen, organized as a defense against the disintegration which environmental failure threatens to bring about. By environmental failure I mean failure of secure holding, and failure beyond that which can be borne at the time by the individual. . . . In illustration of the application of these principles it is useful to think of the nursery rhyme of Humpty Dumpty and the reasons for its universal appeal. Evidently there is a general feeling, not available to consciousness, that integration is a precarious state.

A precarious state, and difficult: Sendak honors the labor of childhood, which is manifest in play. An artist with a profoundly

progressive albeit ultimately tragic vision of life, he creates from a conviction that development, within the context of "secure holding," has a reasonable chance of producing adults almost as lovely and remarkable as kids.

As you turn the pages of Selma Lanes's *The Art of Maurice Sendak,* you can chart the artist's own remarkable development, the sharpening of his vision and his ambition. The finely detailed and ever-so-slightly moody cross-hatching of *Little Bear* was refined and intensified to create silvery nocturnes for Randall Jarrell's exquisite *The Bat-Poet, The Animal Family,* and *Fly By Night,* as well as somber, moon-dappled mysteries for Isaac Bashevis Singer's *Zlateh the Goat and Other Stories.* These illustrated books are not exclusively for children but for all contemplative people. With nods to Rembrandt and Dürer, Sendak brought his pen-and-ink work to a kind of summit with what some consider the most beautiful drawings of his career: the suite of dense, concentrated miniatures for *The Juniper Tree,* a perfect-in-every-detail, two-volume collection of tales by the Brothers Grimm.

Naturally, the first Abrams volume includes art from Sendak's most famous titles, the books he wrote and illustrated: *Kenny's Window, Nutshell Library, Where the Wild Things Are,* and *In the Night Kitchen.* These are among the most discussed and analyzed works of children's literature of our time, credited or blamed (along with the anarchic but actually more moralistic Dr. Seuss) for unharnessing the Unconscious of a generation, for carrying the energies of a protean cultural revolution into the story-before-bedtime hour, for speaking with an unembarrassed immediacy to the sacred and profane beings children become when they dream.

What is often overlooked by the critics of this particular agent of revolution and liberation is the great scrupulousness and care with which Sendak has always addressed his audience. One of the liberatory powers of art is its capacity to mirror, to help the self name itself, to recognize itself and see itself as one among others. This naming of the self is a critical moment in the act of liberation. For any revolution to succeed, it must have a nameable cause. Art, by mirroring, can contribute to that.

But children both need and suffer revolution. They need freedom *and* routine, freedom *and* security. Art for children must not merely mirror, must not be satisfied simply to foment the growth that comes from freedom; art for children must organize as well. Sendak's comprehension of this dialectic, and his masterful expression of it, account for part of his immense appeal to children and scholars alike.

Much writing about Sendak embraces an enduring notion that his success has in some way to do with keeping alive the child he was in the adult he is now, as if the books had been drawn and written by a pre-adolescent prodigy

possessed of an adult's motor skills. The way a child experiences the world is beautifully reflected, beautifully expressed in Sendak's books, to be sure. But it's an accomplishment that is all the more impressive for being the work of a grown-up artist.

Writing with great eloquence about Hans Christian Andersen in a book review included in his volume of essays, *Caldecott & Co.*, Sendak described perfectly the blending of a child's and an adult's perspective:

> Andersen was that rare anomaly, wise man and innocent child; he shared with children an uncanny poetic power, the power of breathing life into mere dust. It is the intense life—honest, ingratiating—in Andersen's tales that make them unique. Discarded bits of bottle, sticks, doorknobs, and fading flowers give voice to their love, anguish, vanity, and bitterness. They reflect on their past joys, lost opportunities, and soberly ponder the mystery of death. We listen, patiently, sympathetically, to their tiny querulous voices and the miracle is that we believe, as Anderson did, as all children do, that the bit of bottle, the stick, the doorknob are, for one moment, passionately living. The best tales of Andersen have this mixture of worldliness and naïveté that make them so moving, so honest, so wonderful.

There is in Sendak's work as well an investing of the adult world of hard facts and inanimate objects with a child's intensity of belief, a child's magical, resurrectional, impassioned invention. But it is a mistake to elevate the child's contribution to this anomalous mixture at the expense of the adult's. Sendak's achievement has at least as much to do with his formidable adult erudition as with his retention of the child he once was. His art has a basis in powerful memories of his own childhood, but these are childhood memories on which he has brought to bear years of psychoanalysis, a lifetime consuming literature, art, and music, and an adult's introspection. He seems never to have considered the possibility that good parenting equaled condescension or mendacity; it seems never to have occurred to him that what he was doing was anything other than serious work, worthy of an adult's full powers, for all that his primary audience was being read to rather than reading.

From his first books with Ruth Krauss, Sendak managed the trick of seeing and speaking double: to see and respond to the world from within a child's perspective, without (and this is the hard part) abrogating the adult sensibility, control, and understanding—wisdom if you will—that makes every good children's book a place safe for children to roam in, to encounter dangers in. A good book provides for children a realm of their own, from which

the aspiration of every child—*to grow up*—has not, a terrifying notion, been expunged. Children's literature, after all, is a kind of parenting, and children don't usually make competent parents. Adults create children's literature, and in the case of the best children's literature, one would expect to find, as one does with Sendak, a most serious adult artist. The trick of doubleness is perhaps the greatest difficulty in the difficult art form that is children's literature, and Sendak manages it effortlessly, or at least he has always made it seem so.

The thanaturgical dream poem/novel/play, *Higglety Pigglety Pop!*, or *There Must Be More to Life*, adorned with some of the artist's funniest, most haunting, and unnerving artwork, and occasionally omitted from lists of Sendak's major books, is unclassifiable by genre, age-appropriateness, or formal convention. There exists a small scattered tribe of this book's devoted fanatical fans (for the existence of which I have no proof beyond intuition), for whom it is a classic to be held up alongside *Alice* or the poems of Edward Lear. It strikes me as perhaps the most personal work of an artist who unstintingly mines his psyche and soul for his art. *Higglety* belongs to the select library of essential art about death and grief.

The Art of Maurice Sendak also features illustrations from a number of "oh I *loved* that when I was a kid" books, including *Hector Protector* and the thoroughly useful *Some Swell*

Pup, which the critic Jonathan Cott calls "the wittiest tale about how to get gently and humanely socialized that I've ever read." These are not major works, not among the break-throughs, radical innovations, or masterpieces that appear with a certain regularity through-out his career, but they are indisputably mar-velous.

Along with her invaluable account of his childhood and early working life, Ms. Lanes discusses, provides examples from, and cata-logues nearly eighty Sendak books, written and illustrated between 1951 and 1981. Though the artist was only fifty-three years old when *The Art of Maurice Sendak* was published, the body of work represented constitutes a monu-mental labor, more than enough for an entire lifetime well spent.

II.

Twenty-two years have passed. Maurice Sendak lives in Connecticut, in a charming old farm-house nestled in hilly woodlands. It's a place of great rural beauty. But his expansive property is now menaced by grotesque, generically chim-neyed-and-gabled faux-French mansions clus-tered and clumped on stingy parcels of land. Sendak has devoted a considerable part of the earnings from his books to purchasing the sur-rounding woods, trying to save them from the buzz saw and the bulldozer. He's driven by his

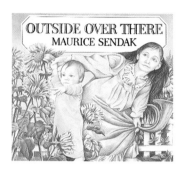

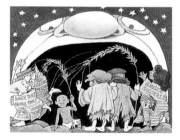

love of the terrain, food for his soul and his art. Accompany him along the road he walks every day and you'll spot several trees, oaks and birches, that have made their appearances in Sendak pictures, surprising amidst their fellow trees, like celebrities glimpsed in crowds.

More than mere conservancy impels Sendak's acquisition. An anxious reclusive instinct is operative, a desire to protect his isolation from the world. To the salutary effects of this thirty-year-long quasi-hermitage, costly to maintain in the material and the emotional senses, may be attributed some of the work mentioned above and all that has followed.

Here's what has followed:

Outside Over There was on its way to press when the Lanes/Abrams book was published. In interviews, Sendak identified it as the third book of a trilogy, the first two volumes of which are *Where the Wild Things Are* and *In the Night Kitchen.* Sendak's grouping is usually accepted at face value, and there are good reasons to do so. All three books are original Sendak texts, and all three involve a protagonist setting forth and returning. But clustering *Wild Things, Night Kitchen,* and *Outside* into a trilogy seems to me to elide an important turning point in Sendak's development as an artist that was taking place while Selma Lanes was researching and writing her summation of Sendak's career to date.

Since 1981 three important picture books— *Outside Over There, Dear Mili,* and *We Are All in*

the Dumps with Jack and Guy—form another trilogy. They represent a dark departure and new direction for Sendak, during which a struggle with despair—born of internal and external circumstance, of psychological, philosophical, and political pressures—seems to have been waged.

Even without knowledge of Sendak's life, anyone comparing his work before 1981 and the work that came after, beginning with the publication of *Outside Over There,* would realize that some sea change had taken place. When I asked him about the tumultuous period in his life that is the context of the creation of *Outside,* Sendak consulted the journal he has kept since 1967, begun in an English hospital after his coronary while touring the countryside at age 39. He noted that, in entries from 1975, he'd already begun thinking about the story. By mid-1976, he was hard at work on the text, which he wrote and rewrote, as is his custom, before beginning drawing. He explained to me some of the book's early evolution, culling dates and memories from the pages of his journals:

Bad draft June 30 76 of Ida.

July 17, 76: Second rough draft of Ida. I was on a plane all the time these years [working on his first opera designs], I did most of my work on the airplane. 'Working constantly on Ida.' Miguel, a photographer, who was the partner of

[the theater director] A. J. Antoon, and A. J. helped me find little girls for the models for Ida and her baby sister.

Dec 10, 1976, we set up a photo session of two kids in the apartment of a high-class type couple on the Upper West Side. They had a 5 year old who played Ida. She *was* Ida, and we got the model for Ida's sister from a family who lived in the Bronx—she was one year old. The little girl posing for Ida thought the session was all about her, she was in ballet school, she was having a great time. Then the baby showed up with her parents. Our "Ida" crashed.

I wanted to see how a little girl would handle the weight of a baby. We handed the baby to our "Ida." She handled her like a garbage bag. We took 70 photographs, all of which I still have. I began the drawings [in pencil] on December 27. [Philip Otto] Runge and [Caspar David] Friedrich are models—first time the German Romantics used this way.

The next year, 1977, was a calamitous one. Sendak was overextended, working on a number of projects at once, difficult for a perfectionist, a slow and meticulous draftsman. "I worked very hard after a three week illness," he told me. "I finished the pencil drawings on January 9, 1977," he said, looking at an entry in his journal, then thinking about it, he added,

This seems wrong. Boy I was working hard. I stopped smoking after my long illness, and an infected nodule on my vocal cord. My father taught us to smoke. We sat around the kitchen table and if we didn't inhale he would know—he was a chain smoker. If we didn't inhale he would say "NO NO NO, *ganze, ganze* [Yiddish for "all"]!

In *Outside*, Sendak wanted to dig deeper and go farther, as a writer and an illustrator, than he had previously. Aware of how unusual and daring the new book was, he worried constantly about it failing. Nicotine-deprived, worn-out, taking misprescribed medication for insomnia, anticipating the tenth anniversary of his near-fatal coronary, Sendak weathered a severe emotional crisis that April—as he described it to me, "the big schlongola of breakdownville." He went to Europe to recuperate, bringing with him the text and the pencil drawings for *Outside*. He showed these to friends in Zurich, who, after examining the work, advised him to abandon it. Sendak left Zurich in anguish and went to Paris, where he stayed with a friend, sinking deeper into despondency, giving free rein to fears of failure,

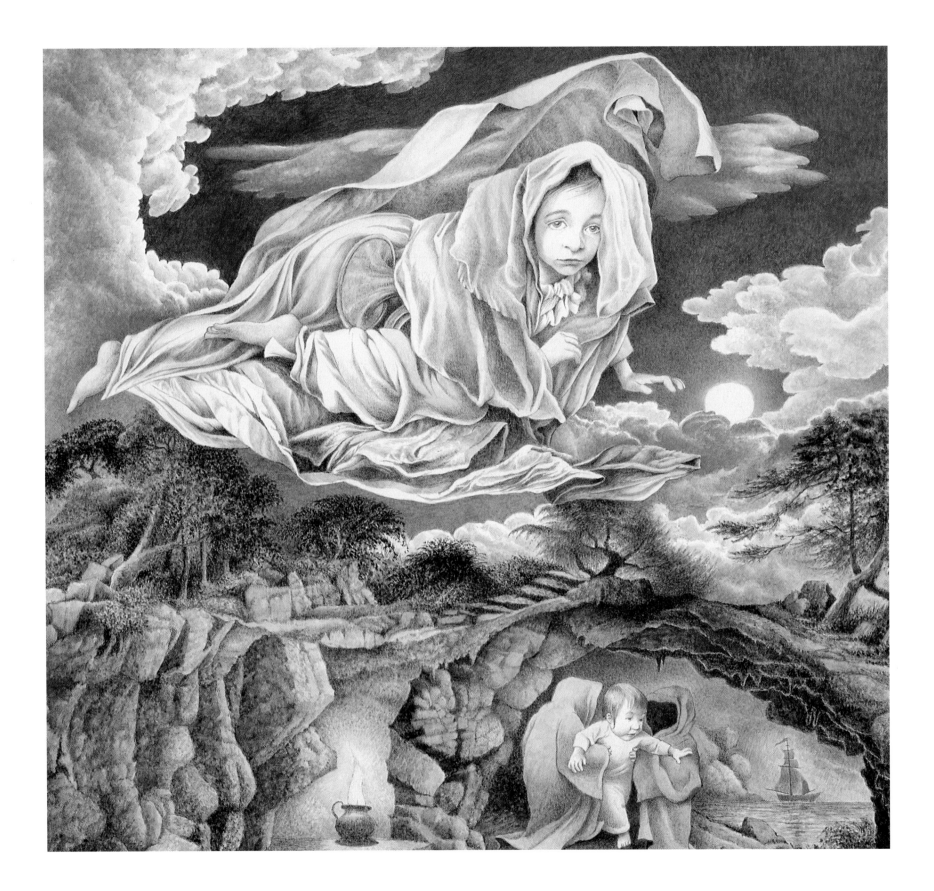

of the absolute loss of talent. The one bright spot was a Mozart concert he remembers attending in Sainte Chapelle in Paris. He returned home to a long, ultimately successful fight out of dangerous depression.

Outside Over There resumed its progress after his recovery, in which hard work played an essential role. In a journal entry on April 1, 1978, he wrote: "April. The missing month of last year. What did I do then? I left Ida on page twelve in her mama's yellow raincoat."

After reading this entry, Sendak explained to me that the yellow raincoat—her mama's rain cloak—that Ida wears when she sets out on her journey to rescue her little sister is derived from the slicker worn by the salt-spilling girl beneath the umbrella on the Morton Salt box. Originally meant to advertise Morton's moisture-resistant, non-clumping product, the slogan beneath the Ida-prototype, "when it rains, it pours," seems an appropriate motto for Sendak's life at the time.

As 1978 advanced, so did the detailed paintings for the book. "On June 10, 1978, my [fiftieth] birthday, 'Ida' was born." He finished the illustrations for the book more than a year later, on July 5, 1979.

The troubled origins of *Outside* are reflected even in the dedication. When I asked Sendak who Barbara Brooks was, he explained that she was a good friend who had loved the *Outside* text and drawings. She had died suddenly and tragically, before the book was published. He told me, with palpable sadness:

I had to pull strings and push buttons to get Barbara's name in the book. It was close to publication date. There's a portrait of Barbara in a wedding costume sketch in *The Cunning Little Vixen* [on which Sendak was working while putting the finishing touches to *Outside*].

Sendak said that *Outside* originally had no dedicatee. Then I found a note he'd written a year before, telling me that the book had originally been dedicated to his mother. When I showed it to him, he replied, "Well, that's interesting. I took my mother's name off it. Wow." The note I found, quoting from journal entries from May, 1981, reads:

On an ordinary day like today, two years ago, Ida was finished. It was originally dedicated to my mother. I hate May, everything seems to begin and end in May. May 3 I had my coronary. The dreadful May. 14th anniversary of my coronary. I count myself 14 years old, I was born with my coronary. Death has the features of Mozart's face and is my waiting friend.

As he'd mentioned in his journal, Sendak's

Opposite: *Outside Over There,* book illustration

17

artwork for *Outside* was from its earliest inception inspired by the paintings of the early German Romantic painters Philip Otto Runge and Caspar David Friedrich. The book is situated historically by its imagery in the Biedermeier world of late-eighteenth-and early-nineteenth-century Germany, decorous and orderly but still shuddering from the shock of the French revolution, imperiled by the expansionist ambitions and revolutionary politics of Napoleon. Sendak chose as his setting a time of unstoppable exploration, journeying, mercantilism, and colonization; a time that would burgeon into High Romanticism, with bourgeois democratic revolutions at mid-century. These revolutions would generate, in response, the resistance of what remained of the feudal world, manifest as both glorious swansong and vicious counter-revolutionary reaction. The illustrations evoke a period pregnant with all the contradictions necessary for the birth of modernism, a world which would prove to be the womb of Victoria, and then of Marx, of Freud, of the Modern—of the sensibility that would produce artists like Sendak, books like *Outside Over There,* and children needing and capable of reading them.

Two images from *Outside* are unforgettable, and quite frightening: the baby being hauled off by hooded goblins; and Ida falling backwards out of the window, outside the security and comfort of her parents' home, and into a world of menacing enchantment. Compared to these volcanically emotional, deeply disconcerting pictures, Max's trip to the land of the Wild Things seems a backyard picnic, and Mickey's sojourn in an oven and flight to the top of a milk bottle seem, well, a piece of cake. Perhaps only Baby, menaced by the spectacularly alarming lion in *Higglety Pigglety Pop!,* faces a danger as stark and dire as Ida and her sister. But that's only one picture, one dark moment in *Higglety* that anchors a book of otherwise bittersweet delight, whereas *Outside* is an entire concert of disconcert; it never lets up.

Outside Over There is a picture book unlike any other. Its gripping quest-story tumbles out of the cave of the unknown and uncanny (more blood-chilling in the German: *Unheimlich! Unbekannt!*), out of E. T. A. Hoffmann and the less well-lit corners of Hans Christian Andersen, out of the dark of the Unconscious. The *Outside* illustrations are almost hyperreal in their intensity; rich, densely colored, mysterious, engaging, and urgent, they're like photographic dream-plates. They're paradoxically cavernously deep *and* hard-surfaced, impenetrably finished, enameled. These are illustrations so strong they seem to menace the very text they're meant to illustrate, illuminating if not igniting the ambiguities of every sentence.

Try to read *Outside Over There* to a child. The first time is always arduous. The kid's curiosity, but also her or his nerves, prickle with every page. The illustrations refuse to reassure,

18

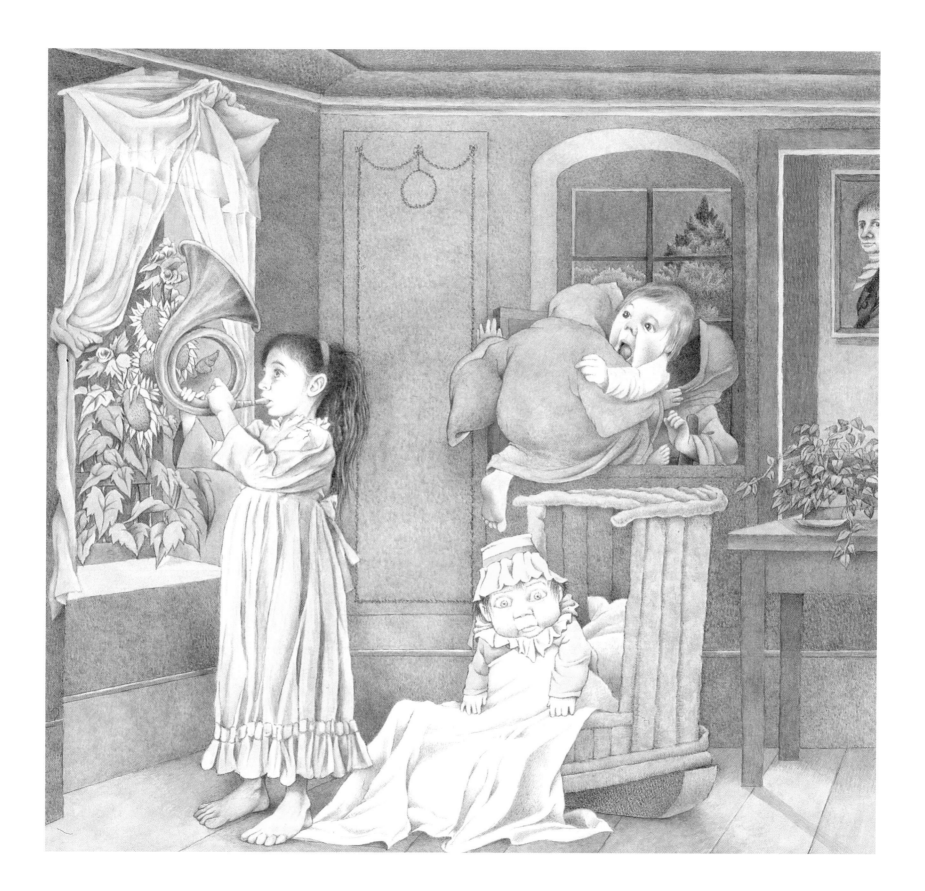

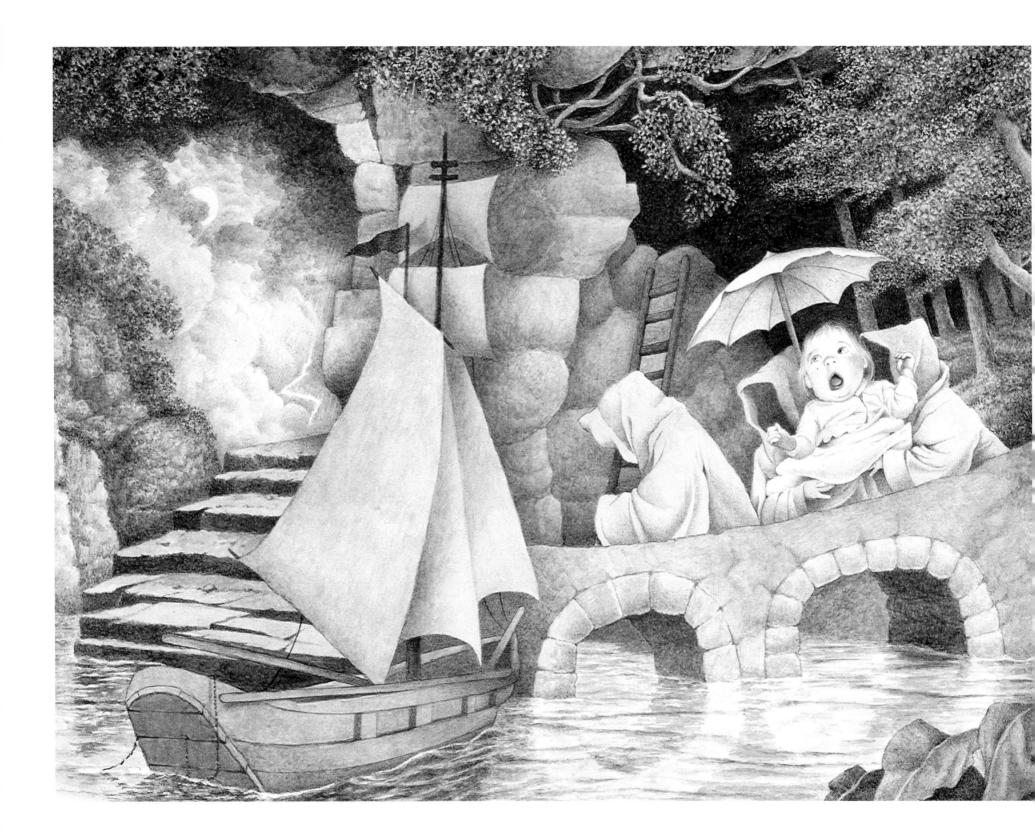

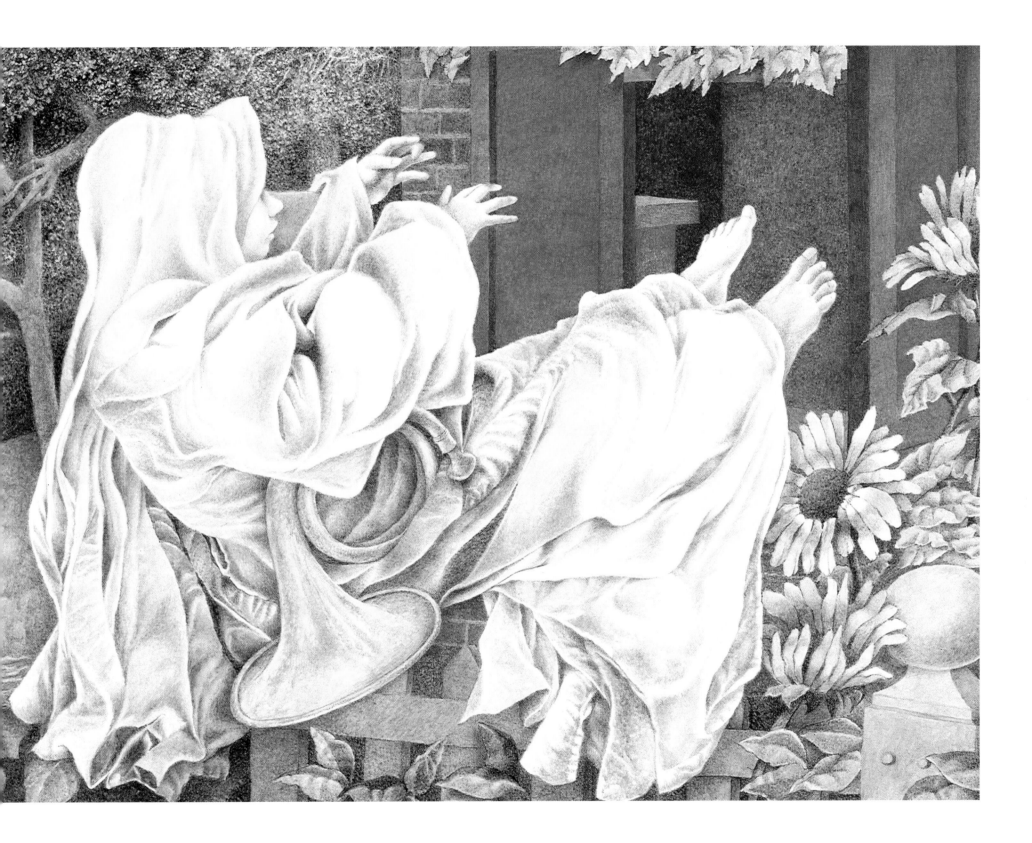

infused as they are with a lemony sort of dis-ease, a subterranean cave-light, the stormy morning light of a not-entirely-welcomed awakening. You'll think, "This book is too scary, I shouldn't have read it to her." (Little girls, in my experience, Ida-identifying, are more agitated but also more gripped by the book than are little boys.) But then you find the child you thought you'd traumatized is addicted to the book, addicted to working through the terrors it elicits, the guilty desires it solicits, and the dreams of valor it inspires.

And yet it must also be admitted that the concern so routinely expressed about Sendak's work—that it is not universally suitable for all children, that it is too strong, too scary for some children, a concern that had felt unwarranted given the nearly universal popularity of books like *Nutshell Library* and *Where the Wild Things Are*—begins to gain a certain justification with *Outside Over There* and the books that follow.

Universal suitability and universal appeal are odd standards against which to measure a work of art. No art intended for adults would be expected to meet such standards, and one should be immediately suspicious of any work for adults, or for children, apparently qualifying as such. I found *The Cat in the Hat* rough sledding when I was a kid. The cat made appalling messes—he freaked me out. Nothing good is really universal, *Goodnight Moon* being probably the lone honorable exception. The

Opposite: *Outside Over There*, book illustration

Teletubbies have universality, I guess, but don't you feel that the toddler responding with such predictable, inevitable glee to those adipose aliens is being fleeced, or worse, recruited?

Children in danger have always preoccupied Sendak. From *Outside* on, the danger starts to emerge as a central concern of his work. The reunion of Ida and her sister with their mother at the end of *Outside* is reassuring, though it should be pointed out that Sendak has taken pains to limit that comfort. When Ida arrives at her mother's arbor, the baby is fitful, teary, wanting immediately to be put in her mother's arms, her face revealing the distress she's felt at this separation. In the final picture, Ida's mother, and Ida herself, look resigned rather than joyful at the news that their absent husband/father will return "one day," which is not, of course, especially reassuring news—*when*, exactly? Ida's safe return at the book's conclusion cannot erase the memory of Over There, and it isn't meant to. What Ida has seen, what the reader has seen—the ice baby melting, the shipwreck sea, the haunted night sky, the labyrinthine underworld—is too powerfully persuasive, too full-blooded, to release its grip. Ida and her readers will dream about the places she's gone. These places will have changed her, as her readers will have been changed. She's older than Max, older than Mickey, and in the end she isn't happily, securely asleep in bed. She's of an age; her sleep will never be so sound again.

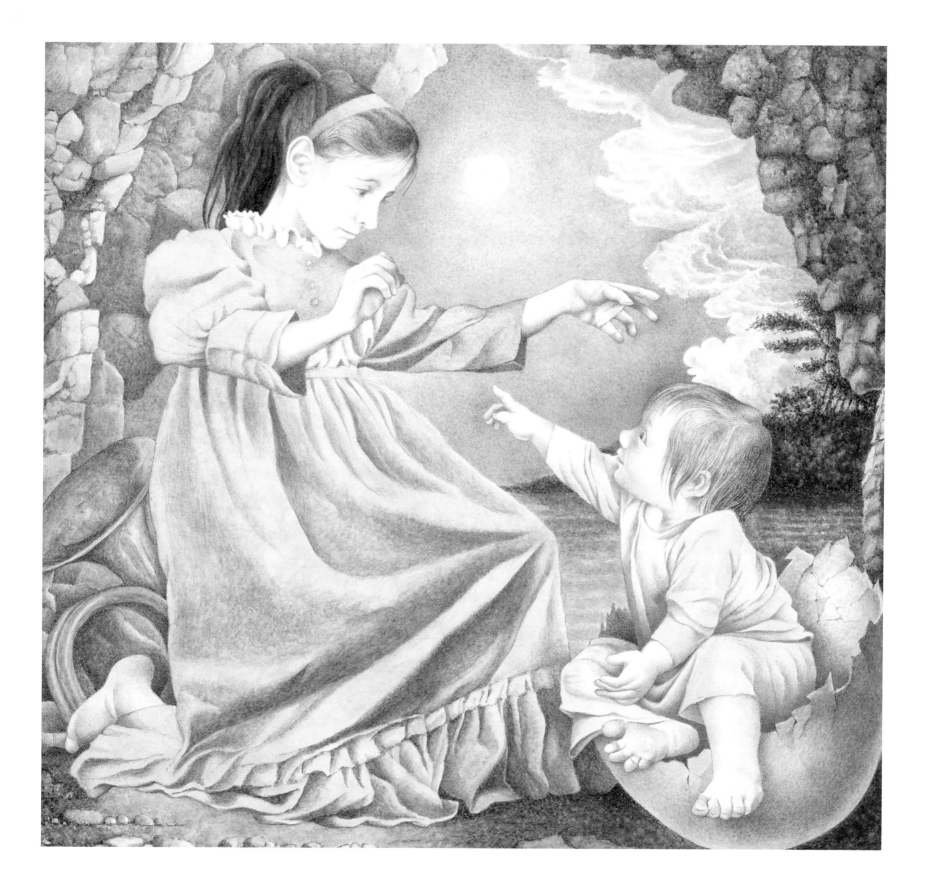

Sendak has never slept soundly, not even as a child. He was sickly, like so many children of immigrant families, nearly dying on a couple of occasions from pediatric illnesses to which he saw other children succumb. The kidnapping of Charlie, the baby of Charles and Anne Morrow Lindbergh in 1932, a crime that obsessed the nation, became a fixture in the fantasy life of the then-four-year-old Sendak, and a fixture it has remained; it's one of the principal autobiographical sources for the goblin abduction in *Outside Over There*. In an entry from his journal, Sendak wrote about this, and about his mother:

> Charlie Lindbergh, the Mush baby. I was never born, I was dead in my mother's womb, I was the ice baby—and my mother didn't notice that I'd been replaced. She could have done the magic trick to get her real baby back but she was too distracted and I stayed an ice baby.

Sendak interrupts his reading to say: "I called him the Mush Baby. Mush is *Moishe* [his Jewish name, the name he would have been given had his parents not opted for the Anglicized Maurice]. That's what *Outside* is about, vomiting that up."

Sendak's boyhood and his adolescence were marked by the insecurities of the Great Depression and the global catastrophe of World War II. And while he was growing up in Brooklyn, Jewish children his age in Europe faced race laws, pogroms, forced ghettoization, and finally transport to the death camps. The knowledge that children are made to suffer terribly, and are only partially, often inadequately protected by adults, is tacitly expressed in Sendak's earlier work. With the creation of this trilogy, *Outside, Mili,* and *Jack and Guy,* what was implicit bursts forth into a great *geschrei* (Yiddish for "a cry or a scream") of sorrow and pity, anger and warning.

These are books meant for children by an author whose ongoing conversation with kids has always been distinguished by honesty and also, as I mentioned earlier, by adult responsibility. In the trilogy it is perhaps the case that Sendak began to chafe at his often contradictory task. In a world of trouble, in a pitiless world, how is one to speak to the young? How much is one to tell a child of the injustices and dangers he or she will confront, perhaps have to confront, long before adulthood and something resembling competence at dealing with wickedness has been reached? (It's the question Roberto Benigni raises and then dodges with offensive sentimentality in his Holocaust film, *Life Is Beautiful.*)

Sendak's life has been spent addressing with integrity this unanswerable conundrum. One of the saddest images in the magnificent pictorial world of *Dear Mili,* the picture book that follows *Outside* in the trilogy, is a chorus of children singing in Saint Joseph's garden

Opposite and overleaf:
Dear Mili, book illustrations

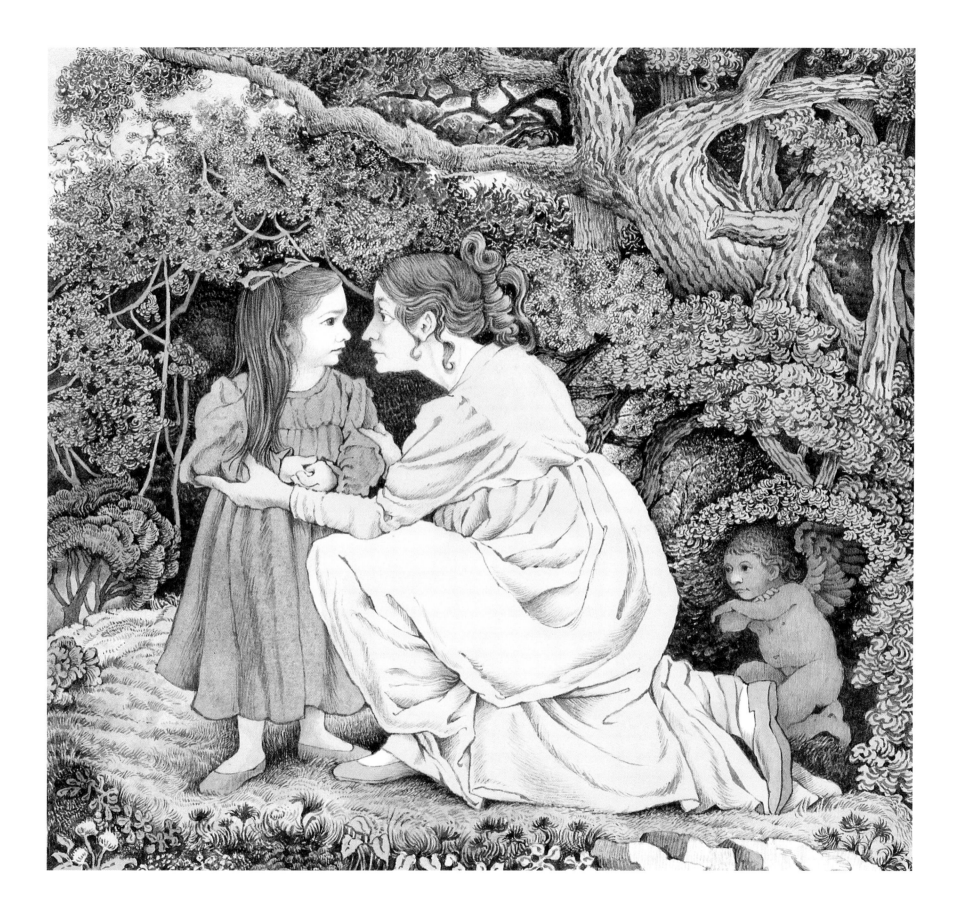

(conducted by the boy Mozart). It's based on a photograph of a group of Jewish schoolchildren taken in Izieu, France, before they were sent to their deaths in Auschwitz. They stand in the garden in *Mili* as a sort of rejoinder to anyone who finds the book too tragic for kids, as many will. The world, Sendak says by including this image, is so much harder on kids, so much more tragic than his book.

Dear Mili is the darkest work in the Sendak canon. Its text is a story—a war story, really—by Wilhelm Grimm. The tale was composed as a letter Grimm wrote in 1816 "to comfort a girl who'd lost her mother," Sendak told me, surmising this to be the occasion and purpose of the letter, about which, in fact, nothing specific is known. It was discovered in Germany in 1983. "It had never been published," Sendak explained,

Farrar Straus Giroux, which is where Michael di Capua was [di Capua, Sendak's longtime editor, inherited the job after the retirement of Ursula Nordstrom], bought the letter to acquire publishing rights—afterwards they sold me the actual letter. Ralph Mannheim translated it.

Dear Mili was published in 1988. Sendak, illustrating the text with large, lavish drawings of windswept, vine-choked, ravished, and ravishing landscapes, unflinchingly followed Grimm's lead on a journey through terror to safety and then to a place of irremediable sorrow. *Mili* is set in precisely the same historical period as *Outside Over There*. The two stories are similar in several ways: an absent father (Ida's is at sea, Mili's is a soldier), a distracted mother, a scary journey into the unknown for a young girl. Mili's odyssey begins for a reason more plausible than Ida's, and in today's world terribly familiar: She leaves home to hide in a forest, not in pursuit of baby-stealing goblins but rather to escape the onrush of a terrible war.

Sendak has, perhaps, provided clues to lead us to consider *Mili* as *Outside*'s sequel. The mother in *Outside* and the mother in *Mili* appear to be the same woman with the same taste for red dresses. Is *Mili*'s eponymous heroine Ida's baby sister a few years later? Mili is the only one of her mother's children to have survived early childhood, so if this is the *Outside* family, one fears for Ida. Is Mili's guardian angel, who appears as a slightly older girl when she assumes a human form in Saint Joseph's garden, a celestial apparition of Ida? The artist seems to invite us to ask these questions, and in asking them we are led to consider the nature of the relationship between the two books.

Mili is a refugee, not a rescuer. The early nineteenth century in Western Europe was galvanized, polarized even, by what we might call

the Ida/Mili dialectic, revolving around a dichotomy of liberation and annihilation. The same revolutionary period of exploration that offers Ida an opportunity for testing her mettle, for adventuring, for growth, was also a period of endless military campaigning, and war has set Mili off on a raw search for survival that she does not find. Her journey is a terrified flight rather than a brave adventure, terminating not in *Outside*'s restoration of a temporarily splintered family, not in the triumph of affectional ties over the Uncanny, but rather in tragedy—both Mili and her mother are dead at the conclusion of *Dear Mili*, for Mili has spent not a few hours in the forest but an entire lifetime—a tragedy over which grieving Providence showers a consoling grace.

In a profile by Nat Hentoff, "Among The Wild Things," that appeared in the *The New Yorker* in 1966, a Jewish version of *Dear Mili* is revealed to have haunted Sendak since childhood. "[My father] was a marvelous improviser," Sendak told Hentoff,

> and he'd often extend a story for many nights. One story I've always wanted to make into a book was about a child taking a walk with his father and mother. He becomes separated from them. Snow begins to fall, and the child shivers in the cold. He huddles under a tree, sobbing in

terror. An enormous figure hovers over him and says, as he draws the boy up, 'I'm Abraham, your father.' His fear gone, the child looks up and also sees Sarah. He is no longer lost. When his parents find him, the child is dead.

This is, a little eerily, the plot of *Mili*, told to Sendak decades before the Grimm epistolary tale was discovered. The little boy and Mili are similarly, distressingly hapless, as any child would be, given the predicaments they face. The Patriarch Abraham and his wife, Sarah (Sendak's mother's name), perform, in Sendak's father Philip's version, the role of Saint Joseph in the Grimm tale, although Grimm's divine rescuer is milder than the rather intimidating "enormous figure" appearing to the little boy in the version from Sendak's childhood. (Sendak illustrated this encounter in the "Little Boy Lost" drawing he made for William Blake's *Songs of Innocence and Experience*.) And the miracle of the brief reunion before death that ameliorates the sad conclusion of *Mili* is absent in the Jewish version, which serves its tragedy straight up.

In *Mili*, Sendak may have carried honesty too far for the purposes of children's literature. Several years ago I read the book to a five-year-old girl. When I'd finished the story, with Mili lying dead in her dead mother's lap, the

Overleaf:
Dear Mili,
book illustration

five-year-old asked, with distinct tension in her voice, "But what *happened* to the little girl?" Forcing what I am sure was a transparently false smile, I said, "Well, Mili found her mother again." My interrogator smelled a rat: "But what *happened* to the little girl?" "Um, she and her mother are together again. See?" I showed her the final illustration, which depicts what is *almost* a reunion. Sendak's Mili, before she dies, walks toward her now-blind and extremely old mother, never quite reaching the woman's open and waiting arms; he doesn't illustrate the death scene, leaving that final bitter business to Grimm. "But what *happened* to the little girl?" I sensed a growing certainty on her part that the answer I was withholding was something really unpleasant. Finally I saw no way around it: "Uh, well, it's very sad," I said, "the little girl and her mommy aren't, um, alive anymore. They died." The next question was, of course, "But what *happened* to the little girl?"

I told Sendak this story. He had been worried about *Dear Mili*'s suitability for children when he decided to illustrate it, and as a precaution read Grimm's letter to a little girl of his acquaintance, also five years old. When the story ended he asked his listener if she liked the story, and she nodded yes, vigorously, obviously not traumatized, not even disturbed. Sendak then asked her some version of "but what happened to the little girl?" His guinea pig looked at him with considerable scorn, shocked that this grown-up could be so clueless: "She *croaked*, of course." Sendak has always understood the protective, necessary ruthlessness of kids, who can't afford the sugary sweetness and oblivious innocence adults wishfully ascribe to them.

When my mother was dying of cancer, three years before I met Sendak, I gave her a copy of *Dear Mili*, which had recently been published, and she was moved by it. She wasn't able to address the subject of her own death directly; she was too angry about dying, too afraid to talk about it. The advent of the cancer had been sudden, and its progress was so rapid it allowed little time for her to make any accommodation. I have no idea whether *Mili* helped, but I was glad I brought it to her. After all, my mother had introduced me to Sendak's books many years before. I believe *Mili* offered her solace. She had a keen, appreciative eye. I think the autumnal beauty of the illustrations mirrored her desolation, made it a tiny bit more manageable. At one point, delirious with pain medication, she asked me for a piece of paper, and she wrote "A rose for the rose quarter," which mystified me at the time; I wonder now, looking over the pages of *Dear Mili*, about the rosebud Saint Joseph gives Mili before she leaves his garden, which will bloom, the saint tells her, when she has returned to him, at the hour of her death. Maybe my mother was thinking about that rose.

We return, as adults, to what is considered

children's literature with guilt and embarrassment. But Margaret Edson showed, in a stunning scene in her play *Wit*, that a woman dying of cancer might plausibly receive real, adult comfort from *The Runaway Bunny*. A professor of metaphysical poetry, after reading the book to her dying colleague (and her former student), offers a textual exegesis, "God will find the soul no matter where it has hid." At times of terrible grown-up duress, great children's books, which are, when all is said and done, *great books,* can collapse years' worth of the rigidifying weight of adulthood, allowing the distressingly hapless child we all once were (and with whom we must daily negotiate) air to breathe, and a chance to be heard, acknowledged, reasoned with, perhaps consoled.

If the trilogizing of these three, otherwise unconnected works, *Outside, Mili,* and *Jack and Guy,* is not merely a construct of my own reading; and if Sendak in *Mili,* bearing the burden of his personal and historical knowledge of the brutality inflicted on kids, had in fact crossed some line dividing absolute honesty from adult sensitivity to a child's capacities; then a synthesis appears to have been reached in *We're All In The Dumps With Jack and Guy,* Sendak's only other original narrative since 1981. *Jack and Guy* is literally synthetic, a splicing-together of two nursery rhymes, contrapuntal to which a unifying, original tale unfolds in the illustrations. Published in 1993, it's his most direct

response to the troubles of the contemporary world: poverty, homelessness, and the AIDS epidemic, during which Sendak has lost many friends. *Jack and Guy* is a quasi-apocalyptic depiction of specifically political wickedness and the resistance that human beings and the natural world itself mount against such wickedness. It's an angry book, with its palette of irate reds and charcoal, its pictures of Bantustan shanties made of newsprint, yesterday's bad news providing meager shelter for the abandoned children today's papers will describe in Rio or Bucharest.

"I'd been trying to do *Jack and Guy* for a long time at that time. I had fallen in love with those two verses and I was determined to make a connection between them," Sendak told me. Commenting on Sendak's recollection, Michael di Capua adds:

Here's what Maurice means by "for a long time." In 1964 or 1965 he read through a complete edition of *Mother Goose*—the Opies', I'm sure [with whom Sendak would later collaborate on *I Saw Esau*]. He was looking for rhymes he could illustrate à la Caldecott.

Randolph Caldecott is one of Sendak's favorite illustrators. Sendak credits Caldecott with inventing the technique, employed in *Hector Protector* and *Jack and Guy,* and to a lesser

extent in *Higglety Pigglety Pop!*, of using nursery rhymes as springboards for original narration. Di Capua again:

[Maurice] found "Hector Protector" and "As I Went Over the Water," which he illustrated and published as one volume in 1965. At the same time he also found "We Are All in the Dumps" and "Jack and Guy"—and even did a rough dummy for a book with these two. I don't think he looked at the poems again until about 1991. That old dummy has no resemblance to the finished book.

Sendak remembers the moment he decided to return to the rhymes he'd discovered twenty-six years earlier.

One night on Rodeo Drive—I was in Los Angeles working on the sets for [Mozart's opera] *Idomeneo*—I saw the naked feet of a kid sticking out of a cardboard box in front of one of those fucking ostentatious stores, and that was when I saw what *Jack and Guy* could be: contemporary, political. I'd also been reading about the rounding up in the night by the police of homeless kids in Rio.

Despite its grim inspiration, *Jack and Guy* is a book of hope, redemption, and rescue, the closest Sendak ever comes to the exhortatory. The familial bond making it a matter of reflex that Ida would don her yellow cloak, pick up her father's horn, and fall backward through the window to rescue the kidnapped baby, *her sister,* has been lost by the time we arrive in Jack and Guy's unparented, unprotected world, where rats steal little orphan boys. When one such little boy is stolen, there is reluctance on the part of the two heroes to take up the cause of defending him, of saving someone who is neither familially nor racially *theirs*. Jack and Guy have learned from the world's harsh tutelage. They, after all, belong to no one; they have had nothing of the domestic symmetry and tranquility that has helped make Ida so splendid, so capable. Biedermeier coziness is long gone, and we are in the worst of the late twentieth century.

But if their reluctance to become heroes is natural, so too is the opprobrium Jack and Guy face by refusing the task. In the best tradition of fairy tales, Nature, represented here by the moon, demands that the boys rise to the occasion. Exorcising the despair that coursed through the previous two books, or perhaps only reclaiming the moral refusal to visit an adult despair on children, Sendak, in *Jack and Guy*, suggests that there is a moral order to the universe which will assert

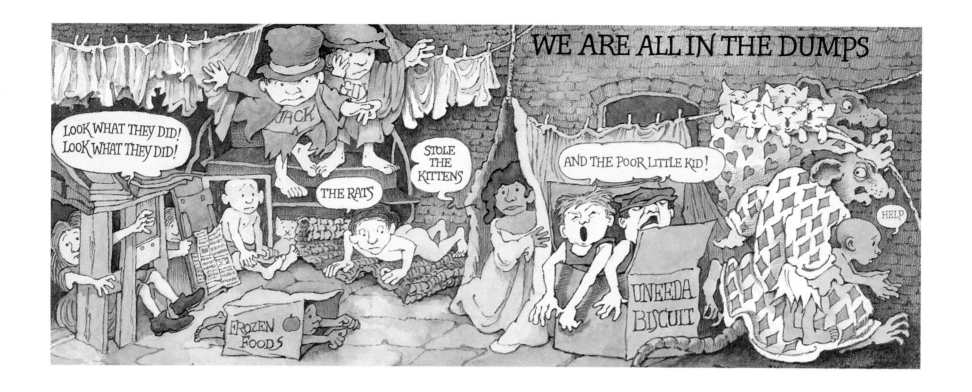

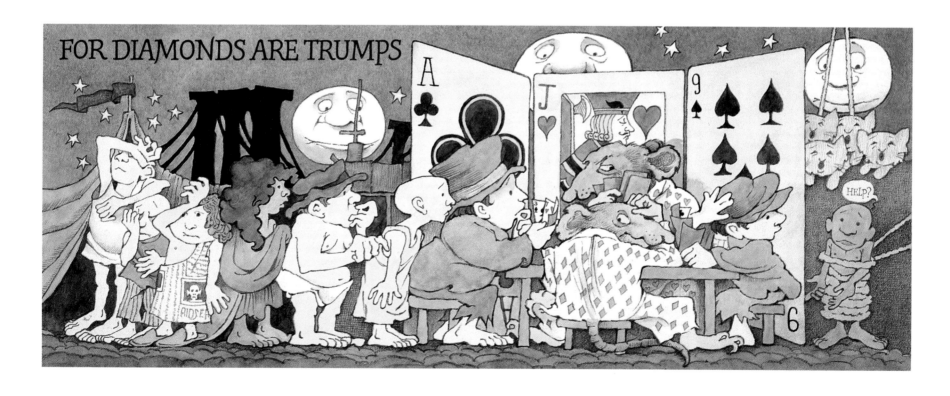

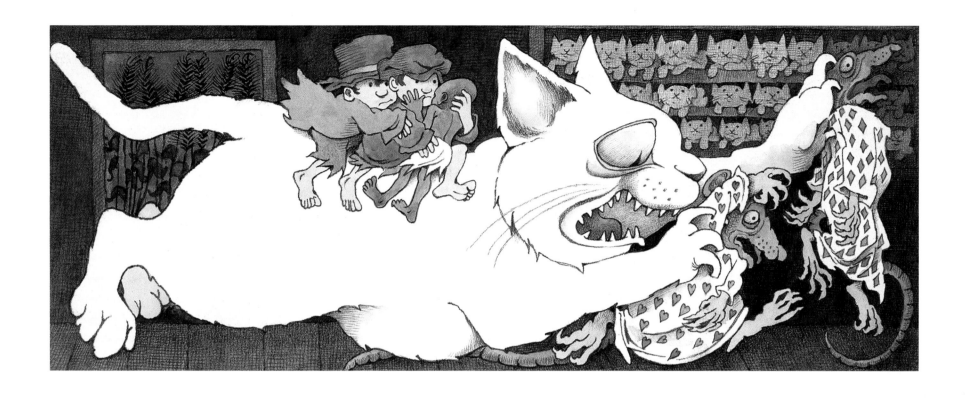

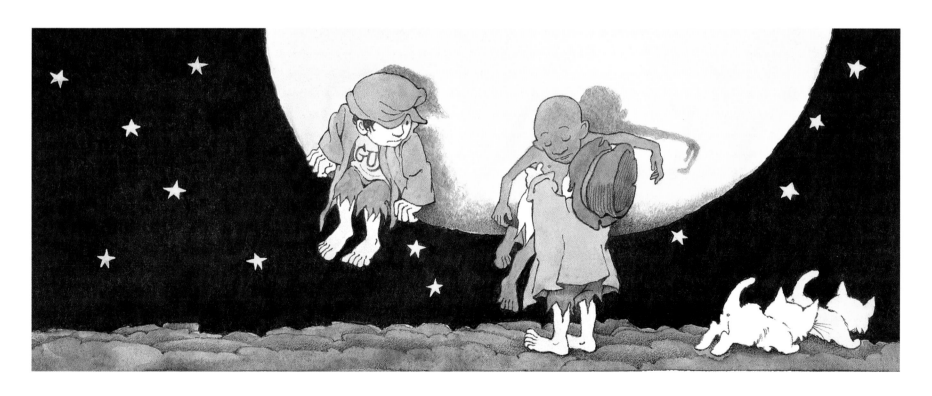

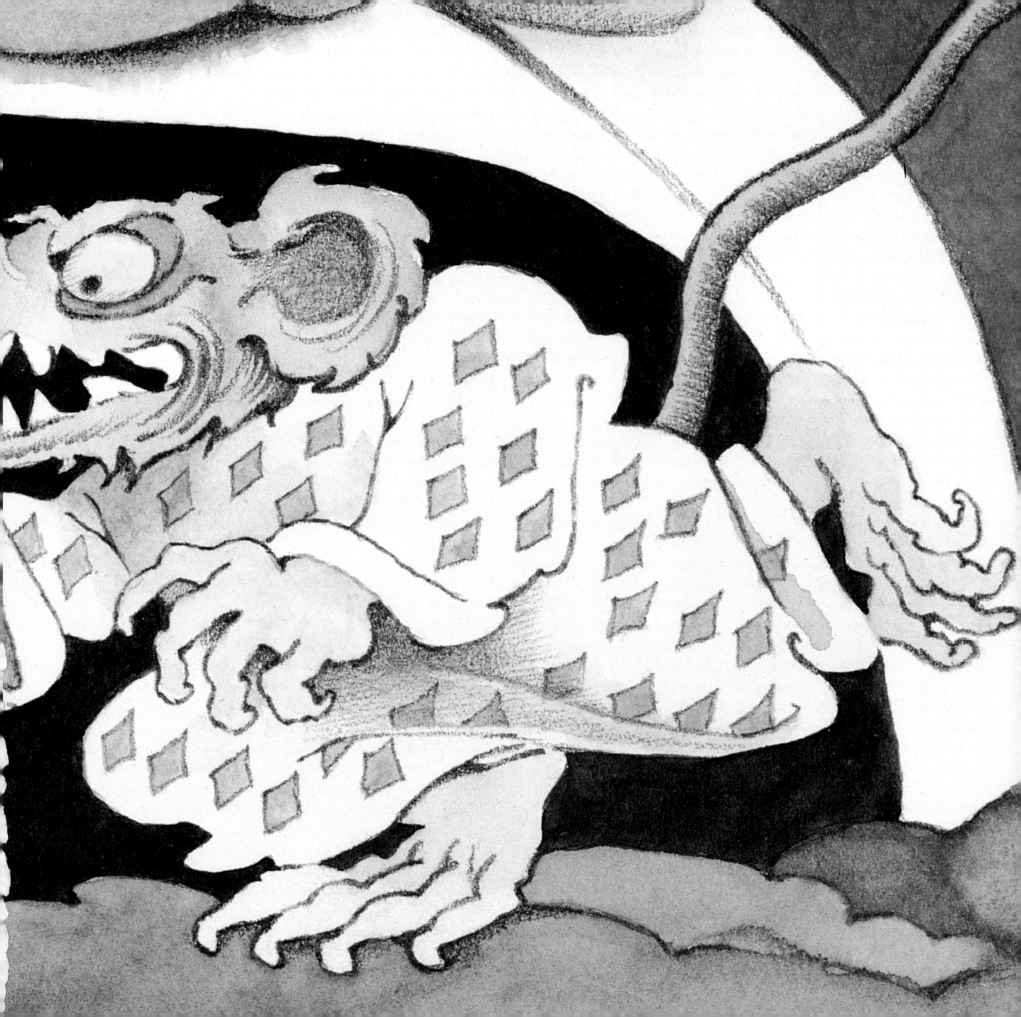

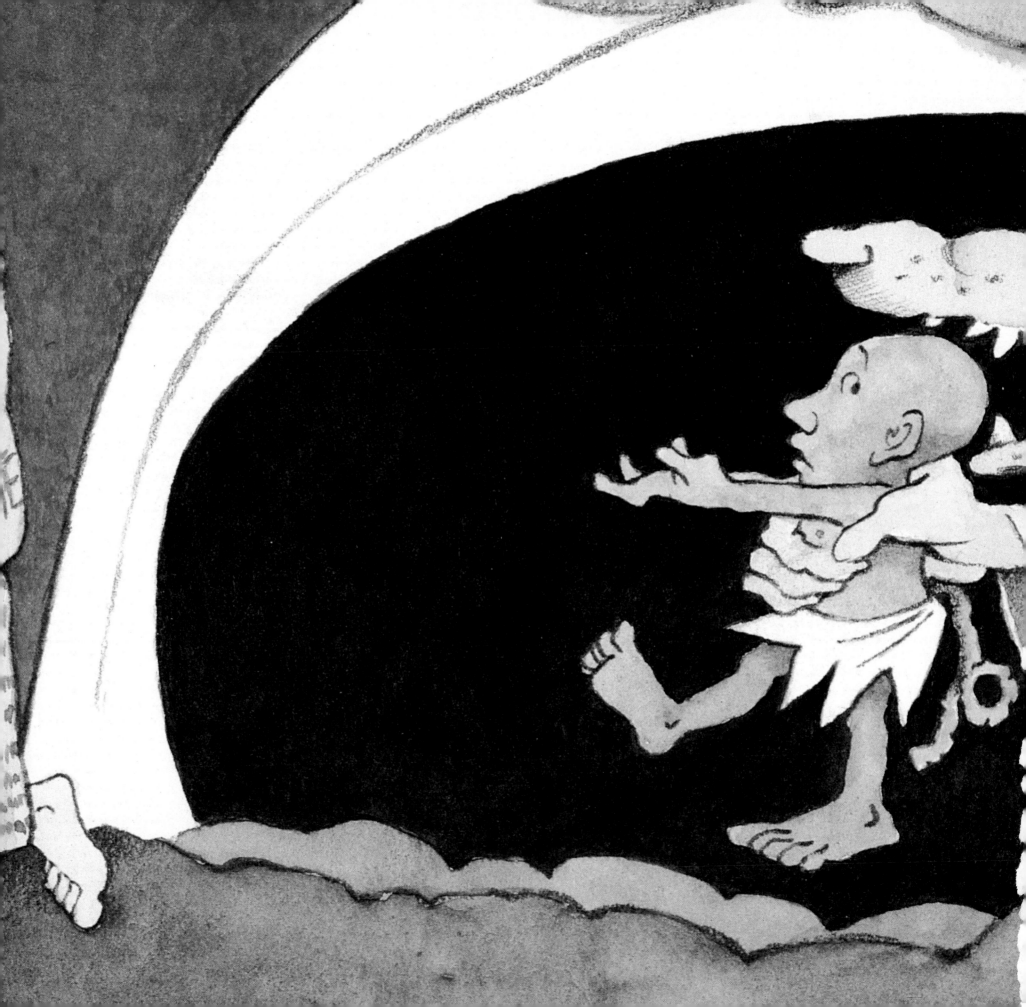

itself triumphantly against evil. He further suggests that evil is as unnatural as an upright, berobed rat, and that parenting, caring, and connectedness, even when not consanguineous, are in some profound sense natural phenomena. There is an imperative in *Jack and Guy*: Rescue is not only possible, it is mandated and will naturally occur.

Thus a Sendakian Divine Comedy, a descent into darkness and an ascent into salvation, in three parts: *Outside, Mili,* and *Jack and Guy*. With the last book of the trilogy, as I read it, Sendak resolves the dilemma between facing despair and locating hope by discovering the only place in which hope can be located, the only place the dilemma may be resolved—in community, in society, with and through other people. The title of the book suggests as much: we may be in the dumps, but we are *all* in there, *with* Jack and Guy, even if we lie to ourselves that we alone have been spared. We lie to ourselves with the word: *Alone*. Jack and Guy triumph over evil, despair, and death by virtue of even smaller words: *we, all, and.*

We Are All in the Dumps with Jack and Guy, book illustration

III.

In addition to the trilogy, the Sendak bookshelf has been expanded, since 1981, by a number of other works for children and, for the first time, two books exclusively for adults.

In 1969, a year after Sendak's mother had died, his father Philip, in poor health—dying in fact—came to live with his son. The father slept in a bed in Sendak's drawing studio in his Greenwich Village apartment while the son worked on the pictures for *In The Night Kitchen*. Philip Sendak wrote a story entitled *In Grandpa's House*. In 1985, Sendak illustrated it.

Sendak told me, "It's like his autobiography. He didn't know it was but it was—he wrote it the year he died [in 1970]. I translated it from the Yiddish, but my Yiddish was very poor. I got Harper's [his publisher] to hire Seymour Barofsky; my translation was then dumped."

The text of the book as eventually published is a compilation of three unfinished stories of Philip's, as well as his reminiscences, recorded by Sendak. It begins with a rather dramatic introduction concerning Philip's early childhood in Mishnitz, Poland, where a new but rigidly orthodox rabbi, having been fired by the group of free-thinkers in control of the local *shul*, curses the town upon leaving it: "The rabbi was angry with [Philip's] Papa and left town, saying that our village would not have any joy from its children." After that, the kids, starting with Philip, come down with typhoid fever, and Philip's father, ignoring his wife's pleading that he ask the rabbi to lift the curse, moves his family to a new village.

This autobiographical section of the book contains wonderful information. We learn that Maurice Sendak's parents met because, at the wedding of a *landsmann* named Hymie, Philip heard Sarah reading aloud a story by Sholom Aleichem—how appropriate that a great storyteller's art provided the occasion for this particular romance. In Philip's voice you can hear one source of the Sendakian cadence:

In Grandpa's House,
book cover

Jackie [Philip and Sarah's eldest son] was born. He looked like an old man, thin and homely. Then he grew more beautiful. . . . Maurice was born. Dr. Brummer said the child would not have a natural birth. The doctor put his instruments in a big pot and boiled them. With the tongs he took the little head and turned it, and Maurice came out all by himself. That was the only time that I saw how a child is born. Maurice's laugh was a little bell.

"Now that I am seventy-five," Philip concludes, "I can no longer imagine myself in a child's life" and hence feels he is unable to tell

a story. But, "since [he has] nothing else to do," with the help of his son, Philip disregards his superannuation and tells the story of a boy, David, who, like Kenny, Hector Protector, Max, Mickey, Ida, Mili, and Jack and Guy, goes off on a journey.

The circumstances surrounding David's travels are of a distinctly Old World variety, flavored with the Old World's anti-sentimental, blunt brutality. Against his parents' wishes, David repeatedly visits his Grandpa until "men came and took David's grandfather away, and Grandpa never came back." Then one day David returns from school to discover that his parents have also inexplicably disappeared. Searching for his parents, he meets a big bird

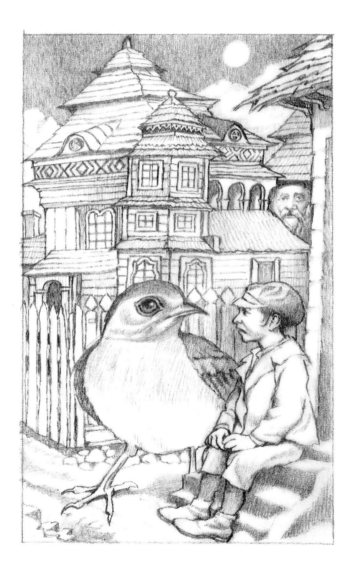

In Grandpa's House,
book illustrations

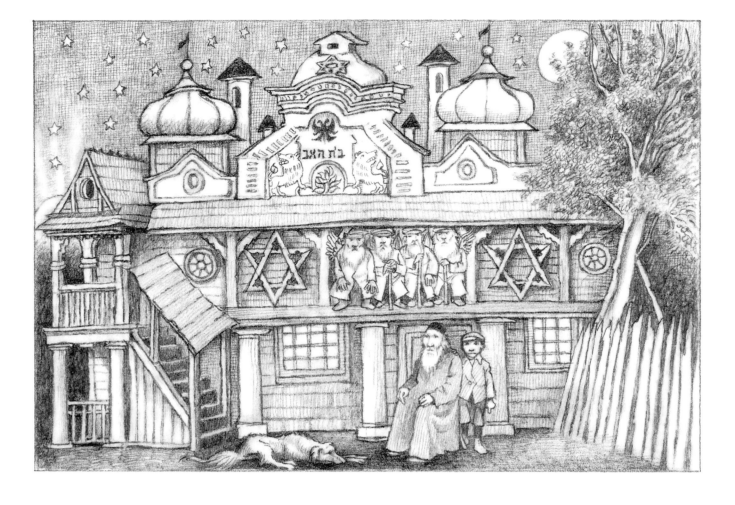

who carries him off to distant lands. He has a variety of encounters, including one with a fish who offers a message right from the pamphlets of the Workers' Bund:

> The little fish . . . had a family and many children and they always had to fight off big fish. Then [the little fish] said, "I don't know if I'll survive this one." But the little fish wasn't afraid, because he

had many grown children who would continue the fight.

David also meets a man who lives in a cave and has freed himself from slavery after discovering he has the courage to take a thorn out of the paw of a lion. "I like to be a free man," he tells David, "I don't like to be a slave." Eventually David arrives at a mansion in a wood at night that turns out to be Heaven,

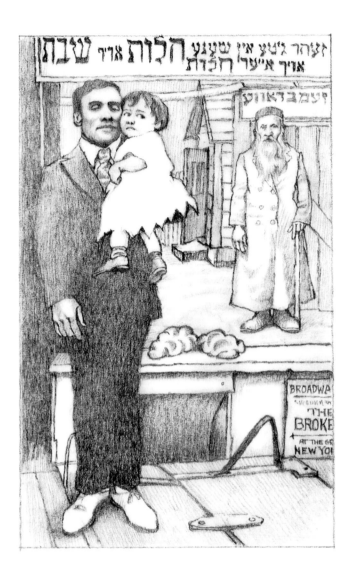

where David's grandfather is waiting, eager to explain the meaning of each of his grandson's adventures:

> Then you were captured by the tiny people, where you saw that if you eat properly you will grow big and strong— and that is better than diamonds and gold. And finally the bird carried you to

the ancient village, where you learned that man has to work as well as study, and where you lost King [David's dog, who has been killed by unspecified "wild animals"], a good friend who can never be replaced. That is why I once gave you a puppy as a gift, and you took care of it and loved it and gave him a name. God made animals to help man, and grandparents should buy grandchildren little dogs as presents.

There follows a brief digression during which a rabbi named Samuel—one suspects this was the first name of the former typhoid-dispensing rabbi of Mishnitz—is disposed of in summary fashion: "They called Satan, who grabbed Samuel and threw him into the fire of Hell. Samuel screamed, and Satan took him out and threw him back again." After this, David is told by his grandfather that his parents disappeared because, ashamed of their poverty, they had fallen in with thieves and died. They have now returned to their house, where, indeed, David finds them waiting— "anxiously," as Philip Sendak puts it. All this happens in forty small pages, generously spaced, large-typed, illustrated.

I can offer no justification for quoting so extensively from this book other than the pleasure I take in doing so. I love the outrageousness of the narrator's voice, the abrupt-

ness, the delectation of vengeance dressed up as solemn moralizing, the solemn moralizing itself, the socialist children's primer the author intends his book to be and believes the world to be. One could try to build a case for situating *In Grandpa's House* as a coda to the dark trilogy of *Outside, Mili,* and *Jack,* for there are tonal similarities—here again, evidence that Philip Sendak heard, in his childhood in Mishnitz perhaps, *Yiddishkeit* variations of the tale Wilhelm Grimm related in his letter. To read Philip's book is to know his son a little better; it's an invaluable glimpse into the *weltanschauung* of the particular Jewish community that produced the people that produced Maurice Sendak.

Sendak's charcoal illustrations for *In Grandpa's House* are suspended between pride and goggle-eyed incredulity, as is only appropriate for the admiring and bemusedly appalled son of an aged father. My personal favorite is the drawing of David surrounded by "the tiny people" who don't eat well, a Gulliver-amid-Lilliputians composition Sendak uses on other occasions: in *Zlateh the Goat* (he once told me his father and mother *finally* became impressed by their youngest child when he teamed up with Isaac Bashevis Singer) and again in *The Juniper Tree.* The tiny people are obviously drawn from memories of relatives and neighbors of Philip Sendak's generation, and David's eyes are wide with wonder as he stares at these

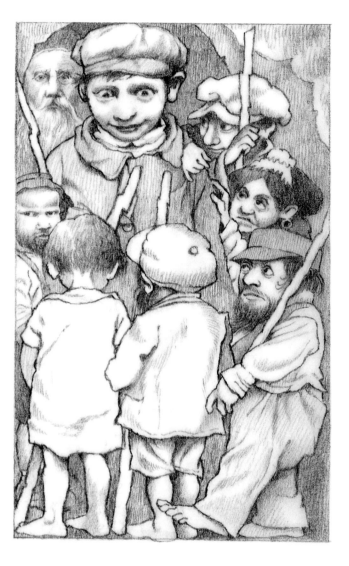

In Grandpa's House, book illustration

malnourished homunculi. He seems to be politely suppressing an impulse to laugh. Perhaps this boy is a Maurice Sendak surrogate. When he grows to adulthood he will remember this reaction, this mix of horror, wonder, and amusement at these small homely people who, purified to their essence in the crucible of his imagination, will transmogrify into the most famous, the best-loved monsters

45

in all of children's literature, the Wild Things.

A mix of horror, wonder and amusement might also be a way to describe the sometimes carefree, sometimes outrageous, often improvisatory sketches that enliven *I Saw Esau*, a book of children's verse collected by the British scholars of children's literature Peter and Iona Opie, authors of the formidable and, for people who are intrigued by the young, the indispensable compendium *The Lore and Language of Schoolchildren*. *Esau* was originally published in an unadorned, shorter edition, subtitled *Traditional Rhymes of Youth*, in 1947. Iona Opie, in her introduction to the Sendak-illustrated volume, explained:

> *Esau* was the first book Peter and I produced together. It was a recognition of the particular genus of rhymes that belong to schoolchildren. They were clearly not rhymes that a grandmother might sing to the grandchild on her knee. They have more oomph and zoom; they pack a punch.

In 1982, after Peter Opie's death, Sebastian Walker, a young British publisher, issued a volume of their collected children's rhymes to commemorate the acquisition of the Opie Collection of Children's Literature by the Bodleian Library at Oxford University. Then

Walker approached Iona for a sequel. She gave him her last remaining copy of *Esau*, which Walker brought to Sendak to illustrate.

Walker and Sendak had met at the Glyndebourne Festival earlier that year, while Sendak was working on his production of Prokofiev's opera *The Love for Three Oranges*. The two became instant friends. "Sebastian was young," Sendak recalls,

> but a throwback to a type, the wealthy liberal intellectual with a publishing house. Everyone thought it was a joke but they underestimated his talent. Sebastian was an opera lover, extremely charming. When you did a book with Sebastian Walker Books you got as payment a share in the company. I still get tiny checks.

Traditional children's rhymes have long been an important source of material and inspiration for Sendak. *Esau* provided a re-encounter with the rhymes in their original state. The book recalls Sendak's early work with Ruth Krauss, in that it catalogues rather than narrates, offers lists rather than stories; Krauss and Sendak, in such books as *A Hole Is to Dig*, eschewed narrative so as to sink deep into the world of a very small child, a child of an age before extended narrative can be comfort-

I Saw Esau: The Schoolchild's Pocket Book, book cover

ably assembled or assimilated, when counting and listing and the non-sequential amassing of facts are the tasks at hand. *Esau* is a similarly non-narrative compendium, though intended for somewhat older children. It meanders, emulating as it does, and as the Krauss-Sendak books had done before it, the passionate aimlessness of child's play.

At least one of *Esau*'s avowed ambitions is to be utilitarian. It was re-subtitled *The Schoolchild's Pocket Book*, and though it's a bit fat for modern pockets, it's sized temptingly small, begging with its manifest portability to be road-tested, knapsacked. Iona Opie beautifully enunciates this intentional usefulness in her introduction:

> Now, with the Sendak illustrations, the book has a new strength and an extra dimension. It is more than ever a declaration of a child's brave defiance in the face of daunting odds. A child *is* Jack the Giant Killer, and Horatius defending the bridge; we rely on him to be so, as we rely on new growth in the spring. So this is his pocket book, his *vademecum* and armoury . . . It is a help, this book, in our universal predicament. We find we are born, so we might as well stay and do as well as we can; and while we are here we can at least enjoy the endearing absurdities of mankind.

Sendak's images engage in cat-and-mouse games with the book's verses. Sometimes the rhymes are illustrated with wit and elegance but in a straightforward fashion, as with the titular rhyme, "I saw Esau kissing Kate." Other illustrations incorporate characters from two or more verses, Caldecott-fashion, to make a picture of a new event that alters, in some cases, the meanings of its component parts. For instance,

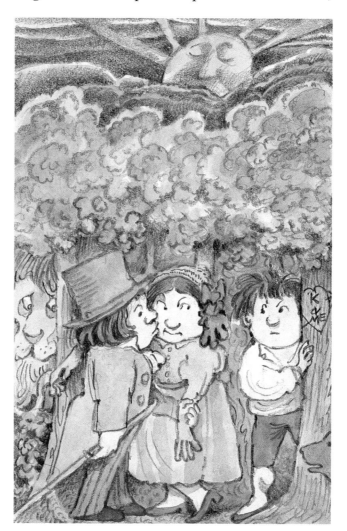

I Saw Esau: The Schoolchild's Pocket Book, book illustration

Charlie, a boy slipping down the bathtub drain, is observed by a character from another rhyme, Caroline Pink, whose "scarlet fever" is a blush caused by prudery affronted at Charlie's nakedness, rather than by germs. This amalgamation of two rhymes offers Sendak opportunity for a delightful, deliberate reading/misreading of Caroline Pink's poem, a chance for him to take a poke at the critics who blush at the nudity in his work, and to reveal a poem's sexual subtext.

A number of the drawings analyze the doggerel, offering a gloss on hidden, even obscure content. One peculiar rhyme tells the story of J. C., the only girl in town who hasn't got a happy life, and who dreams of a husband and a daughter. She's sent to bed, the doctor is summoned, any number of comings and goings are reported, including one by Jimmie, who appears to declare he's "saucy"—well, the poem's narrative contents are indescribable, and one is tempted to pity its

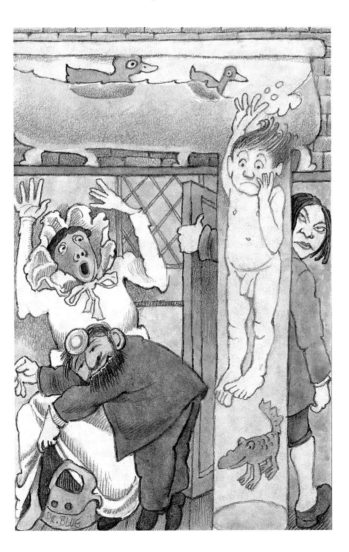

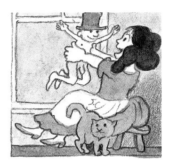

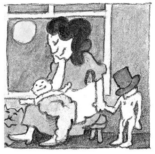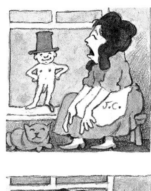

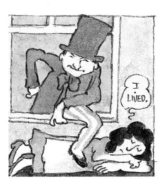

illustrator. Something sexually illicit seems to be going on. Sendak accompanies the poem with a comic strip in six panels: in the first three, J. C., pining for a husband, apparently dreaming, gets her husband (her "dicky, dicky dandy") and she gets a baby as well. In the fourth panel she's awakened by domestic clamor, a cat frisking and a doctor making a house call. "I dreamed," J. C. exclaims/explains as she wakes up. Then she goes back to sleep, sighing as she does, "I lived." Sendak interpolates "I dreamed I lived," and all at once the silly jingle becomes a tale of pathos, of longing, dreaming, sexual desire, and unhappiness. In the last two panels reality appears to confirm J. C.'s dreams and desires. Jimmie, with his chimney hat, climbs in the window. He stands on J. C., looking roguish, and she cocks a consternated eyebrow at him. We worry for a moment that she's about to be raped, but in the last image, on the opposing page, J.C. is back on top, triumphant; she has her baby and she's dragging Jimmie off by the tail of his red neckerchief.

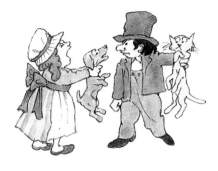

When the *Esau* text skirts mayhem, murder, the penny-dreadful, Sendak either rises to the occasion, goes one better, or reassures. For "Tit for tat, / Butter for fat, / If you kill my dog, / I'll kill your cat," he diligently shows us two kids, each strangling the other's pet. The familiar nonsense rhyme "One fine day in the middle of the night, / Two dead men got up to fight. / A blind man came to see fair play, / A dumb man came to shout hurray" is a little inkwash study for a horror film, the picture literalizing the nonsense and making it more gruesome. But the creepy chant "Hangy Bangy cut my throat / At ten o'clock at night; / Hang me up, hang me down, / Hang me all about the town," is accompanied by an illustration in which Hangy Bangy, who is

All: *I Saw Esau: The Schoolchild's Pocket Book,* book illustrations

49

All: *I Saw Esau: The Schoolchild's Pocket Book*, book illustrations

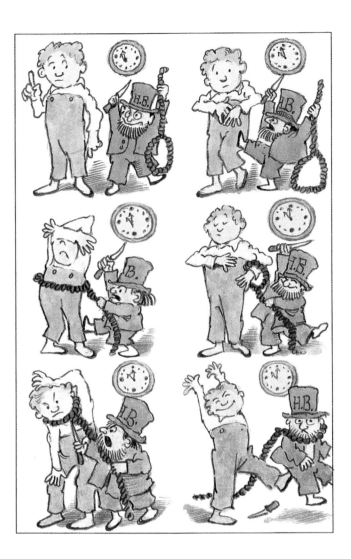

common denominator: mischievous play. *Esau* is an omnium-gatherum of ludic, antic misbehavior, and an invitation to indulge in the same. The sweet baby you meet when you open the book is found a page later hurling a glob of food. These are all naughty children of the sort Sendak has delighted in drawing throughout his career, but they're more rambunctious and boisterous here, more in *trouble* and loving it, than anywhere else in his work. I can find only two peaceful children in all of *Esau*, and they're asleep in the book's frontispiece, guarded by Sendak's German shepherd, Erda, and watched over by harpies sporting the heads of author, illustrator, and publisher in the tree branches above. *Esau* therefore reverses the usual narrative flow of a Sendak book, which typically proceeds from adventure to peaceable repose. In *Esau* the wildness comes after slumber begins; it's as if the book is a dream these two innocent, sleeping children are having, a dream of a world in which no narrative will return them to civilized behavior.

As the embattled protagonist-referents (Jack the Giant Killer, Horatius) in Iona Opie's introduction suggest it's meant to be, *Esau* is a fierce book, bellicose, "an armoury." Underneath the sheer charm of the rhyme and the illustration, something antisocial is at work, something that will discomfit adults, and is intended to. Esau, after all, is the disinherited son of Isaac, the cast-off sibling, the graceless one, the unblessed, the Other one. This is an encyclo-

according to Sendak's rendition some sort of deranged leprechaun, is soundly defeated by the boy he's been invited to murder; on the facing page, Hangy Bangy has been hanged! "In Maurice Sendak's pictures," writes Iona Opie, "the child always wins."

In fact, children are both victors *and* victims in *Esau*'s illustrations, sometimes chasing, sometimes chased. They are united by a single

pedia of little Esaus, rampant in a world devoid of, or hostile to, adults. Children are Esaus, alien to adult morals, conduct, law. This lovely book of familiar rhymes and games is also a doorway into a world apart, for children only, populated entirely by children as we sometimes fear them to be—children as Other.

I Saw Esau is a book for flipping through, and it seems inexhaustible; each perusal introduces some kid, some pun, some pandemonium you hadn't noticed before. The book bears comparison to Pieter Bruegel's painting *Children's Games*, in which another gang of apparently uncountable, unaccountable, unsupervised kids has taken over the streets, the town, the world. The children in the Bruegel painting share with Sendak's *Esau* kids a quality of indifference to adult opinion: They have that concentrated, hermeneutic, exclusionary quality of children engaged in serious, private play. They are in an otherworld, and we are too old to join them there—we're not sure we would in any case want to join them.

As with Bruegel's painting, the interpretation of which has generated a remarkable amount of controversy, *Esau* is a mystery that resists—by virtue of the playfulness it celebrates, by virtue of this quality of inhospitality toward—adult presence—the assignment of certain, fixed meaning. In his brilliant close reading of *Children's Games* and its interpreters in *Inside Bruegel*, Edward Snow acknowledges the

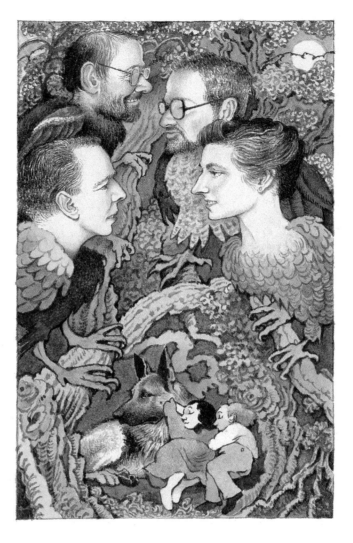

I Saw Esau: The Schoolchild's Pocket Book, left: book frontispiece; below: book illustrations

problems faced by the observer, who must "restrict an unmanageable plurality of images in order to stabilize an object of analysis." Interpretation is "subsumed in a play of differences in excess of whatever idea can be constructed to contain them." It is this non-narrative profusion, this play of differences, that makes *Esau*, such a small book, seem so large. "Play," Snow writes, "imaged as a pure instant, can hold the present, the almost-past, the not-yet,

51

the about-to-be, the held-in-abeyance, the imagined-away, or the permanently translated." He goes on to quote Roberto Mangabeira Unger, the legal scholar and theorist of radical democracy, that "the secret of art" is "depth without abstraction, achieved through detail pursued to the point of obsession." This seems to me a good description of *Esau*, and of Sendak's work in general.

I Saw Esau was published in 1992. "*Esau* is one of my very favorite books," Sendak told me.

Iona and Peter Opie were the godheads of children's books. For the American book tour, Sebastian flew Iona over on the Concorde [Peter Opie had died by this time]. She was very naughty. When I fall in love with women it's very keen

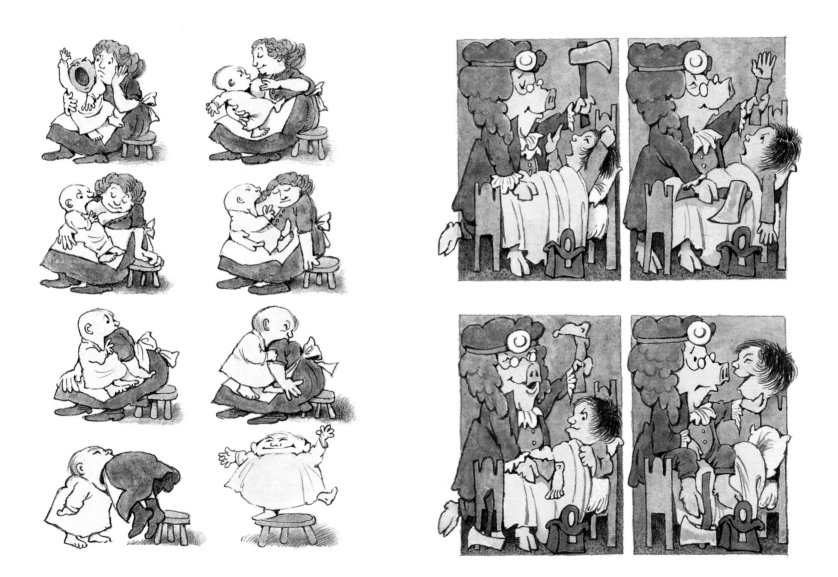

All: *I Saw Esau: The Schoolchild's Pocket Book,* book illustrations

52

and deep, and I fell in love with Iona. We drank and had a wonderful time, we traveled all over the U.S., we had a lecture we did together, a whole lecture tour, reading, traveling, like Dickens.

Sebastian Walker died of AIDS. He and I went walking together in Edinburgh when he was quite sick. He suddenly got very mad at me, saying "It's wrong that I'll die and you'll go on living, you're older than I am, it's wrong." I've met such people in my life, Iona Opie, Sebastian. His death was the end of that whole adventure, Glyndebourne, Iona, Sebastian. The illustrations were done in a flash, the sketches were so good.

All: *I Saw Esau: The Schoolchild's Pocket Book,* book illustrations

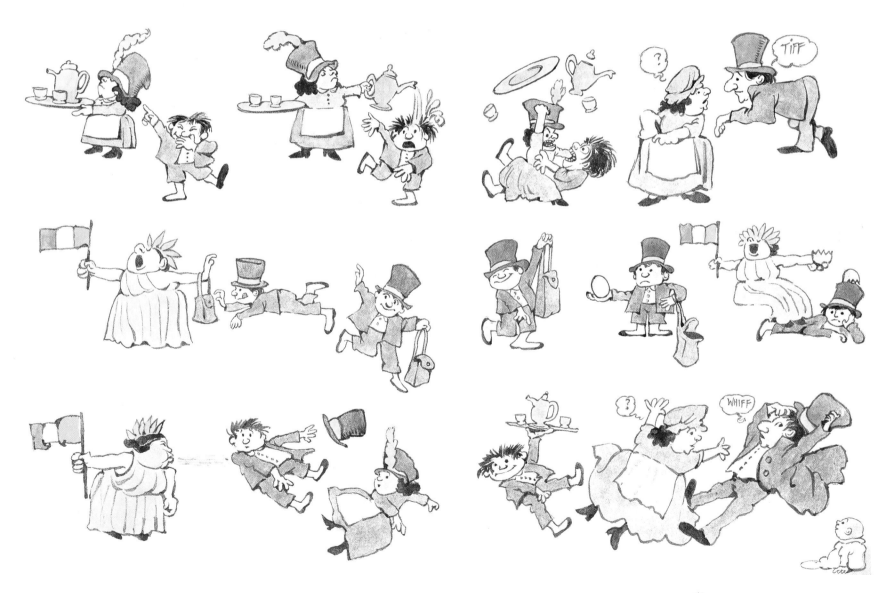

The Miami Giant,
above: book cover;
below: book illustration

The Miami Giant, published in 1995, with text by Sendak's longtime collaborator and friend, Arthur Yorinks, is a surreal riff on the Jewish migratory experience. Gentile explorers set out from western Europe in the fifteenth or early sixteenth century, probably immediately after the Jews have been expelled from Spain. They arrive in the New World only to discover it's inhabited and then some. They land in Miami, home of the Mishbookers, a tribe of giants (*mishpocheh* is a Yiddish word meaning "extended family"). They are descendants, one senses, of the tiny underfed people in Philip Sendak's tale. The Mishbookers are rather well-fed, if not downright upholstered and slipcovered. They are nomads emigrated from anti-Semitic Europe, who, having passed through some Brobdingnagian Borscht Belt, have arrived at their wintering quarters or retirement community near the fountain of Coppertoned youth. One of the Miami Giants returns to the old country with the gentile

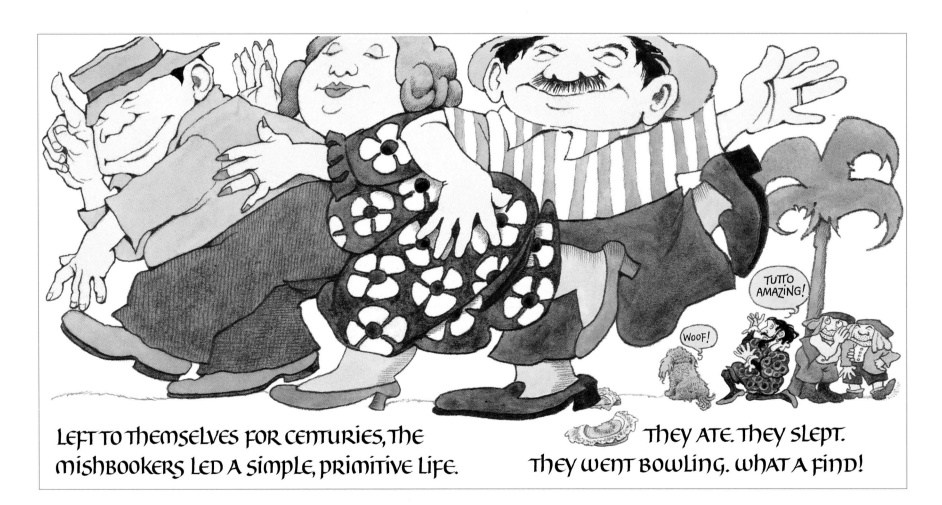

LEFT TO THEMSELVES FOR CENTURIES, THE MISHBOOKERS LED A SIMPLE, PRIMITIVE LIFE.

THEY ATE. THEY SLEPT. THEY WENT BOWLING. WHAT A FIND!

BACK IN ITALY, GIAWEENI RENTED A PALAZZO.

WHERE'S THE BATHROOM?

THEN HE HAD A TAILOR MAKE JOE A NEW SUIT.

NO CUFFS?

WUFF

explorers who have "discovered" him, and he goes berserk, demolishing a city like a klutzy King Kong, the Jew amok in the china shop of *goyische* Europe, a clown-cataclysmic return of the repressed, or in this case, oppressed. Is that Sigmund Freud applauding in the front row, sitting next to Babar, in the theater in which the Mishbooker lets it all hang out?

Sendak met Arthur Yorinks when Yorinks was still a teenager.

He rang my bell on 29 West 9th Street,

came with a packet of stories, the way you don't want anyone to show up, but he was gifted. I saw him grow up and get married. This was the first book I did with Arthur, previously I was wary because I didn't want to muddle the friendship. But I love this book because it is broad.

It is, in fact, an unabashedly punny, giddy cartoon, a book for the children of a Catskills tummler. As Sendak wrote of Yorinks' first book, *Sid and Sol, The Miami Giant* "is reminiscent of

Above and overleaf:
The Miami Giant,
book illustrations

55

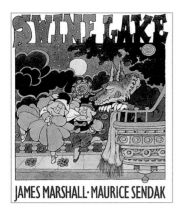

Swine Lake, above: book cover; below and opposite: book illustrations

good, old things." Philip Sendak would probably laugh out loud.

In another picture book of bold bright comedy, *Swine Lake,* published in 1999, Sendak provided witty illustrations for an evolutionary tale of a wild thing, an actual wolf this time, rather than a boy in wolf's clothing. The wolf becomes civilized, though not necessarily made more happy, by art. It gives up wanting to eat pigs and becomes, instead, a *danseur noble* in a porcine ballet company.

The text of *Swine Lake* is by James Marshall, author and illustrator, creator of the immortal hippopotami George and Martha. Marshall also illustrated, among many other works, Harry Allard's series the Stupids, the concluding volume of which has what Sendak calls "the best title in kiddie books," *The Stupids Die.* Sendak was a close friend of Marshall. *I Saw Esau* is dedicated to him. Marshall died on October 13, 1992.

I visited Jim while he was dying. He was erudite, funny, sophisticated, opera lover, a delicious delicious creature. It was a thorough friendship. He died three days after his fiftieth birthday.

Michael di Capua, who had been Marshall's editor, had a manuscript of *Swine Lake* in his files; Marshall had finished the text but had not had time to illustrate it. Di Capua "connected the dots" and asked Sendak if he would be interested in doing the illustrations. "He didn't have to think about it," recalls di Capua, "he said 'Yes!' immediately."

"We'd always talked about doing a book together, though I think *Swine Lake* was one text for which Jim had wanted to do the pictures," Sendak told me. "So I don't know if he'd be happy or pissed."

The city of swine into which the wolf wanders is going through hard times. A recession or a depression is evident in its streets, which are plastered and littered with newspapers. The city is vaguely reminiscent of the dysfunctional, dystopic metropolis of *Jack and Guy.* But Sendak's illustrations for *Swine Lake* are faithful to Marshall's mischievous comic spirit. There are no homeless hogs in pigtown. The headlines and frantic "for sale" signs in the shop windows mostly pay tribute to Sendak's living friends, including Lynn Frost, Sendak's extraordinary gardener/housekeeper/cook/secretary and close friend (*Lynn is great! New Season!* reads the page of one newspaper), or score points in the grudge match between Sendak and his encroaching Connecticut

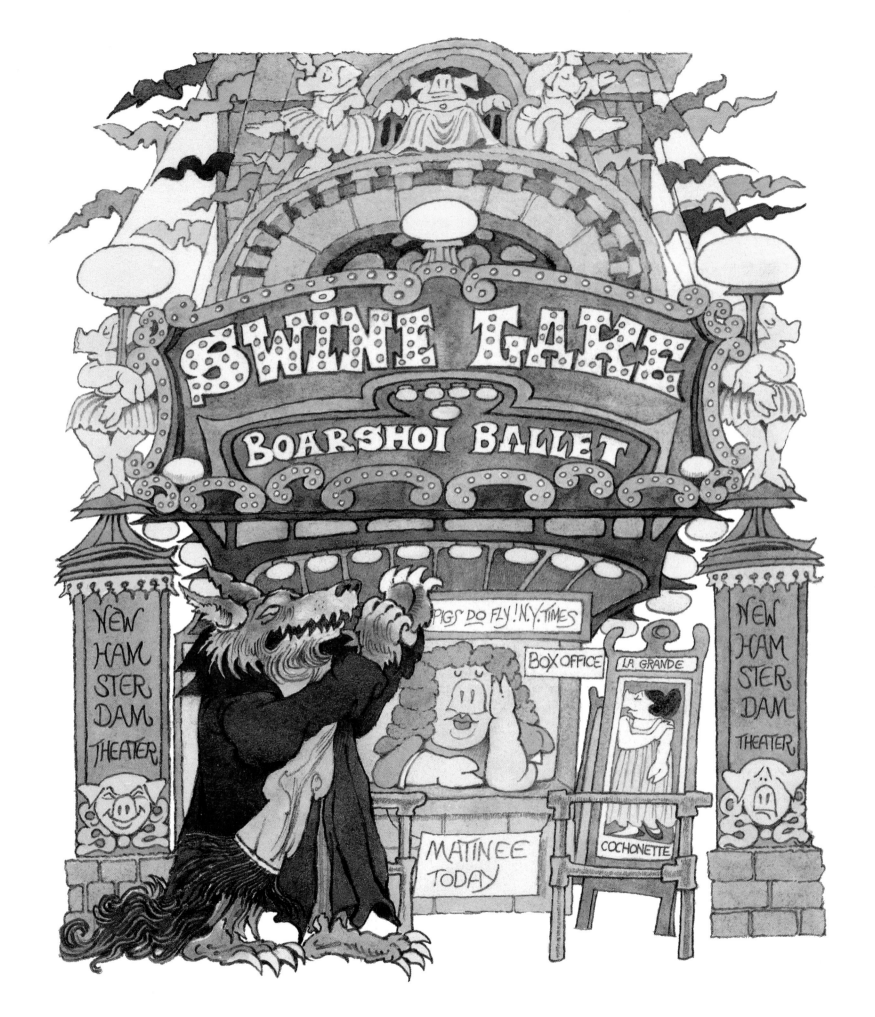

neighbors (*McMansions All Fall Down!* reads another headline).

The protagonist wolf of *Swine Lake* is a portrait of the artist as animal dispossessed of its species-being, the artist as alienated animal, raw hunger replaced by the (arguably) worse torment of an unappeasable aesthetic ideal. In the wolf's case, the call of the wild, and an appetite for pork, is supplanted by the siren song of Terpsichore. This supplanting, one is led by author and illustrator to suspect, brings in its wake a lifelong ache. With bodily hunger, there is eating, and satiety; in art, as Michelangelo, Tolstoy, Proust, Brecht, and many others tell us, and as artists know from bitter experience, there is more often than not the fact or feeling of failure. *Swine Lake* poses a variant of the old question, "Would you rather be Aristotle, or a pig?" "Would you rather be Aristotle or eat a pig?" is the wolf's conundrum. To have a soul is to experience the painful mind/body split. To have a soul is to have a soul divided. To have a soul is both a blessing and a curse.

Swine Lake completes the catalogue of Sendak's work for children, at least as of the writing of this essay. The two remaining illustrated books published during this period, Herman Melville's *Pierre* and Heinrich von Kleist's *Penthesilea*, are intended for adults.

On one street in the *Swine Lake* city, Sendak shows us a forlorn shop, the "Old Fashioned Bookstore," which is going out of business. A placard in the shop's window

Swine Lake, book illustration

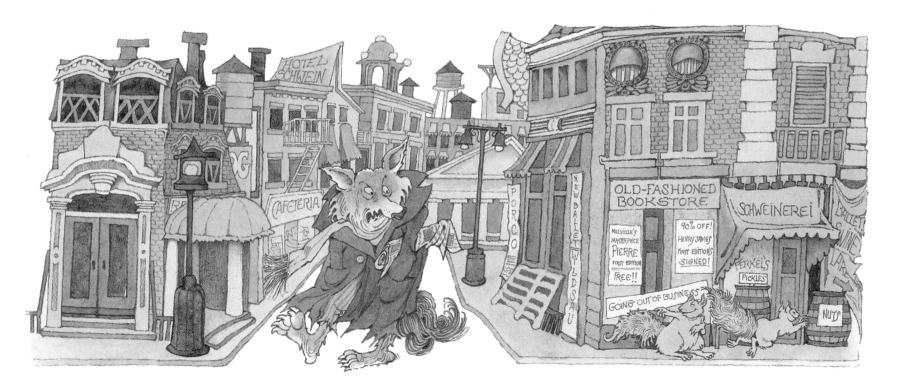

advertises "Melville's Masterpiece PIERRE: First Edition FREE!!"—a grimly ironic reference to the lamentable sales figures for Melville's novel, the commercial and critical failure of which was cataclysmic for the writer's career. In 1995, four years before *Swine Lake*, Sendak made his first foray into illustrated adult literature with a new edition of Melville's unsalable masterpiece.

The *Pierre* poster in *Swine Lake* is both an insider's joke for Melville fans and the sounding of a thematic connection between *Swine Lake* and Melville's book, between the wolf's artistic bedevilment and the perpetual suffering of one of the most important of America's (often tormented) artists. If *Swine Lake* is a light-hearted take on an artist's agonies and ecstasies, *Pierre* is a soul-deep testament on the same theme from a writer for whom the elusiveness of success and the agony of artistic failure were both a curse and a vital source of material, the subjects of some of his most magnificent work.

Sendak, by turning to Melville's *Pierre*, completed a circle. From Melville's novel, which he'd read as a young man, he had taken the title of the best of the four miniature books in his *Nutshell Library*, as well as the name of that tiny book's impossible hero—perhaps the spikiest kid in American children's literature until *Wild Things*'s Max came along and usurped that honor. Every child greets with happy recognition Sendak's

Pierre, his grasp of the power of the Negative; every toddler has already learned how to stop the world in its tracks by shouting some version of "I DON'T CARE."

(In another volume of *Nutshell* there is a second Melville allusion. *Moby-Dick*, the Melville novel that preceded *Pierre*, begins its narrative with Ishmael declaring he knows it's time to go to sea "whenever there is a damp and drizzly November in [his] soul." *Chicken Soup With Rice*'s nameless month-counting boy is Ishmael's cheerier soulmate: "In November's / gusty gale / I will flop / my flippy tail / and spout hot soup! / I'll be a whale!").

If Sendak's Pierre is a miserably obdurate four-year-old (we've all met them) having a bad day (we've all had them) who has to be eaten alive and disgorged—reborn, basically—to learn to care, Melville's Pierre cares rather too much; he is the unstrung hero of a great and under-appreciated novel which is about, among many other things, being great and under-appreciated—something Melville knew something about.

Sendak chose to illustrate a new version of the novel. Hershel Parker, an eminent scholar and author of the definitive Melville biography, stripped *Pierre* of text that he argued was mere diminishing encumbrance, namely several chapters of lengthy, narrative-diluting, irascible digressions about the Manhattan publishing world. This most digressive and perennially

Overleaf: *Swine Lake*, book illustration

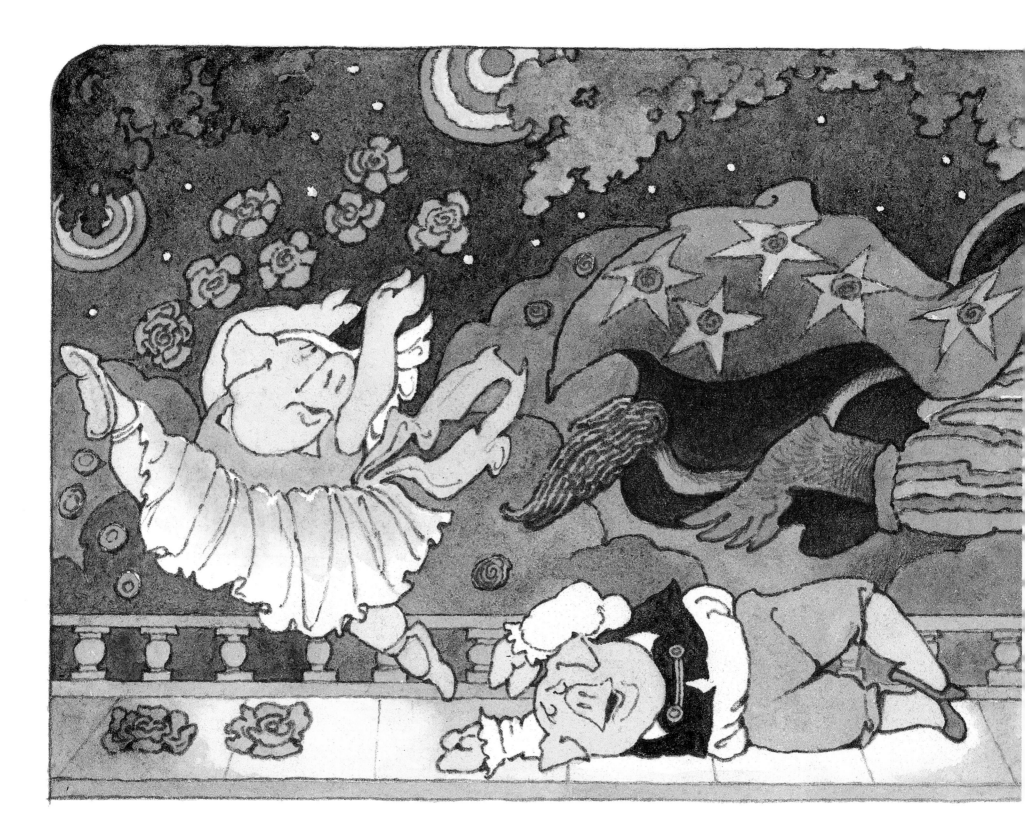

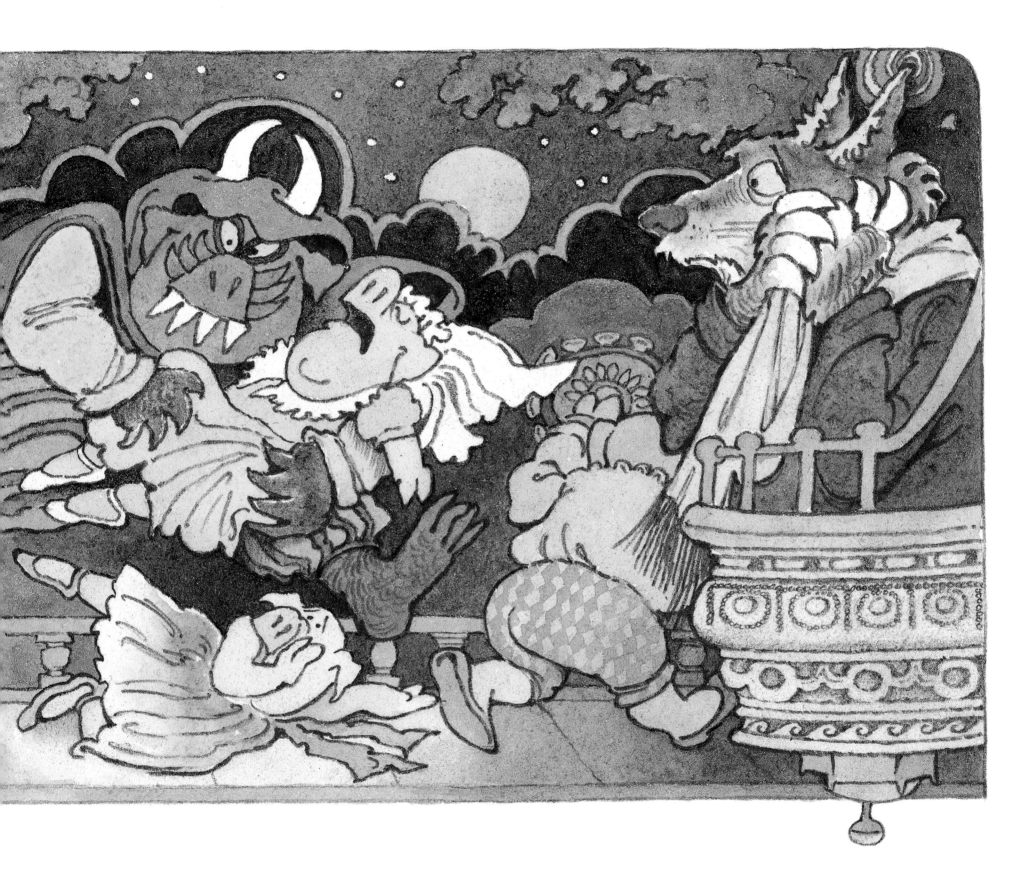

cash-strapped of authors had written these passages in rage and despair over the terrible reviews *Moby-Dick* had received and the offensively penurious contract Harper's had subsequently offered him for *Pierre*. The original text of the novel, according to Parker, is entirely different from the bleak and depressing book we have come to think of as *Pierre*. The first draft reveals Melville in a state of exaltation after completing *Moby-Dick*, his writing alive with the energy and exuberance of his previous work. The addenda visited a crabbed, murky moroseness on *Pierre*, changing the book for the worse. (I'm not sure I agree with this thesis, but it's fascinating nonetheless.)

Sendak and Parker met on May 16, 1991. Sendak explains:

The illustrated *Pierre* began with my friendship with Hershel Parker, whom I met at Arrowhead [Melville's favorite of his homes, in Massachusetts] at a big Melville conference—he was there with Hedy, his wife. Everyone who was anyone in Melvilleland was there, and Hershel and I became buddies. We were both in love with *Pierre*, which had been left out of the canon. Hershel had a very interesting theory about how the book had been composed, why it had failed. We decided to call our edition of the

Pierre, Or, The Ambiguities,
book cover illustration

book the Kraken edition, from a letter by Melville to Hawthorne when he had finished *Moby-Dick*. Kraken were sea-monsters, and Melville wrote to Hawthorne that there are bigger things than whales—there are Kraken. He felt this book was going to be bigger than *Moby-Dick*. But of course in the end both books failed.

Failure and the wild embrace of failure; the recognition that the pursuit of success in art as well as in whale-hunting or in love is also the pursuit of failure; an openhearted passion for the doom that trails all human enterprise; the freedom to try to seize the entire world, to apprehend the unapprehendable; the madness to attempt such a comprehensive apprehension, to attempt to stuff the cosmos into the confines of a book; a beauty that risks gaucherie and excess but that finally, unerringly, for those with souls large and patient enough to pursue it through its only apparently endless divagations, returns to itself, to beauty; a reckless ardor for the truth and a conviction that truth exists and can be, *must* be spoken, no matter how shocking, how unpopular or ugly or despairing it may be; manic good humor and black depression; sexuality both earthy and coy—these are aspects of what draws a person to "Melvilleland." It's an apt phrase. Melville *is* a land; it lies outside over there. He's an alternative, a cause, and a cult object as

much as an author of genius. Though you can find, at different times in his life, Sendak declaring to interviewers his devotion to Henry James, D. H. Lawrence, Emily Dickinson, John Keats, or Shakespeare, Melville is, I think, the lodestar of his literary heaven, seated in the throne occupied in his musical heaven by Mozart, and in his visual heaven, perhaps by William Blake.

Maurice and I became friends after he'd read an interview in which I'd talked about my indebtedness to and love for the work of Melville. Melville idolatry has historically been a calling card, a point of introduction, particularly among gay men.

"I was a Melville fan—*Typee, Redburn, Omoo,* I loved them—in my adolescence," Sendak told me.

> Wonderful popular quirky sexy books. Illustrating Hershel's *Pierre* gave me the privilege of doing a grown-up book, which I'd said I'd never do. It was my commentary on the book. I loved it so much—it didn't need illustrating.

As he had done before starting work on the drawings for *Outside Over There,* Sendak met with a photographer and models and had them assume poses based on sections of *Pierre.* John Dugdale, a remarkable photographer and a friend of Sendak's, used for the session the old daguerreotype camera with which he shoots his exquisite, evanescent still lifes. To the anachronistic presence of Dugdale's plate-and-bellows camera; to the intoxicating effect of Melville's swoony prose, never more fuchsia or fustian than in this novel; and to Sendak's decision to use, as the true parent and original of his visual midrash on this story, the strange mannerist art of Blake, can be attributed the *serioso* extravagance of the compositions, of the illustrations themselves.

Sendak began the illustrations by plotting, as he always does, the entirety of the book's drawings on a storyboard, a "dummy," laid out, in the case of *Pierre,* on a large sheet of paper, over the surface of which double rows of small rectangular watercolors proceed through the novel's falling, falling, falling action. As was the case with *I Saw Esau,* Sendak felt that the *Pierre* storyboard sketches, intended to be studies for more finished, elaborate illustrations, "were so fresh and spontaneous there was no need to go beyond them."

The marriage Sendak arranges between Melville and Blake illuminates an important imaginative, expressive, and intellectual affinity. Sendak makes the two seem kindred spirits, and suggests a third kinship connection—with Maurice Sendak. Here are three artists who play complicated games with aesthetic and intellectual questions of "worldliness and naïveté," of innocence, if you will, and experience. Technical sophistication is displayed

Overleaf: *Pierre, Or, The Ambiguities,* book illustrations

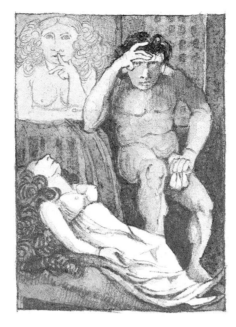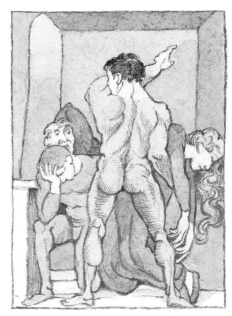

alongside choices and gestures which seem primitive, guileless, "incorrect." Melodrama, farce, and scabrous humor exist alongside sublime moments of pathos and beauty. The celestial, the divine, is engaged with, inseparable from, the secular and downright abject/profane/obscene. "I brought Blake to Melville—Blake revealed sexual aspects of the book which I always knew were there," Sendak says. All three artists share a willingness to use any means, to venture down any defile, no matter how narrow, in helpless, besotted thrall to the pursuit of what is, or might prove to be, a deeper truth.

Pierre of *Nutshell Library* has both a mother and a father, but fatherlessness is something Melville's Pierre shares with a number of Sendak's other heroes and heroines. Max may have a father but he isn't mentioned. Ida's father is away at sea. Mili's father is dead. And so too with Pierre:

When Pierre was twelve, his father had died, leaving behind him, in the general voice of the world, a marked reputation as a gentleman and a Christian; in the heart of his wife, a green memory of many healthy days of unclouded and joyful wedded life, and in the inmost soul of Pierre, the impression of a form

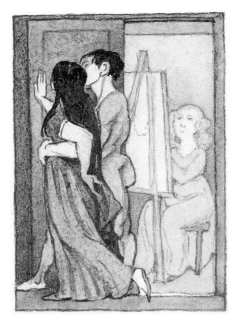 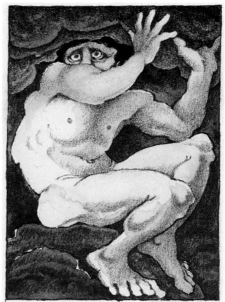

of rare manly beauty and benignity, only rivaled by the supposed perfect mould in which his virtuous heart had been cast.

The removal of the father, the guarantor of law and order, has since time immemorial been a signal that misrule, mischief, a wild rumpus of some sort is about to begin. When daddy is dead, distracted, or away on business, Angelo hits on Isabel; Goneril and Reagan go after their lamblike sister. While her husband is out in the world, the mother of Anne Marie, in the Grimm story "The Juniper Tree," tricks her stepson, the little boy "red as blood and white as snow", into putting his head into that fatal heavy-lidded trunk, looking for apples. With mad, distrait Ahab abdicating his command in favor of his obsession, sinister forces of authoritarian, anti-democratic intrigue overwhelm the *Pequod*. With the ineffectual Starry Vere adrift in a dream of enlightened but ill-advised bonhomie, the purely malevolent Claggart is free to track and trap and destroy his prey, human goodness, incarnate in Billy Budd. And with his father's death, Pierre's destiny for a life of "manly beauty and benignity" is cast asunder; he is engulfed in a moral, sexual, political and artistic fog whence comes the book's subtitle, *The Ambiguities*.

In 1995, I inveigled Sendak into joining me and the gay historian Jonathan Ned Katz in a reading of selections from Melville's writing at Manhattan's gay bookstore A Different Light on the occasion of the publication of the illustrated *Pierre*. Many people in the audience of lesbians and gay men had brought their childhood copies of *Where The Wild Things Are* and *In The Night Kitchen*. Sendak chose to read a passage from Melville relating the thoughts and feelings Pierre has upon gazing at a portrait of his deceased father, who is shown in the painting as a young man. The painting is described as "[an] impromptu portrait of a fine-looking, gay-hearted, youthful gentleman. He is lightly, and, as it were, airily but grazingly seated in, or rather flittingly tenanting an old-fashioned chair of Malacca." Pierre's mother abominates the image, preferring the portrait that hangs in her drawing room and depicts her husband as an older, respectable businessman, possessed of "all the nameless and slightly portly tranquillities." She has banished the earlier painting from her sight. It is kept

in a locked, round windowed closet connecting with the chamber of Pierre, and whither he had always been wont to go, in those sweetly awful hours, when the spirit crieth to the spirit, Come into solitude with me, twin-brother; come away: a secret have

I; let me whisper it to thee aside; in this closet . . .

The audience at A Different Light was visibly moved as Sendak, in his deep, soft, low, grainy voice, gentle and sad, almost whispering into the microphone the words of this very strange book, drew them into Melville's strabismic vision, the doppelganger spookiness at the heart of his novel, its parsing of the doomed struggle against blurring, against distortion, engaged by people who cling to the belief in the possibility of clear vision.

Yet, sometimes dimly thought Pierre, ever new conceits come vaporing up in me, as I look on the strange chair-portrait: which, though so very much more unfamiliar to me, than it can possibly be to my mother, still sometimes seems to say—Pierre, believe not the drawing-room painting; that is not thy father; or, at least, is not all of thy father. Consider in thy mind, Pierre, whether we two paintings may not make only one. Faithful wives are ever over-reverential to a certain imagined ghost of that same imagined image, Pierre. Look again, I am thy father as he more truly was. In mature life, the world overlays and varnishes us, Pierre; the thousand proprieties and polished finenesses and

grimaces intervene, Pierre; then, we, as it were, abdicate ourselves, and take unto us another self, Pierre; in youth we are, Pierre, but in age we seem. Look again. I am thy real father, so much the more truly, as thou thinkest thou recognizest me not, Pierre. To their young children, fathers are not wont to unfold themselves entirely, Pierre. There are a thousand and one odd little youthful peccadilloes, that we think we may as well not divulge to them, Pierre. Consider this strange, ambiguous smile, Pierre; more narrowly regard this mouth. Behold, what is this too ardent and, as it were, unchastened light in these eyes, Pierre? I am thy father, boy.

"So much the more truly, as thou thinkest thou recognizest me not." This sentence could have been written by the other writer whose adult work Sendak has illustrated, another titanic articulater of the ambiguous: the playwright, essayist and short story writer Heinrich von Kleist.

The illustrated *Penthesilea*, Kleist's rarely produced sadomasochistic epic play of gender warfare, of sexual longing, mythic passion, emotional violence, and unsavory, gory lusts, also began with a friendship.

I met Joel Agee, the translator, through

Michael di Capua, who'd edited a book Joel had written about his boyhood in Germany, where he'd lived with his mother after she had left Joel's father, James Agee. Joel and I were so passionately in love with Kleist. We decided on *Penthesilea* as the book to illustrate, and also we wanted to get it produced. The purpose of the book was to get the play done, and Joel had done such a remarkable job translating it. After *Pierre* I was much less daunted about doing it, but it wasn't as spontaneous as *Pierre*—it was more laborious, it didn't spring to my fingers. I thought it would be easier, a dramatic aggressive active passionate play which would make for intense acting and illustrating.

As any perusal of the drawings for *Penthesilea*, or for *Pierre* will confirm, illustrating adult literature provided Sendak with an opportunity, after decades of working for children, to depict grown-up sexuality. That he became notorious for Mickey's penis in *In the Night Kitchen* says much more about American sexual hysteria and hypocrisy than it does about any intention on Sendak's part to sexualize picture books. The pact Sendak has with his very young readers to take seriously their lives, their fantasies, and their bodies made it a point of honor for him to depict nudity. He waited a

Kleist: A Biography,
book cover illustration

Overleaf: *Penthesilea,*
book illustrations

long time to do so, and did it at precisely the right moment in American history and in precisely the right book: *In the Night Kitchen*. In that most American of paradises, its skyline shopped from memories of Sarah Sendak's pantry, in a nighttime world of oral-incorporative pleasure and oceanic, limitless delight, in a make-believe world in which real power belongs only to kids, Sendak stages a return to a state of nakedness that was not only appropriate and axiomatic for any return trip to paradise, but inevitable. Inevitable, too, were the controversial (controversial for certain incredibly unhappy guardians of morality) sphincters he put on pussycats (in *We're All in the Dumps with Jack and Guy*) and the doggie poo he showed puppies capable of producing (in *Some Swell Pup*).

Truthfulness, that is to say a fidelity to what a child apprehends as truth, is one basis upon which Sendak's relationship with his readers, his children, rests. Another is, as I have mentioned, adult responsibility, adult circumspection, and in this regard nothing Sendak has depicted of the carnal or corporeal would mar or threaten in the least a child's developmental progress. The sexual, insofar as it appears in his picture books, provides for his young readers a frisson of consonance, of the assimilable recognizable, an antidote to hystericizing repression. The inappropriate sexualization of children poses a grave danger, destroying a child's control over her or his own body. It disrupts latency, that critical pre-adolescent period of learning during which sexuality is repressed for the purpose of organizing other kinds of development. Adult sexual predation of children has been gaining ground in our culture, in illicit ways and also above ground, in the marketplace of body and youth fetishism. Acutely aware of the power of the forces with which he is engaged, Sendak in his children's books carefully, respectfully offers the body a glance and then restores latency; his children return to childhood, gaining, rather than losing, control of themselves and their world.

Sendak was a pioneer in the recognition in children's literature of children's sexual curiosity, among the first to push at this boundary— to the appropriately reticent degree that he has pushed—and his decision to do so required remarkable courage. The book-banning and book-defacing crowd which, in some instances, actually drew pants on Mickey in library copies of *Night Kitchen*, or those who took the low road of homophobic insinuation when writing about, for example, the picture of David, the naked, airborne hero of *Fly By Night*, must have been pie-eyed when they saw the illustrations for *Pierre* and *Penthesilea*, their eagerness to attack checked by the fact that these are not works meant for kids.

Sendak again gleefully indulged in drawing out the adult sexual content implicit in great literature when he was commissioned to do a series of CD covers for Caedmon's recordings of Shakespeare's plays. For one of the first of these, *A Midsummer Night's Dream*, Sendak's drawing shows a gross, ass-headed, donkey-dicked Bottom nuzzling Titania. The submission of the illustration was greeted by Caedmon with silence (one would imagine stunned silence). Offers to illustrate the rest of Shakespeare were not forthcoming. Perhaps his commissioners hastened to pull the plug before their children's author-turned-satyr had worked his way to plays like *Antony And Cleopatra* or the sonnets or *Venus and Adonis*.

For *Penthesilea*, Sendak outfitted Kleist's characters and staged his scenes in a more theatrical, more brightly colored version of the youthful German romanticism that was the source for *Outside Over There*, and which is the proper historical context for understanding

Far left: *A Midsummer Night's Dream,* CD cover illustration; left: *The Winter's Tale,* CD cover illustration

Kleist's tormented, kinkily eroticized classicism. In Jonathan Cott's article "Maurice Sendak: The King of All Wild Things," Sendak tells Cott that Kleist was, indirectly, the inspiration for the choice of Runge as a visual antecedent for *Outside*:

> I wasn't involved so much with Runge at that point [when he was beginning work on *Outside*]. So I needed a clue, a color clue. I found the first in the film version of *The Marquise of O.*, which was perfect in terms of time and setting . . . all the greens and mauves excited me.

Kleist, by way of the Rohmer film adaptation of his greatest short story, directed Sendak to early romanticism, and thus assisted in the birth of *Outside*. Just as his *Pierre* had done previously, Sendak's *Penthesilea* provided the occasion for a return, from adult source material to children's literature to adult material again. *Penthesilea* spins around the same early nineteenth century collision of freedom and fatality that helped dynamize *Outside* and *Mili*.

The literally naked sensuality of the *Penthesilea* paintings disturbed a few critics, and no doubt some of Sendak's fans as well, as did the rainbow gaudiness of the work. Odd, too, is the juxtaposition, sometimes within a single overstuffed frame, of two or more styles: scrupulously rendered classicist torsos striking tragic poses exist in uneasy intimacy with familiar Sendakian faces, attitudes and tropes. It's as if Sendak is playing hide-and-seek through these drawings, now retreating behind anatomically perfect, contraposto nudes perfectly balanced in Palladian triangulation, now appearing in the nearly Mishbookerite heads atop some of those spectacular bodies.

Sendak's performance of Kleist's rarely performed drama is unnerving, hard to grasp, and as such is exactly attuned to the restless indescribability of Kleist: Prussian and modern, skeptical and devout, reactionary and radical, straightforward, simply entertaining, and entirely mysterious, unfathomable, a precursor to Kafka. These qualities are readily apparent in Kleist's stories and essays, as well as when the plays are read—even in translation, and Joel Agee's translation of *Penthesilea* is superb. It is, however, notoriously difficult to find physical correlates for Kleist's polarities and ambiguities in staged productions of his plays; the heart of his drama easily evades visual, kinetic representation. In his drawings for *Penthesilea*, a tiny production, or rather a stage aesthetic for approaching Kleist, is proposed by Sendak, who has tapped into the deep vein of irreverence that runs through Kleist, without losing sight of his equally deep seriousness, the formal, emotional, and philosophical sublimities he attains. Again, it is Sendak's power to embrace the high and the low, the exalted and

the abject—a power for which being an author of children's books provided the perfect training regimen—that makes him so attuned to the generous, exuberant embrace of extremes found in Kleist, Melville, Blake, Shakespeare, and of course, in Mozart.

It is to Mozart that we now turn, and to the theatrical stage, presaged (thematically if not chronologically) in the illustrations for *Penthesilea*. During the years in which he was producing the work discussed above, starting at the same time as the completion of *Outside Over There* and the publication of Selma Lanes's book, the art of Maurice Sendak began to include stage designs.

IV.

"Kiddiebookland" is how Sendak refers to his medium when discussing aspersions cast by critics, for whom creating and policing hierarchies of art are a misspent lifetime's obsession. In an interview with Walter Lorraine, he lays out the topography:

> Kiddiebookland. . . it's next to Neverneverville and Peterpanburg. It's that awful place we've been squeezed into because we're children's book illustrators or children's book writers. . . . How infuriating and insulting, when a serious work is considered only a trifle for the nursery!

Just like the theater, children's literature has lingering about it something of the inauthentic, if not of the downright disreputable.

It seems to me that the impulse to make illustrated literature for children must be similar to the impulse to make theater, to write a play, or to design a set for it. Confronted with unillustrated or unstaged prose, with letters moving noiselessly, monkishly across a page, illustrator and theater artist alike are compelled to respond by disrupting the silent literary dyad of writer and reader with the insertion of a third term, or a third party. The kindred inclination of illustrator and theater artist alike is to unearth from written language, and to make manifest, its imagery, its iconography, its obvious or buried harmonic or antiphonic accompaniment. And this is why, perhaps, there's something not entirely respectable about either profession, illustrator or theater artist. Some aroma of the exigent and compromised makes novelists and painters, who in the defense of formal purity may become grey puritans, turn up their noses. The illustrator and the theater artist feel in common an ambivalence, a discomfort, an uneasiness with a certain sort of unalloyed purity. We are amphibians. For those for whom purity is an article of faith—monotheists!—such ambivalence, such amphiguity, such amphibbery is an effrontery at best, and at worst, a heresy, a sacrilege.

And you can see their point, you can

Above and opposite: *Really Rosie*, animated version, character studies

comprehend their distaste, those purist picture-haters, those iconoclasts! For who has not been seduced and then abandoned by the impure? What is a picture book for children? It's a trick! Its purpose is to lure kids into the gingerbread cottage, the prison-house, the labyrinth of language. Why are there picture books? Centuries ago, recognizing how strenuous a chore reading is, and how much more strenuous a chore reading is going to get for anyone lucky enough to grow older and graduate to really difficult books, some useful person invented the illustrated book to start kids reading. The picture book performs an allurement; it offers to kids an already familiar language, the visual, as a seductive entry into a not yet familiar, forbidding, and more treacherous world—the world of written language, of serious abstraction, of sayables and unsayables. Children's literature makes us fall in love with books and we never recover—we're doomed. Having spent one night *In the Night Kitchen,* we're on our way to Proust and Hegel and the Holy Scriptures.

Theater probably also began as seduction, as a barely tolerated ecclesiastical honey trap for the flitting imaginations of otherwise inattentive, uninspired, and indifferent worshipers. And though disdain is covered up with sentimentality, distrust defused and diffused by marginalization, to the theater, as to children's literature, oh, how the ghost of ill repute clings.

Both illustrators and theater artists are unmannerly lovers of what is pure, unable to contain their amorous enthusiasms in stoical strict straitjacketed rectitude. Seams burst, boundaries are crossed. Neither text nor image is allowed its chastity. "These words are so fantastic, pictures must come forth!" This image is so brilliant, so powerful, that on our knees we beg of it: "Tell us a story, image, tell us what comes next, use words, become a book! Become a stage play! We know it's not grown-up but we can't help ourselves! Word, speak to us! Word, show us, don't tell us! Picture, talk!" Kiddie books! Make-believe! Not for adults.

There is rigor, of course, in the arts of picture book-making and play-making. Each is a hybridized form with its own strict economy (after I'd written the text for *Brundibar,* a children's book I'm doing with Sendak, Michael di Capua convinced me to cut away so much text I felt like David Mamet). But who believes that playwrights, scenographers, and illustrators can lay honest claim to asceticism? No one. We're no hermits. We want company.

It seems inevitable now that Sendak would move into work for the theater; the kids in his books have long been given to play-acting, dressing-up, trying out roles. Jennie, the Sealyham terrier heroine of *Higglety Pigglety Pop!,* succeeds so entirely in her thespian aspirations that she becomes the leading lady of the World Mother Goose Theater, and in the process transmutes the genre of the book in

which she lives—her picaresque novel becomes a play. Back in 1954, prior to the actual Jennie's arrival in Sendak's life (she was a beloved pet before she died and was incorporated into his art), another play is staged, with a script by Ruth Krauss, in the middle of *I'll Be You and You Be Me*, a subversive, boundary-razing book the title of which could serve as a credo, or perhaps a recipe, for the art of the theater. By the early 1980s, Jennie's best friend would follow his dog's lead onto the stage, as a set and costume designer for opera.

Opera, and not drama. Apart from *Really Rosie* and the work with the Night Kitchen Theater he founded with Arthur Yorinks, Sendak has not designed sets for plays or musicals. This is, in part, a matter of preference. He loves opera, the marriage of narrative and great music, more than other theatrical forms. It is, in part, a matter of sensibility. The fantastical is alive on the stages of opera in a way that it simply isn't in the contemporary adult dramatic theatrical repertoire, and Sendak's stage work has to date been almost entirely for works with a measure of fantasy. This must have something to do with audience expectation, for despite the fact that he has assiduously changed visual styles throughout his career, Sendak's work is always unmistakably his; his name is accompanied by the expectation that whatever it's attached to has something to do with children, and hence, fantasy. Still, one wonders why no *Tempests* or *Winter's*

Tales or *Cymbelines* are included in the roster of Sendak's stage designs. I for one wish they were.

Sendak's love of opera originates in childhood, when, at an early age, his big sister Natalie took him to see *Carmen*, with Gladys Swarthout, at Lewisohn Stadium. "Only act one, it rained," he remembered, "Swarthout was stalwart. She came out with an umbrella for act two but my sister schlepped me home." He remembers, too, listening on the radio to a live Toscanini performance of Beethoven's *Fidelio*. "Jan Peerce was singing Florestan, and that was it for me, that was my Paul-on-the-road-to-Damascus moment. He sang the prison aria. I remember everything about that moment, listening to him, the room I was in, the way everything looked." Sendak has greedily consumed opera, and been consumed by it, ever since.

His career as a stage designer began in December of 1975, when the Théâtre de la Monnaie in Brussels commissioned him to provide the libretto, set, and costume designs for an opera version of *Where the Wild Things Are* by the accomplished British composer and conductor Oliver Knussen. Sendak began writing a libretto, and Knussen the score. But before the opera would be completed and staged, Sendak received a phone call that would change his life for the next fifteen years. In 1978,

Frank Corsaro called me, out of the blue. He was reading my books to his son and

Above and opposite:
Really Rosie, animated version, character studies

fell madly in love with *The Juniper Tree*. He'd been asked to do *The Magic Flute* in Houston, and he wanted me to design it. I protested, I couldn't imagine doing it, I had no idea how to do such a thing. But then I agreed. They had to convince the impresario of the Houston Opera, David Gockley. I met with Frank in New York to impress Gockley. David Gockley said to me, "You know, designing an opera is very different from designing a book for children." I said "Hmmm, really?" but what I was thinking to myself was: 'No shit.' They were very worried about me doing this.

Sendak and Corsaro worked through 1978 and 1979 on their *Magic Flute*. Corsaro assigned the scenic painter and director Neil Peter Jampolis to Sendak to assist him in his work (Jampolis also worked with Sendak on *The Cunning Little Vixen*). Sendak was spreading himself thin—he was already in this sense a typical designer, doing too many projects at once. It was as if the stage had been waiting for him. The moment he signaled a readiness to begin, it pulled Sendak in and swallowed him up. His schedule during his first years as a designer seems more like a mugging than the beginning of a new career. But Sendak made it work. "When there was a hangup somewhere with one project I started something else," he recalls.

"These projects all overlapped: *Ida, Magic Flute*, the Abrams book, papa's book [*In Grandpa's House*]; I started on *Vixen, Really Rosie* was happening [as a stage play], *the Wild Things* opera."

By August of 1979 Sendak had finished the libretto for the *Wild Things* opera for Brussels and much of the music had been written. A white model of the set, with the help of the designer Tom Lynch, had been completed. In the same month, while *The Magic Flute* production was still in its conceptual phase, Frank Corsaro proposed a second collaboration to Sendak: Leoš Janáček's *The Cunning Little Vixen* for the New York City Opera. In his diary, Sendak wrote:

> Frank asked me to do *Cunning Little Vixen*. I was the replacement for the original designer. We had to convince Beverly Sills [the artistic director of City Opera] I was worth a shot. Why am I accepting *Vixen*? I don't know Janáček or this opera and I am doing so many things now . . . Work with Selma [Lanes] on the Abrams book continues.

In spite of his misgivings, Sendak accepted the *Vixen* commission. In September, he recalls,

> . . . I was in London for an exhibition of my work at the Ashmoleon in Oxford. Ollie Knussen and I took off from London to Brussels. We took the boat

train. Ollie and I were rushing down the stairs to catch the train with this clumsy awkward big box containing the white model for *Wild Things* and as we were bumbling downstairs Ollie told me that the pianist Clara Haskell had died on these very stairs; she tripped and fell down the stairs and broke her head open. This realization disturbed Ollie greatly and cast gloom over the whole visit.

By May of 1980 Sendak had completed the designs for *The Magic Flute*. Meanwhile, another project, the stage version of *Really Rosie,* had come to fruition.

The Sign on Rosie's Door was written and illustrated in 1960. The animated cartoon version of the book began in 1973, when the producer Shelly Riss introduced Sendak to Carole King. Together King and Sendak created *Really Rosie,* an animated special for CBS. This is how Sendak, assisted by his journals, remembers their meeting and subsequent collaboration:

After endless phone calls with Carole King and forever negotiations with her agent we finally almost met on December 17, 1973. I was supposed to meet her at some L. A. studio. She didn't show up. I blew up in a rage—we waited two hours, no calls, nothing, I now hated the project, I hated her and mostly the

agent. We finally met, 2 PM December 18 at the old Charlie Chaplin studio. Carole was cool, relaxed, very pregnant, humming, playing piano. I liked the looks of her but I resisted liking her. Immediately after we were introduced I began screaming at her, scolding her for unprofessional behavior, indifference, ungenerousness. She hadn't a clue what I was all sturming and dranging about but she handled it well, hanging her head, looking embarrassed, sheepish, cute. She said with the same accent I have— Brooklyn—"Maurice, you're so insecure. *Relax.*" We became wary friends.

I came to love her very quickly, actually. We were off and running—the collaboration was fun, terrific, it really was. I wrote lyrics for the songs in surprisingly short order for me. I finished a draft of act one on January 21, 1974, acts two and three Jan 23, 1974, and Carole finished the score in late April 1974. She played the songs for me on the phone with all the kids screaming in the background. We recorded the songs at the Chaplin studio in May 1974. The sessions were great fun. The film was finished Feb 14, 1975. It was shown on TV Feb 23rd 1975, CBS.

The CBS executives didn't like it. One of them, seeing *Rosie* for the first

Really Rosie, animated version, character studies

time, said to me "She's ugly and she's skinny and she's got no tits, she looks like a dyke."

In 1978, another producer, Stuart Ostrow, convinced Sendak and King to recreate the show as a stage musical for kids. An out-of-town try-out version was done at Ostrow's Washington, D.C. theater that year. On October 14, 1980, the musical opened, with music by King, and book, lyrics, sets, and costumes by Sendak, at New York's Chelsea Theater Center, directed by the choreographer Patricia Birch.

The book on which the musical is based is the story of the curbside career of one of the stars of Sendak's old Brooklyn neighborhood. His heroine, Rosie, is a smart, domineering, budding director/muse/diva/impresaria, who, accoutered in her mother's cast-off fancy gown, hat, gloves, and boa, throws herself into the task of marshaling for her theatrical productions the neighborhood's children,

Really Rosie, musical, below: finished watercolor for show curtain; opposite: finished watercolors for set drops

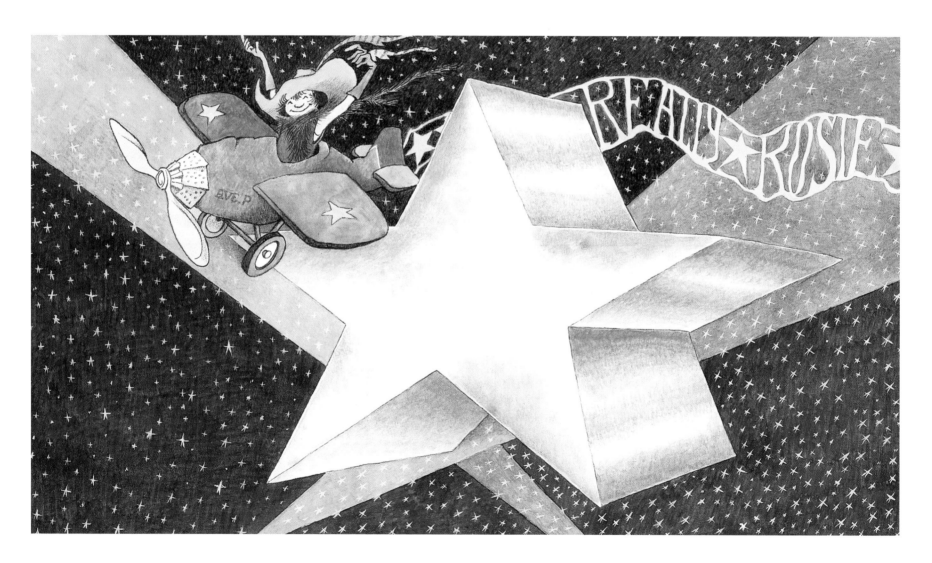

raggedy locals organized in a street gang called The Nutshell Kids. The kids harken back to the RKO films of Sendak's childhood, from which some of the Depression-era optimism of both *Night Kitchen* and *Rosie* derives. The songs they sing are lovely settings by King to Sendak's lyrics, several of which are the rhymed tales from the *Nutshell Library.*

For the production, Sendak rendered backdrops in which realistic cityscapes—the skylines of his Brooklyn childhood—intermingle with the cupboard-and-canned-goods skyline he created for *In the Night Kitchen.* The stoopside theatrics, the intense drama of a childhood lived in an urban neighborhood, in public, on the concrete stages that are New York City sidewalks, the grandiosity and the opulent imagination that arise in counterpoint to the poverty and deprivations of working-class life—the theater was waiting for Sendak, and he made his first entrance as professional set designer with the most familiar scenery from the theater of his childhood, of his memory.

"I went directly from the opening of *Rosie* to Houston for the opening of *Magic Flute*," Sendak says. His *Flute* opened on November 14, 1980, in Jones Hall in downtown Houston.

It must have been both exhilarating and terrifying for Sendak to make his first foray into opera design with *The Magic Flute.* No composer, perhaps no other artist in any medium, matters as much to Sendak as Mozart does. The

composer is featured repeatedly in Sendak's art. He's in *Mili*, leading those doomed French children from Izieu in a chorale. He's in several of Sendak's fantasy sketches, private doodles Sendak has done over the years, some of which have been published. In one series, Mozart dances with Haydn. In 2000, I escorted Sendak to Yale to watch puppeteer Amy Luckenbach stage his Mozart fantasy sketches, using puppets based on his drawings, to Mozart's *Adagio and Rondo in C minor for Glass Harmonica.* Sendak keeps one of the Mozart puppets, a gift from Luckenbach, on the sofa in his studio. And Mozart's presence and influence is felt throughout *Outside Over There.* Sendak, who listens to music while at his drawing table, was working simultaneously on the designs for *Flute* and on *Outside.* He has called that book an extensive response to and in some sense a book about Mozart. The *drei Knaben*, the three helpful little boys who appear repeatedly in *Flute*, can be seen pointing out the way to Ida in one illustration, while Ida and the baby, homeward bound in one of the final pages, pass Mozart himself by. He's seated at the klavier in his *waldehütte*, a small working studio in the deep woods, of the kind also used by Mahler, another Sendak favorite. The *waldehütte* appears in a number of Sendak illustrations. He's drawn to the image of a place of isolation, of concentrated inspiration and industry, and he draws it with an evident longing, if not envy.

Above: *Really Rosie*, musical, costume study; opposite left: *Really Rosie*, animated version, character studies; opposite right: *Really Rosie*, musical, poster

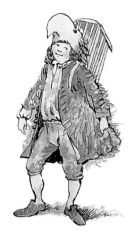

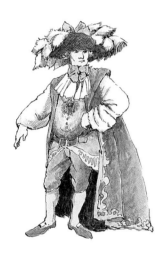

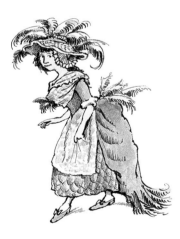

A Mozart infatuation hardly requires explanation. Sendak feels a connection with the composer, as he seems to feel with other artists whose lives, like Mozart's, were marked by personal, economic, physical struggles, and by tragedy—especially artists who died young: Keats, Mozart, Kleist—and whose work was not appreciated sufficiently during their abbreviated lifetimes. It must also be said that he worships Verdi, one of the luckiest and longest-lived of artists, and the octogenarian painters of the fifteenth century, Titian and Veronese. Sendak holds in high regard perdurable good humor in an artist, as well as a romantic and generous disposition, liberalism, sensuality, articulate grief, courage, and humanism. Artists are his heroes and heroines. He likes them to possess, alongside their genius, a reasonable share of the virtues. He finds some failings forgivable, and others less so. Though he delights in the music of Richard Strauss, Tchaikovsky, and Wagner, and years ago could claim that he had memorized nearly all of *Meistersinger*, he bridles so at their anti-Semitism that he rarely listens to them anymore. (There are lapses into Wagner, naturally, because who can live without Wagner?) Mozart possessed all the virtues, including the virtue of having vices. In his personality there was endearing human fallibility; in the music there seems to be none. Sendak was thrilled to hear the pianist Sviatoslav Richter, in a taped interview, despair over the unassailable completeness, the daunting, sheer perfection of a Mozart piano concerto, which seems to *need* no interpreter. Inexpressibly great as they were, Haydn and Verdi write music less unbearably, unerringly *right*, and hence, perhaps, their work is more inviting, less daunting, less divine, more of the earth. But no composer commands Sendak's heart as entirely as does Mozart.

Of all the great Mozart operas, indeed of all the operas in the repertoire, perhaps none is more obviously suited to Sendak than *The Magic Flute*. Its infinite delights require no cataloguing. Its fantastical quest story has been an important wellspring for Sendak's fantasizing. Yet *The Magic Flute* has its detractors, people who think the story a load of Masonic rubbish, a bewildering, slapdash fairy tale, and hence a flawed piece, its glorious score notwithstanding. Like Goethe, who held up *Flute* as the paragon of musical theater, Sendak disagrees with these malcontents. The fantastic has always been for Sendak a transparent and economical means of expressing basic human truths. In an "Informal Talk" included in *Caldecott & Co.*, he writes:

I think some of the most touching moments in *The Magic Flute* have to do with children. Much of the opera focuses on the confusion of an adolescent girl. Is her mother crazy? Is the man she loves crazy? Has the solemn Sarastro saved her or kidnapped her? Isn't this very much what life is like for young people?

Very arbitrary, no rhyme, no reason, no logic. And then, when Pamina is about to commit suicide, she is stopped by the three genies—as Mozart notes in the score, *drei Knaben,* three little boys. When she has lost all trust in all the adults in the opera, these three kids say: "Don't do it, life is all right. He does love you. Come with us and we'll show you." And they break into an incredibly happy quartet. The fact that Mozart would give these boys the simple truth to deliver reinforces my convictions about children and their relationships to adults and the world.

The designs for the production of *Magic Flute* range in style and tone across Sendak's variegated formal alphabet, from sweeping, painterly landscapes to quick, improvisational sketches, as if, for his onstage appointment with Mozart, Sendak drew upon his entire armorarium. The German romantics, and late-eighteenth- and early-nineteenth-century British painters like Constable, George Stubbs, and Samuel Palmer, some of Sendak's important predecessors, have been enlisted for the occasion. Orientalist touches, including the thick, curving palm fronds, may owe something to Henri Rousseau. The marvelous gestural drawings of Tamino, standing alone on a rocky prominence right before the dragon

attacks, remind me of the pen-and-ink sketches Inigo Jones made for Ben Jonson's masques.

And everywhere Sendak has included the giddily Egyptological architectural elements and geegaws familiar from European Masonic hoodoo, and from American Shriners' lodges as well, their solemn Karnakian temple facades, their sequin-bedizened fezzes worn while disporting on tricycles at conventions and circuses. Sendak's version of Masonry is an affectionate, essentially respectful shrug-and-wink; he acknowledges the importance of eighteenth-century Masonic life to Mozart, while at the same time his designs seem to rejoice in the modern American version's silliness and melodrama. His dragon looks like a Chinese New Year's float mated with a corgi, his Monastos is a little cigar stub of a villain. Sendak's wit transforms Masonic symbology with an alchemy similar to Mozart's music: That which seems earthbound and banal is celebrated for the yearning behind it, the reaching toward great mysteries, toward freedom,

toward the Divine. Sendak's design is, it seems to me, absolutely consonant with Mozart's and librettist Emanuel Schikaneder's response to the secret order, or at least what we may infer their response to have been. For example, as is often noted, Pamina accompanies Tamino through the final ordeal, the walk through fire and water. Masons in the audience must have bridled at the inclusion of a woman in their exclusively male rites, and perhaps they still do. Masonic orthodoxy must suffer the affront, for *The Magic Flute* is concerned with greater mysteries, with love and, in the deepest sense, marriage, affinity, and harmony.

Sendak's is a strictly wing-and-drop-style scenography, its technological sophistication not in any real sense advanced from the era of the original *Magic Flute*, or, for that matter, from the Italian Renaissance or Inigo Jones. These are magic-perspective-box designs appropriate to the proscenium-arch stages to be found in nearly all opera houses. The architectural innovations in stage design, audience configuration, the twentieth century's experimentation with theatrical space, the revolutionary theory and practice of the likes of Edward Gordon Craig, Robert Edmond Jones and Josef Svoboda have not influenced Sendak, at least so far as his

own stagings are concerned. The abstraction of theatrical space; its reinvention as sculpture, environment, metaphoric image; the interpretive wildness so much at the core of modern set design appears not to have appealed to this literate, literary, and in a sense *literal* illustrator (as all figurative illustrators must in some sense be). Sendak's artistic life has been spent illuminating the parables by means of which writers confer meaning to their readers—elaborating upon, supporting, adorning the parable, but he has never striven to dismantle what he illustrates. The historical recontextualization of texts, now a matter of addictive habit among directors and

designers of opera, has been scrupulously eschewed by Sendak, for whom, I think, the prospect of a Florestan enchained in some stark cinderblock Ceaucescu-esque modern prison is a kind of traducing of the truth of the music and words, a truth that includes the opera's historical specificity. Ripped-from-the-headlines relevance, or for that matter ripped-from-the-laboratory technology in conceiving and building stage sets, hasn't compelled Sendak the set designer, who is not so different from Sendak the illustrator and author. He's something of a Luddite, a lover of the handcrafted, a man not comfortable with whatever it is

The Magic Flute, opera, below: finished watercolor for set drop; overleaf: finished pencil renderings for set drops

The Magic Flute, opera, finished watercolor for set piece

we ought to call the world we live in—the mid-to-late-Postmodern or perhaps the early-Pre-apocalyptic world.

In a transcript of a conversation between Frank Corsaro and Sendak about the problematic design of *The Love For Three Oranges*, Corsaro made a suggestion: If the opera cannot be designed as a *commedia* piece, "We must think of it in entirely modern terms." To which Sendak replied, testily, "No sir, I'm not interested in some modern 'abstract' design trailing yards of glitzy Mylar and chrome."

If all this sounds like groundwork preparatory to a reactionary manifesto, it isn't. Sendak is certainly no reactionary. His experiments in form changed the way people write and illustrate books for children. He may be a memory artist, but he's not a nostalgist. His memory work trafficks in loss, not false comfort; it is fueled by the absolute fact of the past's irrecoverability. It is, in other words, a modernist memory, not Reaganite sentimentality. Sendak's choices don't constitute a dismissal of experimentation in set design, but rather a personal disinclination to participate in it. His is the disinclination of an artist, not of an audience member. In the latter capacity, he has appetite and enthusiasm for the experimental in opera, in its music, narrative, and design. He knows that successful adventuring as an artist is in part predicated on an innate understanding of and a certain fidelity to one's strengths.

To his own work for the stage, Sendak has brought his immense gifts as artist and illustrator, and he has attempted, in collaboration first and foremost with Corsaro, to animate and theatricalize the world he created in his picture books. His stage designs add a third dimension, that of actual space, to his previously two-dimensional art. The illusion of depth, of course, has always been powerfully present in his masterful illustrations. What is also added, in live performance, is motion.

In his essay "The Shape Of Music" Sendak wrote, "*Vivify, quicken,* and *vitalize*—of these three synonyms, *quicken,* I think, best suggests the spirit of animation, the breathing of life, the swing into action, that I consider an essential quality in pictures for children's books." Critics often remark upon the way Sendak animates his characters, how his drapery moves, his curtains flutter in the breeze; how antic, and balletically obstreperous the Sendak kids are.

There is certainly the suggestion of motion in Sendak's drawings, but the elaboration of detail, the polished smoothness of the finished surfaces, and the balance and harmony of the compositions in much of his best work fight the movement depicted. In many of his illustrations—for example, in *The Juniper Tree*—the characters are not even represented as being in motion; they pose for formal portraits, perhaps out of necessity, for the artist has trapped them in small framed spaces too crowded, too confining for them to consider moving around. As for shifting

drapes and fluttering curtains, Sendak, it seems to me, is intrigued more often by the weight of fabric, its marmoreal voluptuousness, than by its shifting in the breeze. He seems more interested, even in his simplest line drawings, in mass and form than in velocity; more often interested in the back-and-forth, static volumizing of the cross-hatching pen than in the simple, motion-suggesting curved line. One of the central images from *Where the Wild Things Are*, arguably the most famous illustration in all of Sendak's oeuvre, is a case in point. Max and the Wild Things are shown swinging through the trees. In fact, they're actually hanging like breadfruit from those *Typee* palms, ripe and pendent and perpendicular to the ground. In his more casual sketches there are wonderful instances of the successful creation of the illusion of movement. But Sendak embraces, and makes an active ingredient in his art, the chiefest paradoxical essence of graphic representation—that it captures life in motion and renders it motionless.

All figurative painting, all drawing, all sculpture, all photography makes use of the tension between the animate world represented and the cessation of time and motion when an image is seized upon and fixed. In 1999 I accompanied Sendak on a trip to Italy. He loved Bernini's *Apollo e Daphne* in the Borghese Palace in Rome (he refers to it in the final drawing for *Penthesilea*), specifically the way that Bernini depicts Daphne's terrified flight

from the god and Apollo's surprise at the leaves and twigs sprouting from what had been her hands; the way the sculptor makes even marble seem to race, to flow, to breathe, and to bud; how active the whole thing miraculously is. But *Apollo e Daphne* is also, of course, entirely immobile. It is, in fact, a portrait of the mobile becoming immobile, a young girl turning into a tree; it is the sculptor's genius to use his ability to make marble appear to be moving in order to call attention precisely to what marble, even in Bernini's hands, cannot do, what only Hera or some other god can accomplish.

The illustrator supplies an image for what the text describes or implies, but the illustration does not supplant the reader's imagination, which remains the only force capable of animating the characters, the landscapes, the sky. The illustration does not animate. It provides, in a sense, another inanimate text, in need of a viewer/reader to fill its sails and to set it moving.

It is only on the stage that Sendak characters actually move among Sendak forests, houses, and ruins. And yet there's a curious thing about his set designs. These are not polite sets, not recessive, not background; they challenge, they crowd up against the theatrical event, as the best designs do. But for all their depth, sound, and motion, for all their atmospherically evocative power, they evoke nothing more powerfully than they do the book illustrations of Maurice Sendak. They evoke an art that is

The Magic Flute, opera, costume studies

flat, not three-dimensional, silent, not filled with magnificent song, and absolutely still. It is this impasto, illustrational quality of his sets that makes the viewing of a Sendak production a remarkable and pleasurably disorienting experience. The animated stage before you ceaselessly retranslates itself into the pages of a book. Before your eyes, a compressional, two-dimensional force battles an opposing exertion, namely the will and a cleverness which has managed, impossibly, to make these pictures come to life. Here, returned to the pages of a book, Sendak's designs seem to breathe a sigh of relief, resting after their battles in the third dimension. Returned to their creator's natural habitat, the page, his sets become what the work of most stage designers could never be: spectacular illustration.

Perhaps in recognition of his drawings' desire to return to the pages of books, or perhaps simply to satisfy the bibliohunger of his devoted, bookish fans, Sendak turned three of his designs, for the operas *The Love for Three Oranges* and *The Cunning Little Vixen* and for the ballet *The Nutcracker*, into handsomely produced books, published in 1984 (*Oranges* and *Nutcracker*) and 1985 (*Vixen*). *Vixen* and *Nutcracker* are editions of the tales on which the theatrical work was based, accompanied by Sendak's designs and supplemental drawings. *The Love for Three Oranges* is an illustrated and illuminating text by Frank Corsaro, describing the Glyndebourne production of Prokofiev's opera and revealing along the way much about the Corsaro-Sendak collaboration. In this volume we read, from a letter Sendak wrote to Corsaro during the process of developing their elaborate *Oranges* scenario, that the difference between book illustration and stage design is the source of a tension, worrisome and generative of creativity, that very much preoccupied him. Sendak was nervous that a particular scene in *Oranges*, and indeed much of the design, would be cluttered, overfull.

You've heard me before but I think it is a vital issue and needs constant airing. I quite naturally still think in terms of illustration and as an illustration this scene is not cluttered—but we are talking about stage design. I think you will agree that the rather stripped compositions in *The Juniper Tree* and even the seemingly cluttered but rather intense and concentrated composition in *Outside Over There* already suggest a growing awareness of—what?—stage sense? Certainly working with you on *Flute* and *Vixen* has developed this new sense of theatrical composition. I hope so. I worry a good deal (as you know) about the possible dire effects of thirty years' worth of composing for the page on my stage designs. Have I, in fact, been able to bridge the gap between these two disciplines? The *Oranges* divertissement seems a perfect example of my

dilemma. There is a typical two-step involved here; first I must illustrate the scene as though for a book and then re-order it for the stage. There is as much good in this as bad, I think—and you have wonderfully supported my budding conviction that I am more and more directly composing for the stage. There is, too, the perfect good of simply being ignorant of the conventions of stage design and hauling into my theatre designs all the vast repertoire of my life as illustrator. But more to the point—was this not the very reason you blessedly needed me in the first place? You wanted a fresh, dumb designer and, God help you, you found one.

A mere month separated the opening nights of *Really Rosie* and *The Magic Flute*. In an even madder dash, only two weeks later Sendak flew to Brussels to see the final technical rehearsals and the opening, on November 28, 1980, of the first version of Oliver Knussen's *Where the Wild Things Are*, directed by Rhoda Levine.

The opera begins with an ominous sounding of horns and blaring of trumpets, with drums beating out irregular, alarming rhythms, heralding something bad, which arrives almost immediately in gales of fierce music: Max's temper tantrum. And what a temper, what a tantrum! An intricate, pulse-quickening,

escalating alternation commences between anxious, anticipatory suspensions of mayhem and their demonic release, as Max terrifies his dog and his toys. And then, with rage considerably more aggressive than that found in Sendak's book, he goes after his mother. "He" is a soprano in a trousers role. Over and over he sings "Vil-da-chai-ah-mi-ma mee-oh!" It's Yiddish masquerading as a warrior's yodel: "Wildechaya me, Mommy! Oh!" might be one way to translate it. A *wildechaya* is a kid (or, sometimes, an adult) who is behaving in beastly fashion—like a wild animal. It's a nod to and thumbed nose at the Walkyries' "Ho-yo-to-hos," and it's funny, but it's sung with a savage enthusiasm; with its last note abruptly shooting upwards, it's even chilling, and quite beautiful. Amusing though the jokes may be, familiar though the figure in the wolf-suit is to almost everyone, the operatic version of *Where the Wild Things Are* announces at the outset its composer's intention to emulate the surprise, the gravitas, and the lack of condescension that characterize the classic picture book on which it is based. Perhaps Knussen also intends to elevate into overt expression the book's undercurrents of menace—a menace it's essential for a bedtime story to hold in check, but which is red meat for an opera. There's much that is ravishing about the score, but there's nothing in it that's cute. And Sendak's libretto suggests how much the book's author approved of and was partner to his composer's intentions.

Where the Wild Things Are, opera, costume studies

Sendak greeted the audiences for *Wild Things* with a show curtain the design of which is derived from the book's endpapers: an overlay of cross-hatched and tinted foliage, in the middle of which is emblazoned the gigantic, grinning face of the Wild Thing called Moishe (named after guess-who, whom "Moishe" somewhat resembles), with the famous fangy overbite that renders him simultaneously threatening and adorable. The Wild Thing face turns out to be the actual show curtain; the leafy jungle surrounding the face remains as an inner

100

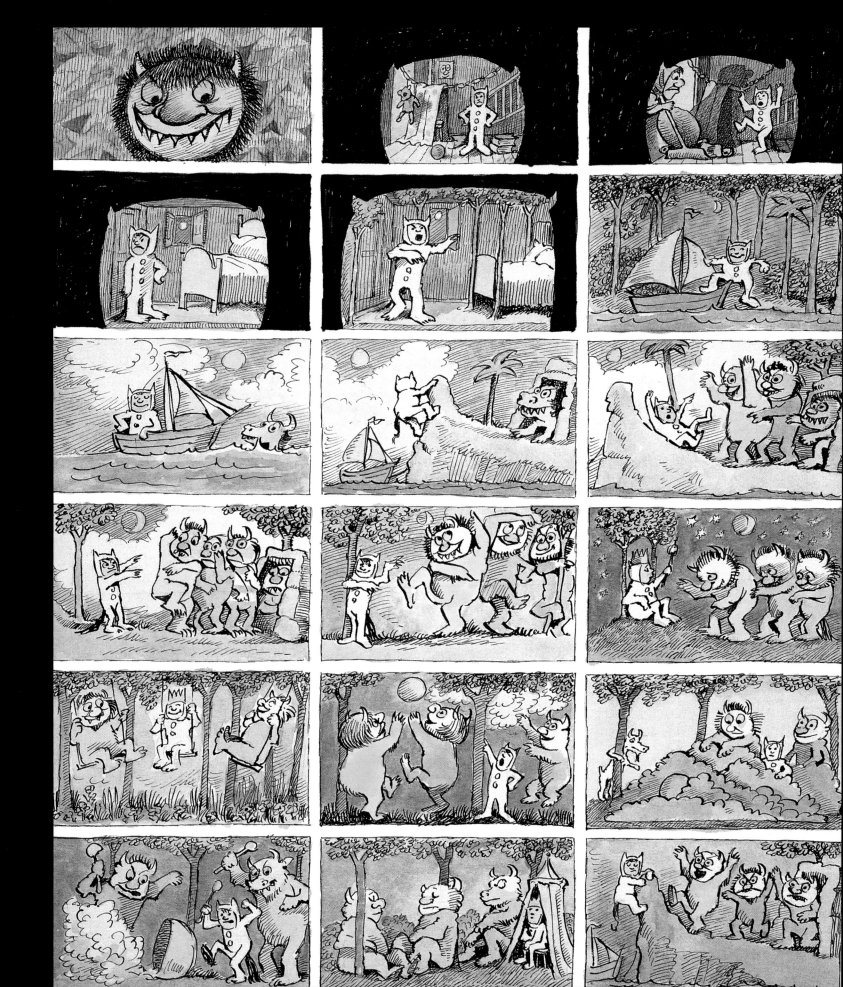

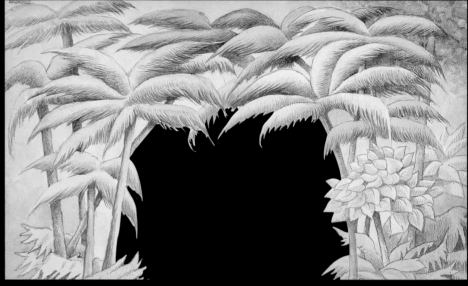

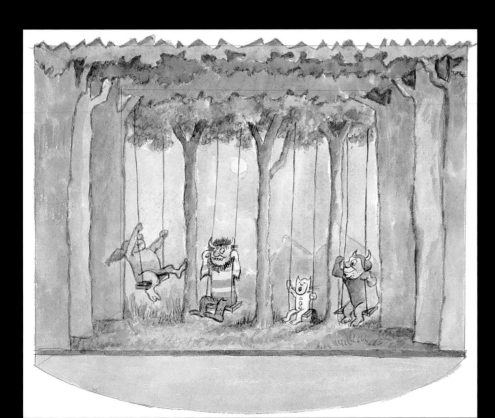

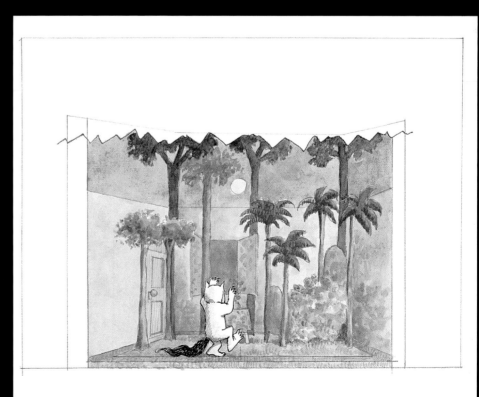

Where the Wild Things Are, opera, above: character study; below: study for set design; below right: scene from the Glyndebourne Opera production (1985)

proscenium arch. When the Wild Thing curtain is raised, the horned contours of Moishe's silhouetted, feral/friendly head frame and contain Max's house and his bedroom. Domesticity seems thus to be a fragile dream inside the head of the beast in the jungle. The dream island Max will travel to is not so far from home, not remote, not entirely Other; wildness surrounds him always, and Max at home is merely a dream of Moishe—which is, after all, exactly the case, given that Moishe (Sendak) is Max's creator. In the note on a drawing for Max's mother's vacuum cleaner, written as instruction for Paul Fowler, the stage engineer at Glyndebourne Opera, Sendak, looking ahead to the work he will do on Prokofiev's *The Love for Three Oranges,* describes the mother's vacuum cleaner as a "Fata Morgana"—a scary monster in her own right. Home is encircled by monsters, infused with wildness.

Where the Wild Things Are opened in Brussels in an unfinished state. Knussen's splendid Wild Rumpus dance had not yet been composed, and the physical production was not fully realized; among other problems, the Wild Things costumes were unsatisfactory. In a more complete state, the opera was later joined with Knussen's and Sendak's *Higglety Pigglety Pop!*

at the Glyndebourne Festival in 1985. It was for this production that Fowler figured out how to bring the Wild Things to three-dimensional life "without," Sendak notes, "killing the actors who had to wear the giant heads. Paul is a great artist, a great craftsman." For people who bring a devotional level of skill to tasks that are ancillary to the original creative work but absolutely essential for its success—assistants, backdrop painters, toy makers, book designers—Sendak reserves a special, grateful admiration.

Above: *Where the Wild Things Are,* opera, scene from the Glyndebourne Opera production (1985); right: *Where the Wild Things Are* and *Higglety Pigglety Pop!,* operas, poster

The Cunning Little Vixen,
opera, costume studies

Sendak's next premiere, Leoš Janáček's *The Cunning Little Vixen* at New York City Opera, took place six months after the Brussels *Wild Things*. The dates on the sketches for *Vixen* reveal that he was working on the opera throughout 1980 and early 1981, during which time he also brought sets and costume designs for *Rosie, Flute,* and *Wild Things* to completion or near-completion. As he began to design *Vixen* his initial skepticism about the piece was only partially overcome:

> I was very worried, I didn't know Janáček. I was not in love with the vixen, and I was annoyed with myself for having accepted the job when I was so worn out.

Janáček's opera is an appropriate vehicle for Sendak for at least one reason—it began as the creation of an illustrator, the Czech artist Stanislav Lolek. *Liska Byštrouška* (*Vixen Sharp-Ears*), the strange and rather marvelous text from which Janáček drew his libretto, was written in 1920 by a novelist, poet, children's author, and newspaper feuilletonist, Rudolf Tešnohlidek, at the request of the editors of a liberal newspaper in Brno (*the Lidove noviny*, to which Janáček also contributed occasional pieces) to accompany Lolek's drawings.

Tešnohlidek's vixen stories are reminiscent of Kafka in the tonal balance they strike between satire and reportage, in the relation-

ships of anthropomorphic animals to zoomorphic people, in the unnerving juxtaposition of whimsy and brutality, delicately detailed naturalism and grotesquerie. Max Brod, one of Kafka's closest friends, wrote a German-language libretto for *Vixen* after its Czech premiere. Janáček's music repeats its source material's disturbing modernist mix of high seriousness and absurdist popular comedy. The folk tale becomes the locus of a post-World War I gloom. A grand, piney, perpetual-twilight-in-the-forest melancholy pervades both book and opera, as the vixen's picaresque story proceeds through thick foliage across a forest carpet of fatalism, death, decay, and heartbroken renewal. The gamekeeper sings, near the opera's conclusion, "Is this a fairy tale or is it reality?" For all Sendak's anxiety, *Vixen* was made for him.

On January 23, 1981, a few months before *Vixen*'s opening night, *Outside Over There* was completed for publication. "Ida and the Vixen," Sendak wrote in his journal, "went neck and neck to the finish line." Both *Outside* and *Vixen* have as their central characters girls in the throes of a perilous adventure, in the former case a Western European pre-adolescent heroine (with her raw shinbones and her wonderful large feet) discovering courage and resourcefulness, and in the latter a Central European teenage antiheroine discovering sex. With her penchant for amoral mischief, the vixen, clad in her fur suit, is more like Max than Ida, but like

The Cunning Little Vixen, opera, top: storyboard;
above: quick character sketch; left: watercolor
character study

The Cunning Little Vixen, opera, above: costume studies; opposite: finished watercolors for set drops

Ida, she stands on the threshold of maturity, of the loss of parental protection, facing a new world fraught with danger, entered only by making "serious mistakes."

Sunflowers are a recurring feature of the twisty narrative of *The Cunning Little Vixen.* The vixen, hiding behind a sunflower, is mistaken by a drunken, amorous, lovelorn schoolmaster to be a woman. The sunflower, that brawny, weedy-uncontrollable, gorgeous blossom, might thus be understood in *Vixen* to serve as an emblem of hidden sexual allure, of sexuality in potentia. The vixen, hidden by the flower, is also unmasked by it. Her hiding paradoxically makes it possible for the schoolmaster to hear her and believe she is a woman (as indeed she is, a soprano in a fox costume); hidden, she becomes more visible, her fox-drag rendered transparent so that the schoolmaster is able to see the human soprano underneath. The fox in the sunflowers: it's a lovely, sexy, species-confusing moment.

It can't be coincidence that the same sunflowers adorn the cover of *Outside Over There.* Given Sendak's taste for homage and citation, they are more probably an homage to Janáček, and also a citation with a serious purpose. Sunflowers jostle one another, in ever-increasing proliferation, in the pages of *Outside* as Ida plays her wonder horn. She is distracted from her role in the family as babysitter and big sister by the concerto she's playing for her ecstatically rising and blossoming floral audience; with her father's horn, she is the bee and the flowers strain toward her, eagerly responding to her call with an invitation: Pollinate! It's a lovely, gender-confusing, sexy sequence, and it leads to calamity (while she plays, her sister is kidnapped) but also to transition, to adventure, to growth.

The strength and splendor of Janáček's libretto and score inspired Sendak to do some of his most beautiful work for the stage. His drawings honor Lolek's simple folk style. They bear resemblance to the early modernist book illustration Sendak has long admired, with its rich and dark, mossy and arboreal colors and its elegant and economical lines, thick and wavy, as if produced with woodcuts. A lifetime of sharply observing animal anatomy, physiognomy and behavior arrives at a kind of apotheosis here, in the remarkable costume sketches of bugs, dogs, and hens. The costume for the vixen combines animal hide and urban ankle-length coat, accessorized with elbow-length gloves. It bridges country and city—the world of animals, in which the vixen flourishes, and the world of humans, in which she is destroyed. The coat seems a little too grown-up for the very young girl inhabiting it, the gloves a little too-too. We're reminded of a child playing dress-up. We're reminded, in fact, of Rosie. This vixen is not quite ready for the world, and it uses her poorly.

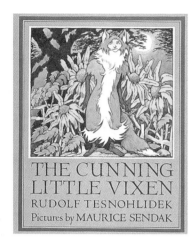

THE CUNNING
LITTLE VIXEN
RUDOLF TESNOHLIDEK
Pictures by MAURICE SENDAK

The Cunning Little Vixen, opera,
top: book cover; above: costume
studies; opposite top: quick
character sketch; below: finished
pencil rendering for set drop

In a journal entry on March 27, 1981, Sendak wrote:

I saw the *Vixen* sets onstage, and they are quite pretty. Ida arrived bound and fine looking. Her official birthday is May but she was actually born (for me) today.

On April 3, Frank Corsaro called Sendak to say that Brian Dickie, the artistic director of the Glyndebourne Festival in England, had approached them to direct and design *The Love for Three Oranges*. Corsaro and Sendak, if they accepted, would be the first Americans asked to work at Glyndebourne, and it was this honor, far more than the Prokofiev opera (about which they had grave misgivings) that convinced them to say yes. As relayed in Corsaro's *Three Oranges* history, their first reaction, upon listening to a recording of the work, was one of "horror" at "a farrago of outdated opera clichés." They agreed to work on *Oranges* at the urgent insistence of "collective agents, colleagues and spiritual advisers."

Meanwhile, *Vixen* opened at the State Theater in Lincoln Center, New York City Opera's home, on April 9, 1981. Giana Rolandi sang The Vixen. Michael Tilson Thomas conducted. The sets were applauded. In his journal Sendak wrote:

Vixen premiere frightened me. What a terribly rough life this poor little Vixen

has had. Why am I doing it when I don't love this thing? I fell in love with it after it opened. The opera is touching, sweet and sometimes I cry . . . It's a very important opera to me now.

Janáček, a late bloomer whose first great opera (*Jenůfa*) was written when the composer was fifty years old, was seventy when he wrote *The Cunning Little Vixen*. I don't know if it was the case twenty-two years ago, but now, approaching seventy-five, Sendak is drawn to, fascinated by, artists who produce important work at an advanced age. Verdi, Titian, and Veronese have already been mentioned in this regard. Sendak is particularly moved by Arrigo Boito's appearance late in Verdi's life and, as a consequence, Verdi's emergence after a long silence, at seventy-nine years of age, to write *Otello*, one of his greatest operas.

The Cunning Little Vixen addresses the subject of time passing, the subject of aging, perhaps even the subject of aging artists. *Vixen* ends with the gamekeeper, the chief human protagonist, falling asleep in the woods, just as he did at the beginning of the opera. Once again, he is awakened by a frog and sees a vixen cub—this time, perhaps, it's the slain vixen's cub—but in trying to seize her he captures only the frog. The frog, a descendant of act one's captive amphibian, tells the gamekeeper that two generations of animal life have come and

The Cunning Little Vixen,
opera, costume studies

gone while the human gamekeeper, grown older, has become a legend, a figure in a tale. In reaction to this information, in the final moment of the opera, the gamekeeper sinks into silent reverie—or, perhaps, is simply stunned, rendered speechless, and songless by the passage of time. "Absentmindedly the gamekeeper lets his gun slip to the ground," the final stage direction tells us. The gamekeeper, capturer of subjects, catalyzer of stories, dreamer confused about the distinction between fairy tales and reality, can be read as an artist surrogate. The news that time is relentlessly passing, that the world stays young while he grows old, literally disarms him—he lets loose the tool of his trade. And so Janáček's opera ends with a vision of the artist in winter; his reputation preceding and superseding him. The artist himself is stricken, frozen, in a sense slain when confronted by new life, which brings with it a blast of the icy wind that heralds the artist's mortality.

Corsaro and Sendak staged a stirring and disturbing event near the end of their production, an addition to the original libretto. After the vixen has been shot and killed by the poultry farmer, the fauna of the forest, bugs and squirrels and birds who have been delighting the audience in scampering about, solemnly encircle her body, heads bowed as if in prayer. As the curtain falls, the little creatures bend down and begin to devour her. It's a moment that speaks to the ruthlessness and absence of sentimentality, not only in nature but also in the children inhabiting the delightful animal costumes.

Children who eat their mothers, or at least who threaten to, appear throughout Sendak's work—in the fantasy sketches, in *Wild Things*. And why shouldn't they? All children want to eat their mothers. All children are devourers. It is through oral incorporation that life, love, and relationality enter the infant body. That which is indispensable—mom, milk, the breast—is first connected to via the mouth. If swallowing milk keeps one alive, how much safer would it make one if one could swallow the very source of milk, and life? And if anxiety is first generated by the dawning realization that the source of life can be withdrawn, or absented, that the source of life is in some distressing way separate from one's vital need, then the fantasy of swallowing may be accompanied by anger, by a little oral sadism. Children, animals, nature itself—everyone is greedy for Mother.

And so, of course, is any audience, child or adult, for art. Sendak and Corsaro's image of the fallen vixen consumed by her fellow woodland creatures, the most memorable stage image of the many I have seen these two create, illustrates both primitive incorporation and the consumption of art (and the artist). The image adds to the power of the opera; it speak to the drama of death and rebirth central to Janáček's beautifully

112

reticent animal story. It is an image of mortality in Arcadia, of the paradisiacal, infinitely resurrectional power of the natural world.

The image of rebirth through being eaten is also a metaphor, perhaps, for the renewal of the artist's resources, which must have felt to Sendak, during this period of overwhelming productivity, dangerously close to exhaustion. "Do you see how manic this all is?" he wrote in his journal, after reporting that Corsaro had proposed doing an *Abduction from the Seraglio* (which, alas, never happened) after *Oranges*, while *Outside* and the Lanes/Abrams book were both approaching their publication dates. "What kept me going at this period was [Jean-Jacques] Rousseau, of all people: *The Confessions*." Sendak renewed himself by devouring another artist; he replenished his own drained self by partaking of that great coiner of the Self, Rousseau. And just as Henri Rousseau may have provided source material for Sendak's *Flute* Orientalia, the earlier Rousseau, exponent of the belief in the fundamental benignity of nature, supplied Sendak a passport to the realms of natural innocence, as is evident in the pastoral, rustic glory of his designs for *The Cunning Little Vixen.*

The Cunning Little Vixen, opera, right: poster;
below: costume studies

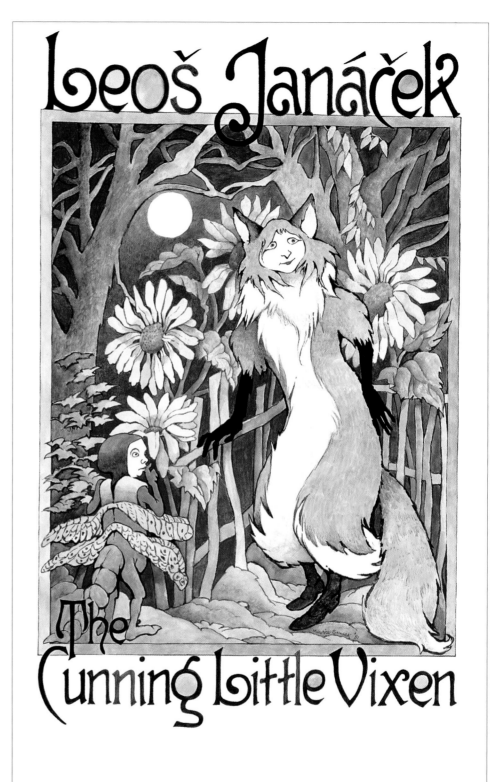

Sendak seems to have been on a French toot in terms of his reading material, for it was while he was resting from his labors for a summer and incubating *The Love for Three Oranges* that he read Proust for the first time. An entry from July reads:

Reading Proust. Proust I think will have taught me to love summer. "Fine" summer days. Why does the word "fine" set up a perfect humming of sound and clarity of vision?

German music and art also figured prominently at this time. "Mozart sonatas washing my brain clean of Janáček," he went on to report. During a trip to Europe for an exhibition of his work in Germany, a trip he called "my German *Reise*," Sendak "saw the Isenheim altarpiece in Colmar." Matthias Grünewald's strange *Crucifixion* depicts Christ nailed to a crucifix which is oddly arched, as if bending under the weight of His body. He is pierced by numerous green splinters (or whatever they are —the figure has been called "the plucked chicken Christ," the splinters resembling nothing so much as broken quills clinging to flesh, as if Christ were a sacrificial animal prepared for consuming). It is one of Sendak's favorite paintings; a postcard reproduction sits on the desk in his studio.

But it is France—the fiery revolutionary period of French history proceeding from the Enlightenment brilliance of Rousseau, preceding by a century the *fin de siècle* splendors of Proust— that provided Sendak and Corsaro with an answer to the conundrum of how to stage *The Love for Three Oranges*. They turned their full attention to the opera on August 2, 1981. Meeting in Manhattan, they began to puzzle over the peculiar plot, a filtering of Gozzi's magical *commedia*, *The Love for Three Pomegranates*, based on an Italian fairy tale, which Sendak called "a grim, bloody, and fabulous piece of medievalism." By the time the story had reached the operatic stage in post-Revolutionary Russia, it had become, in Corsaro's opinion, as reported in his *Oranges* text,

A satire on operatic and literary forms, played in a never-never land of fairy tale creations . . . it appeared a series of conceits, rather than a unified work of art. At best it had the veneer of Dada kitsch popular in Prokofiev's time but unlikely to interest our own. The libretto was devoid of the kind of human conflict Maurice and I doted on. Wrapped in a cold if brilliant score, it would last but a night in Russia, where nights are longest. Could two men, under six feet, warm up the tundra?

The disdain expressed for *Oranges* by these

two collaborators is surprising, and surprisingly vehement. The work, it seems to me, owes less to "Dada kitsch" than it does to Russian symbolism and revolutionary-era Mayakovskian surrealism. The great stage director Vsevolod Meyerhold gave Prokofiev a version of the Gozzi play, hoping that it might provide the basis for a libretto. Meyerhold had taken the title of the Gozzi play for his journal of new theatrical art; in its first issue, he published his own version of the play as a manifesto rejecting naturalism. The *Oranges* story is a bit loopy, though surely no looser or shaggier than *Flute* or *Vixen* (all three operas can be criticized for their "Oh-yeah-and-then-another-thing-that-happened-was" dramaturgy). All three operas make entirely credible cases for themselves by their final curtains. And if *Oranges* is a lesser work than *Vixen* or *Flute*, it is still great, great fun. The score is as sweet and acidic and full of brilliant flashes as anything Prokofiev wrote; and while Corsaro is correct in his belief that *Oranges* isn't likely to move anyone deeply (and in that regard it absolutely parts company with *Flute* and *Vixen*), the tale it tells has neurotic charm, hyperactive imagery, and a screwy magic. It seems appropriate enough a choice for Sendak to design, but in *Oranges*'s case, suitability didn't make the heart grow fonder. "On the surface this should be the perfect material for me," Sendak told Corsaro, "but it would be like illustrating a book I didn't want to do!"

Corsaro and Sendak found a solution to their qualms through a reinterpretation of the piece more radical than any they'd attempted so far. They removed the Gozzi/Meyerhold/Prokofiev frame of quibbling, squabbling aesthete-clowns, but retained the idea that the story is told within a frame, that the real audience is watching a stage audience watch a spectacle. Corsaro and Sendak made historically specific both the frame and what the frame contained.

They began with the main story of the opera: the tale of a clinically depressed, hypochondriacal prince, of the witch, Fata Morgana, and of the curse of and/or quest for love in the form of three hypertrophic oranges. They decided that one problem was the vagueness of the opera, set as it is in "a never-never land" of unspecified locale, culture, and time period. On the other hand, Corsaro said to Sendak,

The Love for Three Oranges, opera, top: prop study; above: costume study

. . . in the never-never land of your picture books, dogs look like dogs, children like children, and demon creatures ditto. Looking at them you know they will all have addresses.
Maurice Sendak: Compliments will get us nowhere! Go on!

Corsaro went on to recommend that they return the play-within-the-play to its *commedia dell'arte* origins, to the eighteenth-century

Venice of Gozzi, since, as he pointed out, the characters retain their Italian names. He must have felt that sunny Italians would "warm up the tundra!" Sendak brought to the mix the drawings and etchings of Giovanni Domenico Tiepolo. In a letter quoted in Corsaro's book, Sendak wrote:

> The color schemes of the sets and costumes are based on the Tiepolo drawings. I'm working to reproduce that delicate, undulating, sepia-line, and peach grey look of his work. In essence I'm designing a huge series of watercolors. The costumes, in stronger, bolder tones, will act as contrasts.

Later, when Sendak was struggling with the setting for a scene, he wrote to Corsaro about his use of Tiepolo. As he teased out his relationship to this source material, he provided an insight into the vitality of his connection to his antecedents, and their value in his work throughout his career.

But of course our faithful Domenico Tiepolo will provide the inspiration for the Divertissement scene. Has he forsaken us yet? I have an unshakeable faith in the people I steal from—a certainty that once having invested our trust in them, they will provide everything—just

The Love for Three Oranges, opera, above: costume studies; right: storyboard

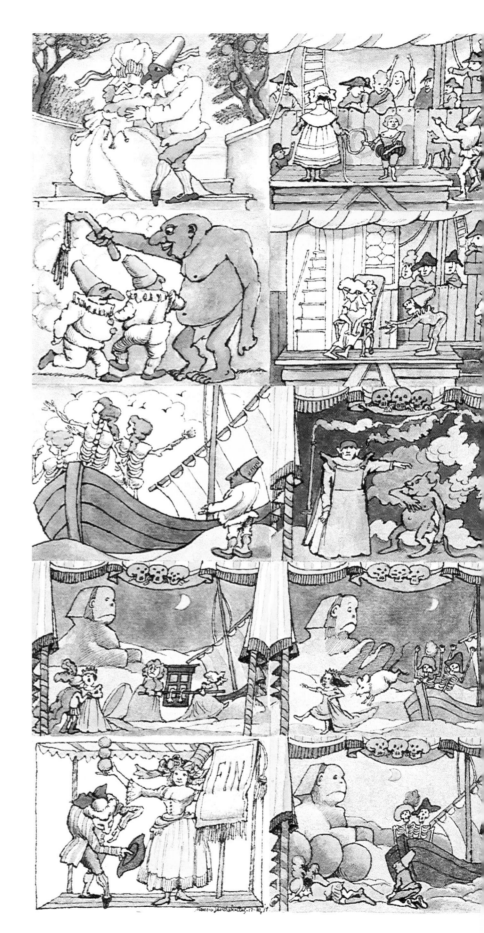

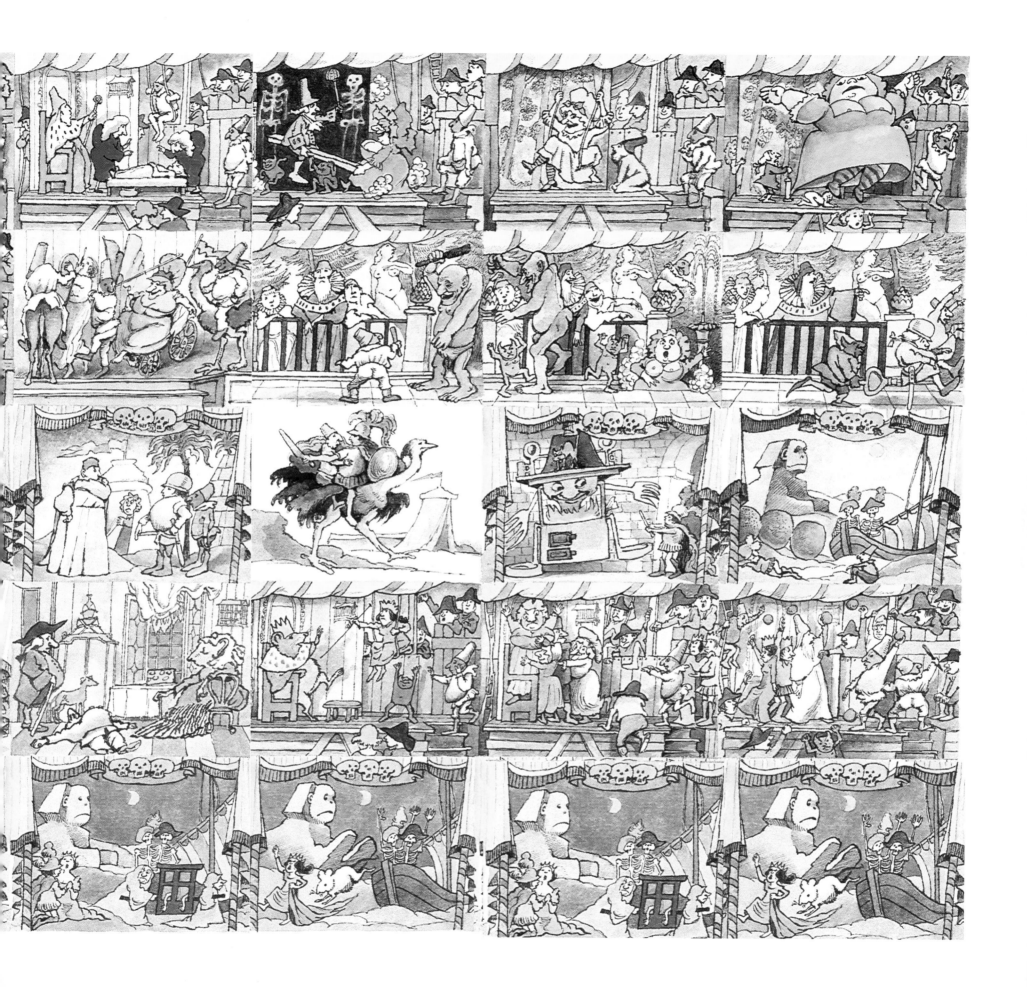

so long (and here is the crucial hitch) as we are certain that in the final cooking and basting we will transform the basic ingredients of their work into something absolutely our own. It is an odd matter indeed, this almost magical union that occurs between stealer and stealee; it is as though I know what I want but can see it only inside (in this case) a Tiepolo drawing and then I can draw it out and make it properly my own.

Having thus settled the tale proper in the context of a seventeenth-century theatrical and visual aesthetic, Corsaro and Sendak began to ponder the framing device. Whom, they asked, shall this bumptious, peremptory audience comprise? They found their answer by turning again to the opera's history, taking a clue from Glyndebourne's intention to have its production sung not in Russian but in the French of the first production. At the Chicago Lyric Opera in 1921, Prokofiev and a partner had translated the work into French, since American audiences were as yet unaccustomed to hearing Russian sung on opera stages. Glyndebourne's Brian Dickie decided to use the French-language version (Tom Stoppard later provided an English-language libretto for the touring version of the production).

Tapping into the revolutionary rejectionist energy of Gozzi/Meyerhold/Prokofiev (with a nod to the opera's satirizing of the notion of royal blood) and making hay of the French the singers would be singing, Corsaro arrived at a clever idea. In their production of the opera, an expatriate Italian *commedia* troupe, dubbed by Sendak the "Teatro Tiepolo," touring through Revolutionary-era France, performs *The Love for Three Oranges* for an irruptive audience of revolutionary sailors, plebeians, and newly minted bourgeois in some seaside French town. Corsaro reported the first discussion of this plan with Sendak:

FC: What would happen if this Italian troupe of ours would be playing a piece glorifying royalty to a French audience

during their revolutionary period?

MS: *Mamma Mia!* Why should they do such a suicidal thing? Are they crazy?

FC: Their audience would stone them, right?

MS: Certainly, since the opera celebrates the aristocracy!

FC: Ah, so here's the rub! Let's backtrack a bit. Musically, the opera opens as the chorus is discovered in mid-argument.

MS: But isn't it among themselves?

FC: What caused the argument in the first place? Couldn't they be reacting to something they're seeing?

MS: How do we do that? There's no overture.

FC: Never mind that yet. The important thing is that they've come to see a show—which is not a satisfying experience.

MS: And the choice of *The Love for Three Oranges* is?

FC: Interesting you use the word choice! If so, whose choice is it and why is it made?

The two decided to use their own skepticism, their own dissatisfaction with *Oranges* as the starting point, as their hook, as a correlate to the aesthetic argument that begins Prokofiev's opera. Corsaro and Sendak theatricalized their distaste, their dyspepsia, locating it within a highly politicized audience's class-based ressentiment.

It's an impressively inventive way into the opera for two people who began by seeking a way out. And it released all manner of

The Love for Three Oranges, opera, costume studies; opposite: costume studies

subsequent theatrical invention. It is also a risky departure, the imposition of a meta-narrative unsupported by the original text. This clearly made Sendak, at least, nervous:

MS: Frank, are we or are we not being a bit desperate?
FC: Maybe, but who cares? If it really works, if it really stimulates us, who cares?
MS: Yes. It will be like doing an entirely other opera.

"Push it, Maurice," Sendak, in his journal, recorded Corsaro instructing him. "Make it mean something."

I'm not sure that the attempt to "make it mean something" was entirely successful. When I saw *Three Oranges* I found it wonderfully strange but confusing, the effort to "mean something" at odds with the resolute gooniness of the story. If it is about anything at all, *Oranges* is, as Meyerhold and Corsaro and Sendak all knew, a play about the theater, and has nothing to do with, and really nothing to say about, the French Revolution. Their interpretation was more at variance with the original narrative than anything else they did together, and the results, in which perhaps a lingering discomfort is evident, are telling. Scrutinize the Sendak storyboard for the production, or for that matter flip through the backdrop, set, and costume designs reprinted here. With or without foreknowledge of the

The Love for Three Oranges, opera, left: finished watercolor for show curtain; above: costume study

The Love for Three Oranges, opera, finished watercolor for set piece

conceit, one may find the storyboard and the designs, though great fun, a little baffling. How, one wonders, did all this fit together in a single evening of theater? The Sendak design is more shambolic, more Dada-disjunctive, than the opera. The storyboard might be unspooling some outlandish dream, something a wild Russian modernist-fantasist, Bely or Mayakovsky, might have cooked up. *Oranges* would appear to have resisted the painstaking labor to make it "mean something"—an enchanted, ahistorical meaninglessness (or rather the elusive meaning of great nonsense) has triumphed.

The troublesome vagaries of the overall conception aside, the sets and costumes for *Oranges* show how inventive a designer Sendak was becoming within the conventions of

proscenium-arch perspectival scenery. They demonstrate a growing confidence and willingness to experiment.

The most memorable moment in their production came with the appearance of Fata Morgana, an immensely powerful fairy or witch. Corsaro apparently got the idea while flipping through Selma Lanes's *The Art of Maurice Sendak.* In the first edition of the book there is a pop-up page featuring a model of a toy that Maurice and his older brother, Jack, had designed when they were young, in which Little Red Riding Hood encounters the wolf in bed (when you pull the tab the wolf sits up and Red Riding Hood faints). This pop-up led Corsaro to call Sendak and suggest that they render Fata, in the scene in which she is meant to provide

tremendous menace, as an inanimate object, a helium-filled balloon, "a gorgeous beautiful Fata monster—the epitome of no good" as Corsaro explained her to Sendak. (To which Sendak replied "*Gott in Himmel!* A relative just came to mind who would be a perfect model.")

A swollen balloon is the perfect expression of the mock-serious threat posed by Fata, and the swelling roundness of such an object as it inflates fits perfectly with a theme Sendak makes explicit throughout his design. In Corsaro's book, Sendak voices concern about the eponymous oranges, which he feared would have to be three enormous orange balls. In the production, he renders the oranges from which the three princesses emerge as big circus hoops instead. But the spheres which worried Sendak appear in his design over and over: orange balls, ball-shaped topiary sculpture, the full moon. There are ball shapes everywhere, including cleavage; exploiting the libertine liberty of French Revolution-era fashion, Sendak's costumes make a prominent display of décolletage. One might in fact read all the opera's orbs and rotundities as bosoms: the three oranges the prince seeks, which will restore him to life, to joy, which bring him love and grief, are, Sendak infers, breasts. His drawings delineate a breast-besotted cosmos.

This privileging of the breast makes sense. The profusion of bosoms in Sendak's design makes of the world of *Oranges* an infant's fantasy,

a uberous paradise. The opera's nonsensical chop-logic and its rude and fretful rhythms are thus rendered as the consequence of developmental arrest, infantile fixation—*Oranges* as primary process, as lip-smacking narrative baby food.

Sendak and Corsaro's *Oranges* is thoroughly gynocentric. Sendak at one point mentions that the oranges, or their hoop equivalent, will look like giant letter Os. Is it carrying it too far to suggest that Sendak has identified the mammoth citrus fruit as a vaginal as well as mammarian symbol? In any event, the male characters in *Oranges* are mostly ineffectual dopes and mopers. The women are far more vital, albeit largely villainous. Sendak revels in their power. He described the wicked Clarice to Corsaro as "a mad, wonderful termagant in the raw." When he showed Corsaro his design for Clarice's costume, in which she sports pistols, Sendak exclaimed, "Voila, Miss Annie Oakley of Never-Never Land!"

What really warms the tundra is the way that, beginning with the breast motif, Sendak and Corsaro sex up the opera. The kabbalist playing-cards and dressing-room screens from Fata Morgana and Tchelio's card game become, in Corsaro's words, "a series of comic erotic *tableaux* in a Sendak Venusberg." "Perversity," Corsaro declared, "thy name is Sendak." To which Sendak replied, "It takes one to know one."

A gleeful vulgarity seems to have been their watchword, consonant with the spirit animating

The Love for Three Oranges,
opera, costume study for balloon

Prokofiev's opera. It starts with the title, as it usually does. Is there any color more vulgar, more dubious, than orange? It's the opposite of the blue and an impure relation of the red in the *tricouleur*, a color without portfolio, Frank Sinatra's color of choice for his dens of iniquity, not primary but secondary, the color not of the King but of the consort, not of the mighty lion but of the smaller tiger, not of the mighty gorilla but of the potbellied orangutan. It's the color of warning, of the flickering flame, out-of-place in chilly Russia. Orange is Mediterranean, southern, hot. Sendak uses orange as the visual connective thread in his design: glary, startling, intentionally off-kilter, merrily dislocational.

Oranges, as it was intended to do, brought Corsaro and Sendak to Glyndebourne, in May of 1982, where they had a terrific time. Sendak wrote in his journal,

Fainting in Glyndebourne over a performance of *Fidelio*. Worked all day on *Oranges*, went to the opera every night. Mad about Brian Dickie and his wife Victoria. Went nuts over Maria Ewing as composer in *Ariadne Auf Naxos*. Rolandi was Zerbinetta. Simon Rattle conducted.

The Love for Three Oranges, or *L'Amour des Trois Oranges*, as it was called at Glyndebourne, opened to great acclaim on May 25, 1982.

The Love for Three Oranges, opera, above: watercolor study for puppet show; right: finished watercolor for set drop

The Nutcracker, ballet,
costume studies

In early 1981, Sendak had been approached by choreographer Kent Stowell, the artistic director of Pacific Northwest Ballet in Seattle, and his associate choreographer (and spouse), Francia Russell, to design a new production of Tchaikovsky's *Nutcracker* ballet, which seemed to them a perfect project for an eminent illustrator of children's books. Russell admired Sendak's picture books, and on that basis had convinced Stowell to contact him.

Sendak described his reaction to the offer in the introduction to his illustrated version of E. T. A. Hoffmann's tale, *Nutcracker,* beautifully translated by Ralph Manheim, published in conjunction with the Pacific Northwest Ballet production.

My immediate reaction. . .was negative. . . . I was flattered, but my reasons for saying no were plentiful and precise. To begin with, who in the world needed another *Nutcracker?* The mandatory Christmas tree and Candyland sequences were enough to sink my spirits completely. And the fantastical subject mixed generously with children seemed, paradoxically, too suited to me, too predictable. I didn't want to be suited to the confectionery goings-on of this, I thought, most bland and banal of ballet productions. Finally, and most seriously, after only three operas and one

off-Broadway musical for children, I didn't have clue about how to approach a ballet. Where would I find the time to design a giant production—two full acts and over 180 costumes?

Sendak overcame his reservations after talking with the choreographers. "They both wanted a darker, richer version [of *Nutcracker*]," he recalls, "which of course meant going back to E. T. A. Hoffman, dumping all the sugarplum shit. I liked Kent, I liked Francia, they liked my ideas."

Serious work on *Nutcracker* began after the May 1982 opening of *Oranges* and continued throughout 1983. The scenario of the ballet, by the choreographer Marius Petipa and Ivan A. Vsevolojsky, the intendant of the Imperial Theater, was derived, Sendak discovered in a book by the critic Jack Anderson, not from the Hoffmann tale but from a French version of the original written by Alexandre Dumas *père*. Sendak and Stowell agreed that "the ballet needed renovation."

From Sendak's introduction:

What is potentially dramatic in act one is dissipated in the carnival atmosphere of act two. How to dramatically bridge the two acts and focus fierce attention on our heroine Clara. . .became the exciting goal.

The first act, as they saw it, was only *potentially* dramatic. The ballet's scenarists had stripped the mysterious central event of act one, the battle between the Nutcracker and the monstrous Mouse King, of that battle's causes and meaning, without which nothing much seems to be at stake. Hoffmann had delivered the requisite exposition in a tale Judge Drosselmeier tells Clara, "The Story of the Hard Nut," in which is recounted the grisly genesis of the baby princess Pirlipat, who was bitten by Madame Mouserinks, the mother of the Mouse King, and transformed into a hideous changeling; this explains the malevolent fury of the seven-headed Mouse King (he wants revenge for his mother's death, killed retributionally by Pirlipat's parents!). "The Hard Nut" also, critically, reveals the origin of the Nutcracker himself, of the crucial, fateful role played by nutcracking; it reveals further how a handsome prince (who turns out to be an ancestor of Drosselmeier's) came to be imprisoned in the body and gruesome hooked-nosed horn-chinned Pulcinello head of the Nutcracker. "'The Story of the Hard Nut' gives the fairy tale dramatic sense and needed psychological meaning," Sendak wrote in his introduction. "Its absence in the ballet leaves the center critically vacant."

Without this "backstory" (as folks in the movie business call it), the plot of the ballet is an unsatisfying head-scratcher, as many puzzled children have complained over the years; it's comprehensible only as an indigestion-induced nightmare. Hoffmann intended these overheated opening events, up to and including the battle, to be experienced first as a wild, confusing dream so alarming it makes his protagonist, Marie (Clara in the ballet) fall ill. But Hoffmann provides the stricken, dream-burdened Marie with a talking cure; he relieves his protagonist, and his readers, of the affliction brought on by incomprehension by means of a fairy tale. Judge Drosselmeier, anticipating Freud, reveals to his goddaughter/patient the original trauma behind the dream by telling her, in three parts, on three successive nights, "The Story of the Hard Nut." Like all good therapy, it takes several visits to make progress. When Marie's "therapist" has helped her make sense of her terror, the symptom of that terror, her neurasthenia, vanishes, and her own story can resume. If Marie/Clara's nightmare is understood, as it often and almost unavoidably is, as an expression of her prepubescent sexual panic, Hoffmann's and Drosselmeier's timely intervention can be seen as releasing the girl into a world of burgeoning sexual possibility, and hence into the glittery romance of Act Two. Remove the talking cure, the therapeutic explanatory fairy-tale-within-the-tale, and you're left watching a bewildering sketch of a not especially successful Christmas Eve party, followed by an unpleasant night's sleep—an

The Nutcracker, ballet, top: book cover; above: costume study

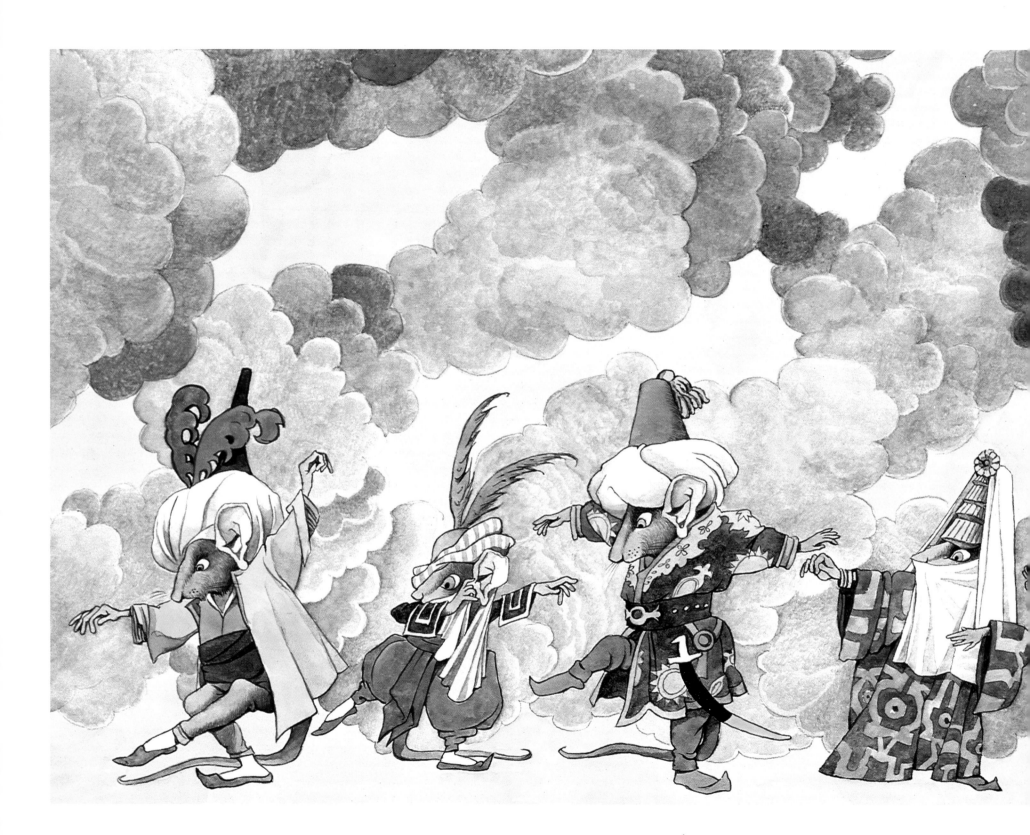

unpromising narrative that is wisely but unceremoniously dropped after intermission in favor of a rather protracted journey down Candy Cane Lane, with sideshow attractions. It's easy to share Tchaikovsky's disappointment in the ballet.

Solving this problem would not be easy for the Seattle team. The original scenarists knew they had to pare down the complicated tale to make it suitable to the limited narrative capacity of a wordless art form. Sendak and Stowell knew they couldn't match the intricacies of the Hoffmann story to the fixed fact of Tchaikovsky's score, but they wanted at least to find a way to sublime into the ballet long-banished dark aromas and a few characters from "The Story of the Hard Nut."

"There are odd, magical means by which one eases oneself or talks oneself into a project," Sendak wrote in the introduction to the *Nutcracker* book.

When I began *Nutcracker* I was beady-eyed, looking for a proper sign. It came from Herr E. T. A. Hoffmann himself, who out of love for that most lovable and best of all artists, Mozart, changed one of his middle names to Amadeus. Tchaikovsky adored Mozart and wrote a number of compositions in homage to this master and my particular hero. So there he was, smack in the middle of

The Nutcracker, ballet, left: finished watercolor for mouse scrim; above: prop study

The Nutcracker, ballet,
top: costume study;
above: prop study

this production, the great papa, so to speak, of all involved.

Sendak explained to me, twenty-two years later, precisely what this shared Mozartolatry led to.

Since most of the scenario for the Tchaikovsky score ignores all the most fascinating points of the story, I wanted to have something of that [darkness of the original tale] indicated in this version. But there wasn't any music for it, so I suggested that we take the serenade from the party scene of [Tchaikovsky's opera] *Pique Dame,* which was a Mozart pastiche by Tchaikovsky in the same key as *Nutcracker.* Kent resisted but then I played it for him on a record machine; and so we created from it a tiny interlude in the *Nutcracker* party scene where all the grown-ups go into another room to listen to singing [the *Pique Dame* serenade], like you did in those days, and the kids are left alone. And Clara's already holding the nutcracker doll and suddenly the lights go eerie. Three figures appear, the scary figures from "The Hard Nut." Clara rushes into Drosselmeier's arms—which is of course just what he intended. I felt that when we had injected "The Hard Nut"

into the story, we darkened it. I was, of course, concerned about not doing any harm to the score, to Tchaikovsky.

"Tchaikovsky's music," Sendak went on to write in his introduction,

bristling with implied action, has a subtext alive with wild child cries and belly noises. It is rare and genuine and does justice to the private world of children. One can, after all, count on the instincts of a genius.

Whether or not the interpolated musical interlude clarified Clara's journey in act one, it certainly amplified the sexual and emotional violence underlying the ballet. To further this end, Stowell insisted on casting Clara as a twelve-year-old, on the verge of puberty, rather than the seven-year-old she is in Hoffmann's tale. Again, from Sendak's introduction:

I endowed [Clara] with the wisdom and strength I conjure up to endow all my children. . .Together, [Kent and I] created a prepubescent twelve-year-old, all nerves and curiosity and devouring the world with her eyes and her imagination, just awaking to her first wonderful, fearful, erotic sensations. The stage became her half-real, half-nightmare

130

battleground. The drama grew as we watched Clara, frightened yet exuberant, cross that battleground.

Having thus dealt with the narrative problems of Act One, Sendak now had to rethink Act Two, with its dreaded visit to "Candyland." Frank Corsaro helped him find an approach. "*Nutcracker* was my first project without Frank," he told me. "I was so afraid to be weened from him, I tried out every idea for the project on him walking on Riverside Drive."

On one of these walks Corsaro suggested a new destination for Clara and her triumphant, liberated prince. Inspired by the dances with which the pair of young lovers are entertained, as well as by the interposition of Tchaikovsky's Mozart pastiche in Act One (and perhaps mourning the lost chance to do a Corsaro/Sendak *Abduction from the Seraglio*), Corsaro urged him to stay true to the tale of sexual awakening he and Stowell began in Act One. Clara and the Prince should arrive not at a regressive fantasyland, but rather at some sexual/romantic adult destination. And so in the Seattle *Nutcracker* the pair sailed off through arctic seas to arrive at (perversity, or at least audacity, thy name is Corsaro) a seraglio. It's not, of course, the sort of bawdyhouse that scorched the permafrost in *Oranges*, but it's a pleasure garden nonetheless, on an island set in the nocturnal sea. There's no going backwards

for Sendak's and Stowell's Clara: full steam ahead!

Despite all his dramaturgical work on the scenario and his concern that his *Nutcracker* would be "predictable," Sendak demonstrated considerable fidelity to the traditions of *Nutcracker* as a Christmas spectacular leavened by cozy warmth and humor in his designs. One has to look closely to see the subtle touches with which Sendak introduces his interpretation, through which something wilder, stranger, fiercer emerges. For all his ambition to "renovate" *Nutcracker*, Sendak has treated this cherished and magnificent ballet (and, in his additional illustrations for the book, Hoffmann's masterpiece) with a wise and deep affection and gentle restraint. He digs deeper, but with delicate probings that are all the more effectively unnerving because of their delicacy. He leaves the Christmas family show intact; he gives the people what they want: Maurice Sendak's *Nutcracker*, as delightfully *heimlich* and rich as one could hope. But he leaves candles in the candelabra unlit so there are chilly shadows. He leaves gaps in the Karl

The Nutcracker, ballet, above left: pencil study for set; above: costume studies; gatefold and gatefold top: watercolor studies for set drops

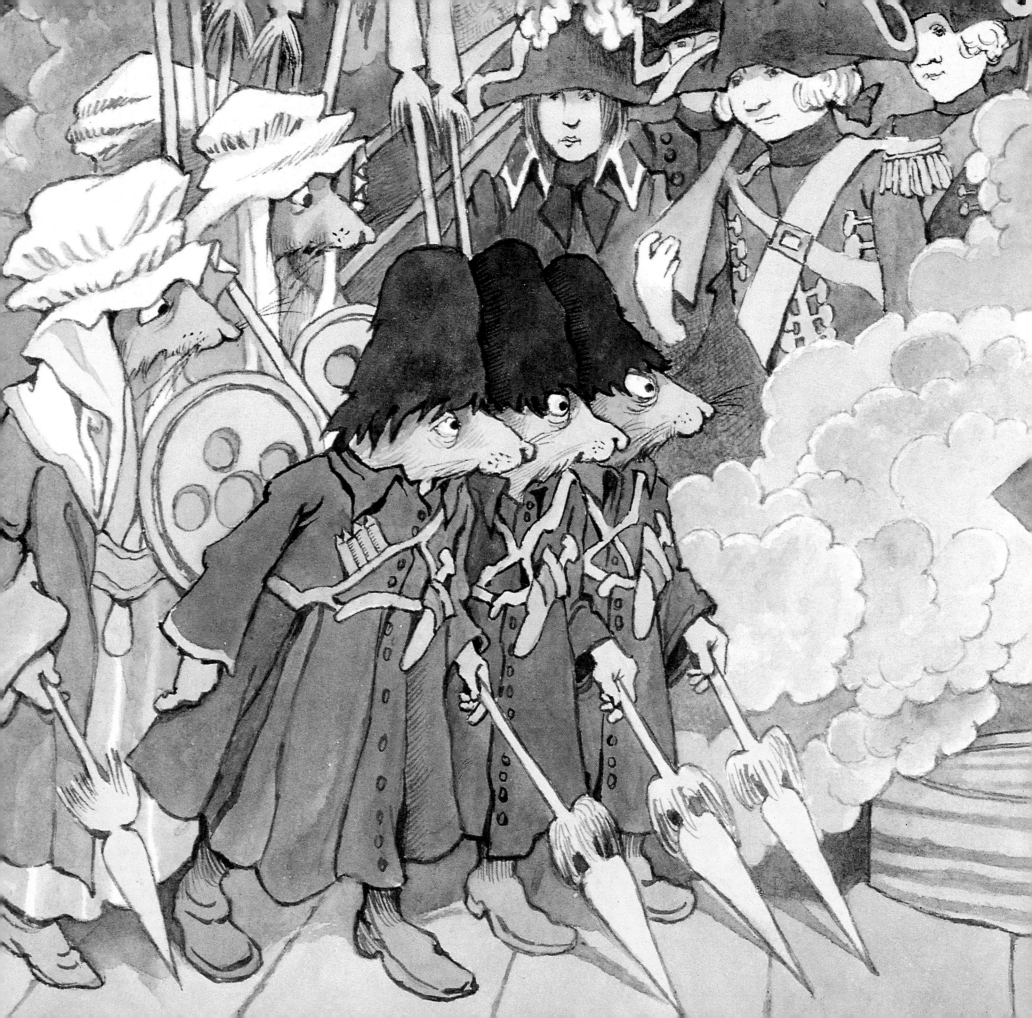

Friedrich Schinkel-inspired architecture to let vagrant cold breezes in. Sendak's *Nutcracker* both honors, deepens, and enlarges its originals. In the book's exquisite drawing of a startlingly womanly Clara, supine on her bed, there's a hideous changeling Pirlipat doll agog, on guard in a tiny crib nearby. The book jacket's jolly Christmas tree is actually a snarled mass of branches for the tangled fury of which the excess of decorations provides mere cover. In the set design, a geographical and cultural anomaly is produced by Oriental wallpaper on the walls of a stiff European living room. Even after they've been defeated, mice and rats reappear on clocks, on proscenium arch decoration, a grim nod to the dread of vermin infestation which is obviously one of the deep sources of Hoffmann's tale. Act two's backdrops are expressive less of holiday cheer than a quiet loneliness.

If breasts and orbs were the threading motif in Sendak's *Oranges* designs, *Nutcracker* seems a show about eyes: the saucer-eyed owl on the proscenium arch, the multiple beady eyes of the mice, and Drosselmeier's one visible, and visibly bugging, eye (and behind his slightly sinister black eyepatch some ocular weirdness must be hiding). My favorite of Sendak's *Nutcracker* drawings is his show curtain, on which that Christmas cliché, the Nutcracker's face is spread; Sendak has Mercator-projected that over-familiar phiz into a gasp-inducing, spine-tingling mask of madness, dental aggression,

astonishment or anguished dread, surprised recognition: *this*, Sendak is telling us, is what we identify as the trademark face of Christmas jollity, this *meshugah* mug!

It is also, maybe, the face of primal shock. Primal shock is Freud's term for the moment of gobsmacked horror, awe, excitement and discombobulation a kid experiences when, as is unavoidable, she first catches her parents in the act of copulation, or comprehends through various clues, often aural, that such an act is taking

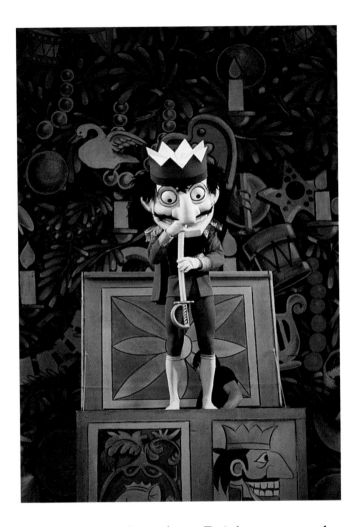

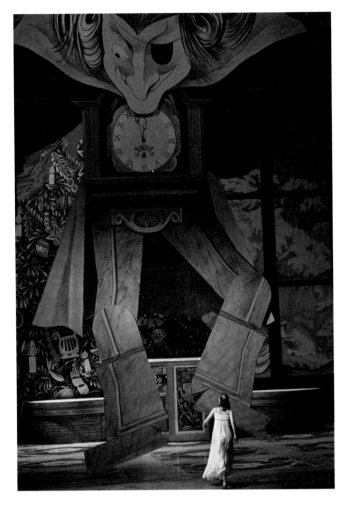

and has taken place. Anne Roiphe, among others, plausibly suggests that the bumping noises which send Mickey, the hero of *In the Night Kitchen,* off on his adventures are, well, mommy and daddy doing it in their room down the hall. It's a calamitous and providential moment of departure from innocence, from ignorance.

It's Sendak's genius to start *Nutcracker* with a curtain that blazes with a warning: OPEN YOUR EYES! LOOK AGAIN! SOMETHING IS GOING ON HERE, SOME-

THING EXCITING BUT NOT ENTIRELY NICE! He then raises the fire-curtain to reveal a world which appears familiar but which, because of what we've seen—that shocked expression—is unsettled, refreshed, made new, made all the stranger for being dressed in its ordinary holiday clothes. This is what Bertolt Brecht calls *verfremdungseffekt,* the closest English approximation for which may be the Brechtian scholar John Willett's "the Distanciation Effect" (more often, and problematically, it is translated as "the

Nutcracker, ballet, above: costume studies; top left and right: scenes from the Pacific Northwest Ballet production (1983); overleaf: finished watercolor for show curtain

137

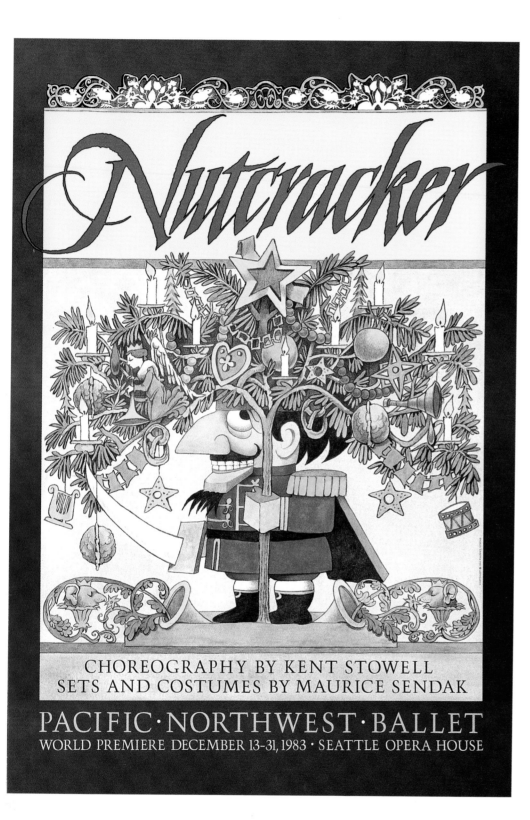

Alienation Effect"). In Brecht's words, it's the power theater has to make "the strange appear familiar and the familiar appear strange." Brecht, too, uses the uncomfortable fact of parental libido to demonstrate this "V-Effect." "It is difficult to see your mother as a woman until, after your father dies, she remarries and becomes some man's wife." Primal shock *verfremdungseffekt*-ively makes the recognizable world unrecognizable to a child, and so traumatically forces new ways of seeing. The trauma will be stored away so that latency's necessary labors can begin, but what has been seen and remembered as a wound will emerge again in puberty, and so begins a journey from innocence to adulthood.

And so, with its shocks and its pre-adolescent Clara, *Nutcracker* becomes another installation in Sendak's exploration of early puberty as a potent, perilous state. In a journal entry after the opening of *Nutcracker*, Sendak wrote, "*Nutcracker* and [*Outside Over There*'s] Ida will be forever twinned in my head." He went on to identify this conjunction as "a new density and color in my work," and one certainly sees what he meant, but it seems also to be the case that the "twinning" stems from a sorority of sorts: Clara joins her sisters Ida, Mili, and Vixen Sharp-Ears as another Sendak heroine "crossing the battlefield."

Sendak has preferred sending female protagonists to make this crossing. And let's face it;

puberty, the world in general, is more fraught with peril for girls than it is for boys. Girl heroes arguably require greater courage than boy heroes do, and one might venture that Sendak admires these girl warriors more. The little boys who are Sendak's early protagonists are sometimes heroic, sometimes not, but their adventures take place within the reliable confines of a secure domestic arrangement. His heroines are in stories in which they must face real, not dreamt-up, trouble. They are often missing at least one parent and must do without that protection.

It was only later, after the first horrible years of the AIDS epidemic, that Sendak created older boy protagonists, who confront real-world perils without the security of a loving family or a home. But Jack and Guy have one another. They are a protagonist pair, unique in the Sendakian universe, where heroes and heroines mostly go it alone.

As the world got uglier, in the years since 1980, Sendak turned repeatedly to early adolescence as a subject, perhaps as a metaphor as well. The world appears to be passing through a liminal period, changing from one thing to another—we don't know what yet—and we are all in a state of possibility and of possible peril. As the world's worries and woes bear down on human existence, making themselves felt even in luxurious, formerly privileged places, the space permitted for childhood buckles and contracts. The young are prematurely thrown

into myriad battles, made sacrifices to political economies and ideologies in which children occupy no sheltering place. Sendak continues to be the mirror of childhood's sorrows and fears as well as its beauty and joy.

Sendak completed the *Nutcracker* designs by October 1983, a process that involved much traveling between his Connecticut home and Seattle. On November 15, Sendak wrote in his journal,

FINALLY allowed to see Kent's choreography. Kent's work is clean and unsentimental. Works wonderfully well with sets and costumes All the lady dancers delighted with their costumes. Xmas tree refuses to work, everybody's fault, we started construction too late, watching it grow is like having a heart attack. Endless costume rebuilding and repairs. The production seems too big, overdone, fussy, I lose all confidence in the production, new tree being hastily constructed in NYC, terrified.

Proust again, or at any rate a volume encountered as a consequence of having read *À La Recherche*, restored Sendak's equilibrium. He noted in his journal that he was "reading the *Life of Madame de Sévigny*." The biography of Marcel's grandmother's and mother's favorite author "calmed [him] down."

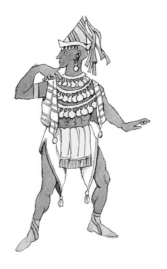

Nutcracker, ballet, above: costume studies; opposite: poster

141

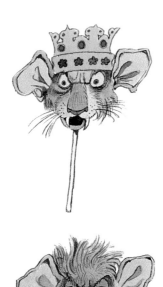

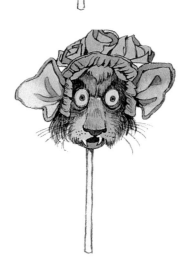

Nutcracker, ballet,
studies for masks

In a succession of journal entries, Sendak described the build-up to *Nutcracker*'s opening night:

December 5: Back in Seattle again, getting ready, rehearsals costumes quick changes, repairs, despairs & fatigue.

December 7: Setting up the opera house, loading in, MORE costume changes. I will stay through till opening.

December 8: Lights with Ken Billington [a well-known Broadway lighting designer]. Kent says they're dancing but they don't know what they're doing, they don't know what the story is. He let me go onstage to tell them what was happening. This was my first time directing. Two Claras, the blonde and the dark, both lovely, both smart, 10 years old, wise intuitive lovely dancers, capable actors. Excitement builds up to December 10, then disaster strikes: floor is the wrong color, no one can dance, tree is sticking, bits of set get torn, fall down, raw anxiety, horrible hostility, tree sucks. NO HEROES HERE except backstage crew; they must make the best of all the shit we dump on them.

December 11: Totally depressed. I feel the set is a huge fatally flawed bit of junk, it is my failure. Looks so much like *Outside Over There*, wind makes curtain stick on everything.

December 13: Opening night. Audience yells heads off, a great success despite many many technical flaws. Me and Kent embrace. Kent and Francie give me as a gift recordings of [Gluck's] *Alceste* and *Don Carlos*. Lots of lovely presents.

All during this dramatic week, Sendak was working with his assistant set designer, Peter Horne, in his Seattle hotel room, "frantically" drafting the sets for his next work, Oliver Knussen's *Higglety Pigglety Pop!*, which would soon (soon in opera-world terms) join a revised *Where the Wild Things Are* as a double bill at Glyndebourne, directed by Corsaro. On December 16, three days after the opening of *Nutcracker*, he wrote in his journal:

Flight to London with model [for the set of *Higglety*], worrying over *Nutcracker* book which Crown has just contracted me for.

Much satisfaction with quality of ballet despite stupid fucking tree.

All these flights—to England to Seattle, *Nutcracker* all by myself without Frank! I am baptized finally into a new theater life.

His new theater life immediately brought Sendak back to opera and Corsaro. As the journal entries above indicate, 1984 and 1985 were spent preparing designs for a series of productions: the long-awaited teaming of the Knussen/Sendak fantasy operas, *Wild Things* and *Higglety*; as well as Mozart's *The Goose Of Cairo*; Stravinsky's *Renard* in Amsterdam, paired with *Wild Things*; Ravel's *L'Enfant et Les Sortilèges* and *L'Heure Espagnole*; and finally Mozart again, with *Idomeneo*.

In January 1984, the Barbican Centre in London presented *Where the Wild Things Are* in a concert version on a program with Janáček's children's songs. The Glyndebourne Festival's touring production of *Higglety Pigglety Pop!* opened in October of that year. "Oliver hadn't finished *Higglety*," Sendak recalls. "It was scenes from *Higglety* and some guy who narrated the passages that weren't composed." Sendak spent the spring and summer of 1986 planning and designing the Stravinsky and Ravel operas.

April 16, 1986. Amsterdam—meetings for *Renard*. Traveled from Glyndebourne for the Ravel double bill, April 13–15, with Frank and huge package of sets, sketches, costumes designs for Ravel and Stravinsky. Presented the two Ravel models at Glyndebourne on April 14th. My assistant, Peter Horne, helped immensely. Frank, seeing the designs for the first time, along with Glyndebournians. I am lucky—everybody in good mood and my model seems to please. The Ravel double bill is now set for 1988 [1987, actually]. Amsterdam meeting held in old theatre (1890-ish) is utterly charming and seats just a bit more than Glyndebourne—very like Théâtre de la Monnaie in Brussels. Everyone likes the *Renard* backdrop and the simple set and Frank especially admires my costume watercolors—very sexy—this *Renard* is going much too easily—I tremble. It is on the double bill with *Wild Things*. How in the world will they go together?

My tiny, dinky hotel is just a short walk from Anne Frank's house. And just a few blocks more to Van Gogh museum.

Problem, at last! They want to paint my sets in Holland and I want them to go to my shop in Montreal [the scenery building shop he preferred to use]. Peter Horne and Michael [who continues to be Sendak's scenic painter of choice] painting them. Expensive schlepping but how to trust shop when I know no one here? This *Renard* being a one-acter, even with the changes, there is fairly little for me to do. The big problem is Ravel. Two complex one-act operas with animation yet. *Gott in Himmel.*

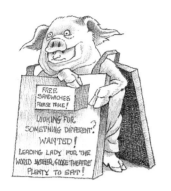

On August 5, 1986, *Wild Things* and *Higglety*, the music still in development, opened together at Glyndebourne. It would take thirteen more years for Oliver Knussen to bring the score for *Higglety Pigglety Pop!* to completion. (The two Knussen/Sendak operas, both now complete, have recently been released on Deutsche Grammophon, conducted by the composer—wrapped in fabulous packaging designed by Sendak.)

Sendak's libretto for *Higglety* is a perfect dramatization of his children's book. It preserves the original's subtlety, its kindly humor, and its affectionate, keenly observed portrait of Sendak's beloved Sealyham terrier, Jennie, the book's heroine and the opera's soprano leading role. Part pampered pet, part pampered human, Jennie is torn by desires both unappeasable and gratifiable, by soul- and belly-hunger, plagued by spiritual emptiness and loneliness. Her heart is divided; she's an innately dignified beggar for food. She's a complex character, a brilliant creation, most human when most canine and vice versa.

The text of the libretto replaces the book's prose with verses of irregular scansion and clever, loose, jangly rhyme. As an example of the style, consider the song Jennie sings to trick the uncooperative baby into eating an egg.

Said Chicken Little, "Before I die
Oh sky—oh night"—

(she wasn't very bright)—
"Let me lay a little egg
I beg
To be remembered by."
And she did and he did
And here's the egg—Oh my!

This wonderful ditty might be stitched into samplers under the heading "The Artist's Prayer." "Let me lay a little egg / I beg / To be remembered by." Amen, Chicken Little! Amen, Jennie!

As with the book, Sendak's libretto explores the dark country on the other side of death. It raises, in the quietest, mildest manner imaginable, key human questions: why is love not stronger than death? How can someone, human or animal, who is needed, adored and adoring, consent to go away? *Higglety Pigglety Pop!*, book and opera, poses the question of loss as a child would: not conceding for an instant that the lost one might not have had a say in the matter. Sendak wants to give full expression to the special grief that burns at the heart of the one left behind; child or adult, no serious loss can be sustained without the one who has suffered the loss feeling betrayed.

Jennie leaves in search of experience, with an emphasis on the "ex," the prefix which can connote both *out*, something you must go away to get, and *former, previous, past*. As we learn from the advertisement on the Pig's

sandwich board, EX is the EXchange code for the phone number—EX1-1212—of The Castle Yonder, that remote terminus of pilgrim Jennie's progress, undiscovered country from whose bourne no traveler returns, though to which phone calls, albeit unsatisfying phone calls, can be placed and from which mail, at least in Sendak's cosmology, can occasionally be sent. What is heartrending, Bartleby-like, is that we do not and can never learn whether Jennie's final letter to her friend was received by him.

Knussen's score for *Higglety* is as powerfully yearning, as elegiac and spare as his *Wild Things* score is raucous, lusty, full of danger. It starts with a dying fall, on Jennie's sliding, declining aria, "Why am I longing?" Jennie's vague discontent, her restlessness, is given distinctly adult gravity in Knussen's music; it's a sorrow she never quite shakes off, even in her eventual triumph. Her duet with the house plant is terrifically moving, reaching a pitch of piercing unhappiness on the couplet "I cannot call my dream by name / But it calls Jennie just the same. . ." The diva may be dressed as a cute white dog; there may be magic and Mother Goose afoot; but *Higglety* is not a children's opera. Its iridescent score has a hovering, fluttering, slightly panicky wingbeat rhythm and a quality of breathlessness. A faint motor is spinning underneath, whispering dread. The struggle between Jennie and the baby (that

colicky, impossible, scowling little monster, the original drawings of whom are a self-portrait of baby Sendak, he whose laugh was "a little bell") is very funny, but at the same time, Knussen scores the baby's "NO EAT" to sound like a factory whistle announcing some chemical accident; it's music that sets teeth on edge and causes cardiac arrhythmia, compared to which Max's "Vil-da-chai-ah-mi-ma-mee-oh!" is positively euphonious. Even the happy "Ein Mädchen oder Weibchen" which Knussen quotes (a *Magic Flute* homage that plays on the Baby's nursery music box) is in *Higglety* spookily etherealized, misted into shimmering dust motes and moonbeams and then diffused into dissonance.

Sendak's designs for *Higglety* recreate the crowquill-pen cross-hatching and soft grey tonalities of the book, providing variations on and elaborations of the original illustrations. The city in which Jennie encounters the Pig and the peculiar milk-giving Cat is more recognizably the Lower East Side of Manhattan or the Brooklyn of the 1920s than I'd imagined it would be, having had only the very shadowy glimpses of its streets the book affords. The Castle Yonder, not quite seen in the book, is in the stage design looming on a hill behind the proscenium arch of the Mother Goose World Theater, revealed, as one might have suspected it would be, as a ruin, a dead building—the habitation of ghosts.

Higglety Pigglety Pop!, opera, costume studies; overleaf: finished pencil renderings for set drops

Higglety Pigglety Pop!, opera, storyboard

The Goose of Cairo, opera, below: costume studies; right: finished watercolor for set drop

In September of 1986, Corsaro and Sendak returned to Mozart, where they staged an opera buffa fragment, *The Goose of Cairo,* at the Lyric Opera of Kansas City in Missouri. *The Goose* is an opera that neither merits nor requires close scrutiny. Mozart abandoned it before it was finished. He felt its librettist, Giovanni Battista Varesco, lacked "the slightest experience or knowledge of the stage" as he wrote in a letter to his father. And he had already moved on to far better work. *Idomeneo* had been composed (with an originally overlong libretto by Varesco); and Lorenzo da Ponte was waiting in the wings. For Sendak and Corsaro *The Goose* was obviously a lark, a way of taking a breather from more strenuous work. Sendak told me that the Goose's head and opulent headdress was inspired by his "imagining of Elizabeth Taylor."

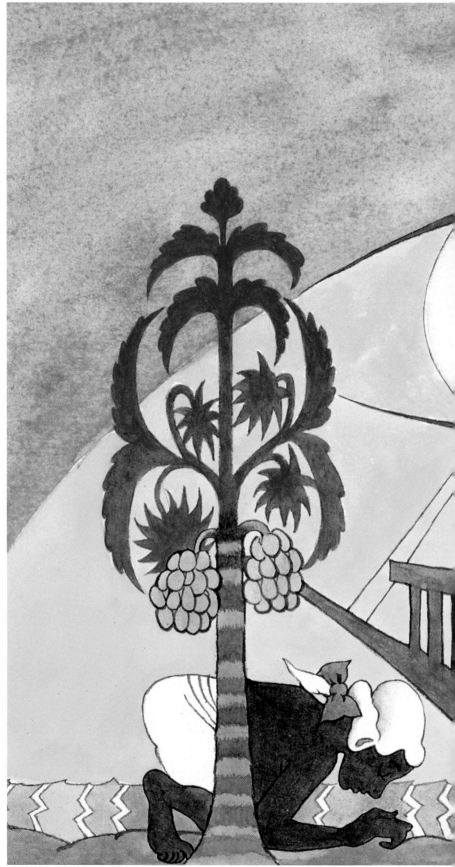

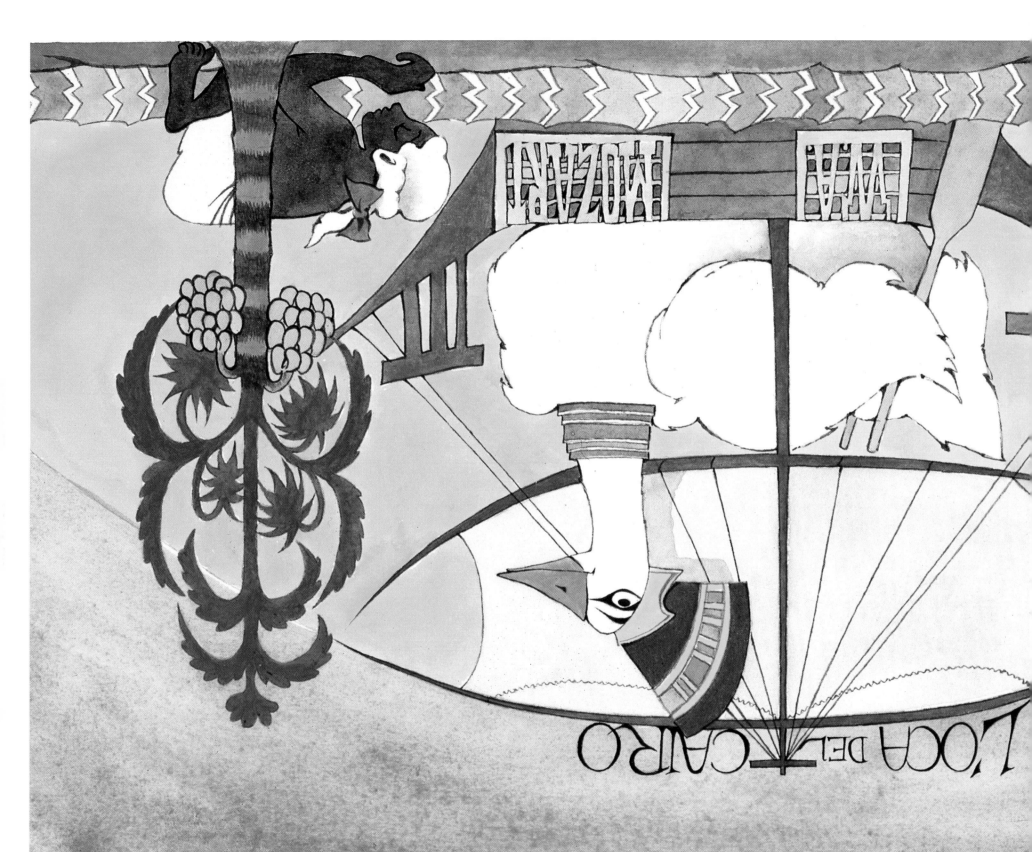

On December 23, the indefatigable team was in Amsterdam, opening Stravinsky's *Renard* at the Netherlands Opera.

A few weeks earlier Sendak had made the following entries in his journal:

Amsterdam again. Arrive November 30, 1986. Will be here from December 1st to the 23rd. Three long weeks. Thank God for Van Gogh, Rembrandt and Anne Frank. The new opera house with its ghastly tall chimneys looks like Auschwitz and it squats on the old Jewish Quarter. My frequent visits to the Van Gogh Museum are not unlike my experience in Colmar with Grünewald—Vincent and Grünewald are my two angels.

December 10th. Meetings galore. Happy costume fittings. Singers are pleased except for the fat ones. Watched run-through of *Renard* (*De Vos!* Dutch title for Stravinsky). It is short, funny and all full of Frank's schtick. Good schtick! Fresh—excellent cast.

Frank and I, for the first time, talk about *Idomeneo*.

Kröller Müller Museum—more—incredible Van Goghs.

December 14–19. Rehearsing and light-ing in Utrecht (had to do all the work in

Renard, opera, costume studies

Utrecht, don't ask me why). Pouring rain every day. Terrible time.

December 23rd. Opening night. Decent performance. Active audience. *Renard* was good technically. *Wild Things* a mess. Low energy all around. I hate these fuck-ing operas!

Renard is a fifteen-minute songspiel, origi-nally performed by Les Ballets Russes. Derived by Stravinsky from a Russian folk tale, its nearly non-existent plot concerns the doings of a crafty fox, a gormless cock, and his rescuer/saviors, a cat and a ram. The fox gets the cock, the cat saves him, the fox gets him again, the cat and the ram kill the fox. Stravinsky makes of this piffle a robust, luscious, earthbound, Slavic-medieval romp, with flutes shrilling above downbeating, heavy-footed drums and viol strings, while a *ghuzla*, a metal-stringed balalaika, is strummed (provided a ghuzla and ghuzla player can be found). It's a lot of fun, reminiscent of the fair-ground music in *Petroushka* and parts of the *Pulcinella Suite*.

Sendak and Corsaro respected the compos-er/librettist's wishes, staging the show as if per-formed by a medieval *giullari* troupe, itinerant street players upon a trestle stage. But Sendak set the trestle stage against a *Dies Irae* background, a European city in flames. They seem to have read the tale as an allegory of death stalking life.

In a mordant and truly medieval gesture, they made Renard a fox only in disguise—he's actually Death, his glabrous head a skull, his skin putrefaction-pale and spotted with buboes; his legs are serpents, his crotch is a hellmouth, and below his scaly back, an imp's face is blowing a raspberry fart. The Ram and the Cat are starveling peasant farmers with protuberant clavicles. Whether or not they are "sexy," as Sendak reported Corsaro declaring them to be, is in the eye of the beholder. They are definitely weathered, road-weary, tattered adults.

What must this wisp of plaguey whimsy from the dark ages have played like alongside the entirely modern *Where the Wild Things Are?* There's a musical connection between the two

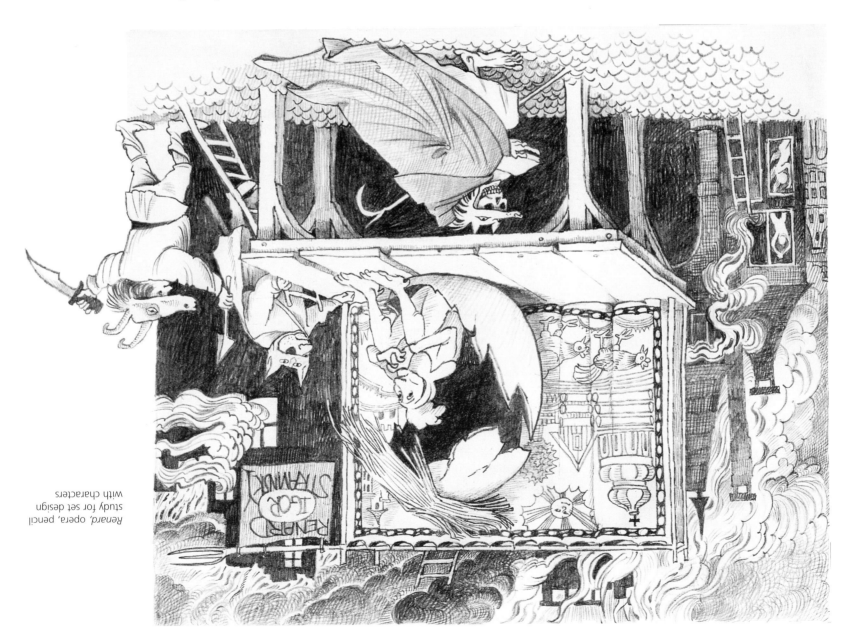

Renard, opera, pencil study for set design with characters

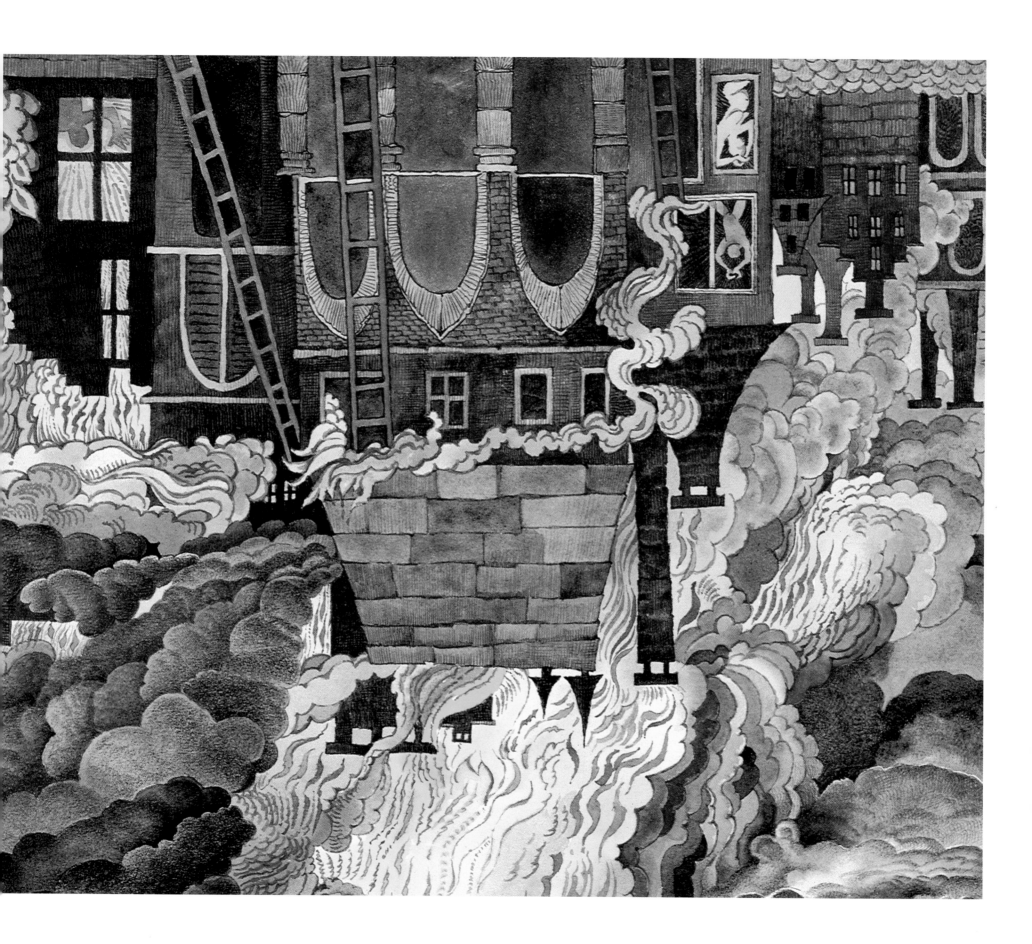

composers, at least. Otherwise the pairing strikes me as peculiar, as it seemed to have struck Sendak and Corsaro. Perhaps a discomfort with the Stravinsky piece occasioned their decision to bring consequence and mortality to a thin animal tale, but this only makes *Renard* an odd, dessicated, dour adult companion for bright, vital, and very young Max.

Sendak brought the two most powerful images from his *Renard* designs, the burning city and the hobgoblin Death, back into service thirteen years later, when he collaborated with the dance company Pilobolus on a dark Holocaust fantasia, *A Selection*. Both Renard and *A Selection* are, ultimately, tales of death's struggle with the living. One is reminded of the Book of the Apocalypse image at the conclusion of Ingmar Bergman's masterpiece, *The Seventh Seal*, when Death leads the characters, all silhouetted against a stormy sky, across a ridge. Antonius Bloch's squire, watching, speaks the film's last line (or nearly the last) "And Death dances off with them all." For most of his career, Sendak has drawn from the visual vocabulary, history, and literature of the modern era, even if at times he visits its earliest formations. The Holocaust moved him, as it moved the guilt-stricken Bergman (and in despair as Hitler, if not the Holocaust, moved Thomas Mann in *Doktor Faustus*), to cast back farther into the recesses of time, back to an earlier dark age, to find an antecedent for a contemporary horror.

Renard, opera, left: finished watercolor for set drop; above: costume study

On July 22, 1987, the two Ravels, *L'Enfant et les Sortilèges* and *L'Heure Espagnole* opened at Glyndebourne. *L'Heure* is Ravel's investigation of the mechanically driven plots of *opera buffa*, cleverly set in a clock shop. Its action commences with a rich interplay of melody and shifting meter, the ticking of numerous timepieces in the overture. It's been remarked that Ravel's father was an inventor whose house was full of the sounds of clicking and clanging machinery, and so the whole contraption of *L'Heure* can be viewed as an Oedipal drama. It tells the story of a younger man, a muleteer by trade, closer to beasts than machines, who diddles the wife of a miserly old daddy—a daddy named Torquemada, after the infamous Inquisition scold and mass murderer. In Ravel's charming piece of amoral French frippery, fearsome Torquemada is clockmaker and an asexual cuckold. The opera posits rhythm as the source of amorous love, or at least of amour. The throb of the pulse and the ticking of the clock stretch out our hours; monotony slides us into lassitude, and from torpor comes sexual

arousal. A steady rhythmic beat measures out our lives, reminding us that time and youth and desire are fleeting. The score is frequently charged with being cold, but I've never found it so. It's indolent, drifty, sensual, and gorgeous, as Ravel's music always is. Who hasn't passed a Spanish hour from time to time?

Sendak crowded his eighteenth-century Toledo with red-tile-roofed buildings bearing anthropomorphic clocks and other pastel-colored, sugar-frosted baroquosities. On a roundel of the main tower of the clockmaker's house, if I'm not mistaken, there's a little American calling card, a reminder of Sendak's affection for and attentiveness to early- and mid-twentieth century product trademarks: the upper-right-hand clock would appear to be embedded in the breast of the cereal company Kellogg's cornflakes rooster, who brings the best to you each morning.

L'Heure Espagnole differs strikingly from Sendak's previous designs, with their saturated bold or dark color schemes. He blessed the characters and circumstance of this doors-and-windows farce with pale colors, a lightness,

L'Enfant et les Sortileges,
opera, watercolor study
for set design

and a freshness that makes the stage action innocent rather than venal and treacherous, the foolish bumbling more childlike than idiotic. Sendak gives *L'Heure Espagnole* permission to be a soufflé with no need to justify itself beyond the sensual pleasure it provides.

This pastel tonality connects *L'Heure* to Sendak's designs for the later, far more substantial work by Ravel with which the opera is nearly always performed, *L'Enfant et les Sortilèges.* Again one notices in the sets and costumes a non-Sendakian paleness of tint and hue. It's his version of Gallic exquisiteness, that hyper-refined French taste, chinoiserie-inflected,

precise, slightly off-puttingly perfect, a little too comfortable, and gracious. He's saluting and gently mocking the developed eye that can bring a half-timbered hut from *l'ancien régime* to chic modernity with apparent effortlessness. Following the librettist's instructions that the ceiling of the child's room should be low, Sendak imagines a medieval common room as decorated by the librettist herself, the hyper-refined, slightly off-puttingly perfect Colette, in between the words of whose flawlessly pearlescent prose sex oozes and madness threatens.

Sendak may have approached *L'Enfant* with trepidation, given the similarities between

Colette's story and his own most famous book (now a famous opera as well). You can't have read *Where the Wild Things Are* and not think about Max when watching and listening to *L'Enfant*. Given Sendak's early and sustained love of opera, it seems probable that the Colette/Ravel one-act is a source of inspiration for *Wild Things*.

Inspired or not, indebted or not, whatever the level of his—or for that matter, Oliver Knussen's—anxiety of influence, Sendak intentionally elicited a comparison between his book, his opera, and the Ravel in his design for the latter. The colors in the book are stronger than those used in the sets and costumes for Sendak's *L'Enfant*, but the *Wild Things* paintings have a similarly subdued palette. In his book about childhood reading, *The Child That Books Built*, Francis Spufford, an admirer of *Wild Things*, observes that its "reds and yellows

and greens are the slightly faded colors of a 1940s toy theater." The *L'Enfant* storyboard shows the pink and the robin's-egg blue of the opera's beginnings eventually overwhelmed by the *Wild Things* predominant color trio of dark blue, green, and moonlight white, as the Ravel opera shifts from daytime to the nocturnal dreamworld the French child shares with Max. As he did in *Wild Things*, book and opera, Sendak causes trees to lift up and carry away the house of *L'Enfant*; domesticity has been broached and conquered by wildness and animal life (at least, as wild and animal as one might encounter in a French garden).

The nasty, sadistic child's non-human nemeses are his relatives, ensorcelled by the designer, changed into *cauchemar* animals intent upon revenge. Sendak is again borrowing a page from his own book. Though it isn't made explicit in *Wild Things*, the monsters

L'Enfant et les Sortileges,
opera, costume studies

Max tames are Sendak's *mishpocheh*, his relatives, who had seemed to him when he was a boy outrageously *meeskeit* (homely), certainly not the French fashionplates to whom the child is related. But to Sendak they were also marvelous and exotic. As he explained it to me:

We had a cousin—she was a Communist, her brother was a Communist too. She didn't have a beautiful face, but she did so much with it; she was so glamorous. I was so impressed that she would deign to visit us! She took me to art events, she talked to me and my sister, she treated me like a man, she was so sophisticated and cultured. How romantic being loved, being respected, being *looked at* by a Communist! She was our only superior relative.

All gone to glory now, the Communist cousin and the other shaggy, toothy, round-headed Sendaks and Schindlers (Sendak's mother's family) and their *landsmanner*, all waiting for Max on the island of the Wild Things, with their staring yellow eyes.

In a particularly nice and eerie touch, Sendak and Corsaro used Ravel's cat duet as an opportunity to present two jitterbugging felines, the child's parents, entranced with each other and indifferent to their son. Parental indifference is the most alarming aspect of the

L'Enfant et les Sortileges and *L'Heure Espagnole*, operas, left: storyboard; above: costume studies

family drama, and Sendak alludes to it time and again. Max's mother, whose bratty boy is left to his own devices, while the father is perpetually absent; the parents in *Higglety Pigglety Pop!*, gone to Castle Yonder, leaving Baby behind; the bumping, clumping parents, keeping *In The Night Kitchen*'s Mickey from a sound slumber; Ida's mother, holding her husband's letter, inattentive, preoccupied, negligent: these parental derelicts, among others, offer glimpses of romance, partnership, devotion which excludes its own offspring, private sexual *pas de deux* in the passionate intensity of which the child fears it is crowded out, forgotten. And the child is, for a brief moment or in some cases for a long time, correct.

Sendak may be drawing comparisons between *L'Enfant* and *Wild Things* to point out their differences as well as their similarities, for in many ways the two works could not be less alike. A comparative study could be made of European and American cultures using Colette and Ravel's child and Max, contrasting the penitential overcast of *L'Enfant* with the liberationist exuberance of *Wild Things*; comparing the way that the French work describes the birth of a moral imagination which leads to acquiescence to the social order, while the American imagination is anarchic, replete, and lonely. The American boy conquers the wilderness, while the French boy is shamed and then tamed by it. Loneliness and the need for affection is what tames Max. Christian

sacrifice, martyrdom, grief, compulsion to make restitution for one's victims—in other words the heavy burdens of history—are what lead the child in *L'Enfant* to call out for his mother, to enter his "Paradise of Tenderness." Colette and Ravel tell the story of civilization, while Sendak tells the story of one of its discontents, without apology. *L'Enfant* is moral, judgmental; *Wild Things* is observational, psychological. *L'Enfant* is instructive; *Wild Things* is "permissive," emancipatory. *L'Enfant*, perhaps, accepts the doctrine of original sin, while *Wild Things* refuses to concede any portion of childhood, even the most aggressive portion, to sin and guilt.

Through the years there's been a certain amount of phumphing over the "moral ambiguity" or even the "moral shallowness" of *Where the Wild Things Are*. It's identified as one source of the book's supposed potential for unhinging children, disrupting bedtimes, causing bouts of hysteria. The book is strong stuff for kids—freedom, after all, is just another word for nothing left to lose. But *Wild Things* is in part about confronting your fears, and, even while you celebrate its vitality, subjugating your own antisocial wildness. The book champions important virtues: courage, daring, and responsibility. The universe isn't hell-bent on reforming Max, nor are the woodland creatures he meets Sunday school teachers; he lives in a secularized universe in which, in the tradition of Dorothy Gale of Kansas, you have to figure things out for

yourself. Sendak leads Max on a tour of the labyrinth within, introduces him to his minotaur (turns out he has six!), and then, after Max has exhausted and/or dominated them, he is deposited (or rather deposits himself) a couple of short steps from the door that leads to moral growth. Max is all the more likely to knock, open, and venture within for having gained, through his travels, self-knowledge. Sendak seems to suggest that children who aren't made ashamed of themselves will discover an innate goodness and don't really need to be policed. Of course children require moral instruction—so do adults!—but Sendak's point is sound. Excessive moral policing produces love of morality less often than it produces love of policemen.

Several months before the Ravel opening, on December 7, 1986, while Sendak was working on *Renard* in Amsterdam, he traveled to Glyndebourne to discuss his desire to incorporate film animation into his designs for Ravel's *L'Enfant et les Sortilèges*. "I knew Ravel had wanted to go to Walt Disney for *L'Enfant*. He was talked out of it, so I wanted to do right by him, and use animations," Sendak told me. "There was much concern about it—it's so expensive." But in the end, Sendak got his way.

There was a cartoon film. It started right up with the overture. It was done by Ronald Chase, a friend of Frank

[Corsaro]'s from Los Angeles, a stage designer and a real experimenter. In the movie, you travel through the woods, past a huge statue of Ravel, and then you come upon the house. We used the film technique again, when only the little boy, L'Enfant, is on stage. He has a temper tantrum with the chair, a temper tantrum with the wallpaper, a temper tantrum with this and that, all of it animated. The film stuff was extremely primitive, but it wouldn't have been any more sophisticated in Ravel's day. I think Mr. Ravel would have been pleased. He had asked for animation to be used in staging *L'Enfant*, but this was the first time anyone had tried it. It was all done on the cheap, it was the worst experience I had doing opera, but in the end it all worked like in a Ruby Keeler movie!

I should like to draw attention, before moving on, to Sendak's storyboards, since the one he made for the Ravel is so handsomely detailed. I've heard him fret, regarding a current opera project, that he might not have time to make a storyboard, and I've wondered why he finds them so necessary. On occasion, as with the illustrated *Pierre*, the storyboards have become final product, the finished artwork for a project extracted from them, but mostly

163

L'Enfant et les Sortileges,
opera, finished watercolor
for set pieces

they're supposed to be utilitarian. They are also, it should be noted, astonishing in their own right—distillations of a graphic storyteller's art which tempt the viewer to write her or his own narrative, in which beauty, rather than narrative causality, moves the story along. Between this panel and the next, what could have happened? The storyboards are wordless and won't answer. I love their inviting, teasing silence and secrecy. The mind cannot help but respond by fashioning a tale. The storyboards contain an entire produc-

tion miraculously compressed on a single page, its central gestus, its specific heartbeat, fragrance, tenor, and tone. They share with his other work qualities that make Sendak great. He spares himself no pains, and nothing is ever simply utilitarian. His is the business of creation, and at every turn he gives his viewer, his reader, not merely an illustration or a stage set or a storyboard, but something more densely packed, various, blooded, quickened—an invented world, crowded with life.

In 1989, Corsaro and Sendak began an exploration of *opera seria*, with preparations for a more-or-less hypothetical production of Mozart's *La Clemenza di Tito*. The scheme and design were on spec. The team was daunted by the demands of *opera seria*, Sendak remembers. "I was wild to do it, but I couldn't make it work. It was my problem, not Mozart's. It was done very well by my old assistant Tom Lynch years later." Sendak discussed *Clemenza* with Brian Dickie and made pencil studies and watercolors, but on March 21, 1990, plans for a production at Glyndebourne fell through, and that was that. The production never took place. "Nobody wanted it, finally."

La Clemenza di Tito, opera (never completed), watercolor study for show curtain

Meanwhile, Corsaro and Sendak prepared their next production, an earlier Mozart opera, *Idomeneo, Re di Creta.* Less formally modern than the masterpieces that would follow, *Idomeneo* seems years advanced, in its dramatic, psychological, and musical subtlety, from *Clemenza,* which was written ten years later. It was without question a significant departure for the Corsaro/Sendak team. On his own, Corsaro had done productions of dramatic opera, including a highly acclaimed *Carmen,* but with Sendak he had concentrated on the fantastical side of the repertoire. *Idomeneo* combines mythic and supernatural events with a tremendous emotional power and psychological realism. Its characters, especially as expressed through the filter of Mozart's music, are human, flawed, profoundly decent and divided.

The Los Angeles Opera's production of *Idomeneo* opened on September 25, 1990. Sendak's designs are more faithful than is usual for him to the aesthetics of the period in which the opera was composed, suggesting perhaps an anxiety not to misstep, to stay out of the way of the sublime music. A serenely lovely curtain drop shows Mozart contemplating figures from the opera: human antagonists—king, jealous spurned lover, grieving captive—along with Neptune's tridents and the sea monster, are revealed to the observing composer under the rays of a hieratic, blazing sun. A neo-Platonist moment of revelation is depicted: Mozart understands his

Idomeneo, Re di Creta, opera, above: costume studies; right: finished watercolor (and pencil) for show curtain

adversarial characters as interlinked, all seated on the same celestial cloud, components of a single grand harmonious design. This image is then dismantled as the opera progresses; the figures act out their disunity until the god of harmony, Mozart, unites them once again. On the way to final sublimation Sendak shows us id-fragments, *Walpurgisnacht* witches, cat-headed houris dancing in the sky. At the finale, the designer gives a Blake-inspired vision, in which a deified Mozart, bearing Newton's compass and an hourglass, the personification of humanist reason and grace, banishes a beast, Blake's stupendously monstrous flea, from the orderly heavens above him and down to the roiling infernal realms below.

Re di Creta, opera, finished watercolor (and pencil) for set drop; opposite above: storyboard; below: finished watercolor (and pencil) for stage prop

168

In 1990, after *Idomeneo*, Sendak returned to book illustration. He published *Jack and Guy*, which he'd been writing and illustrating during his work on *Idomeneo*, followed by *Pierre*, *Penthesilea*, *I Saw Esau*, *The Miami Giant*, and *Swine Lake*.

Together with Arthur Yorinks, on October 24, 1990 Sendak founded The Night Kitchen, a children's theater company for which he has written, produced, designed, and directed. *So, Sue Me*, a play written and directed by Arthur Yorinks, was produced at the Kennedy Center in Washington D. C. in September, 1993. *It's Alive*, again written and directed by Yorinks, followed in October 1994 at the Tribeca Performing Arts Center in New York City.

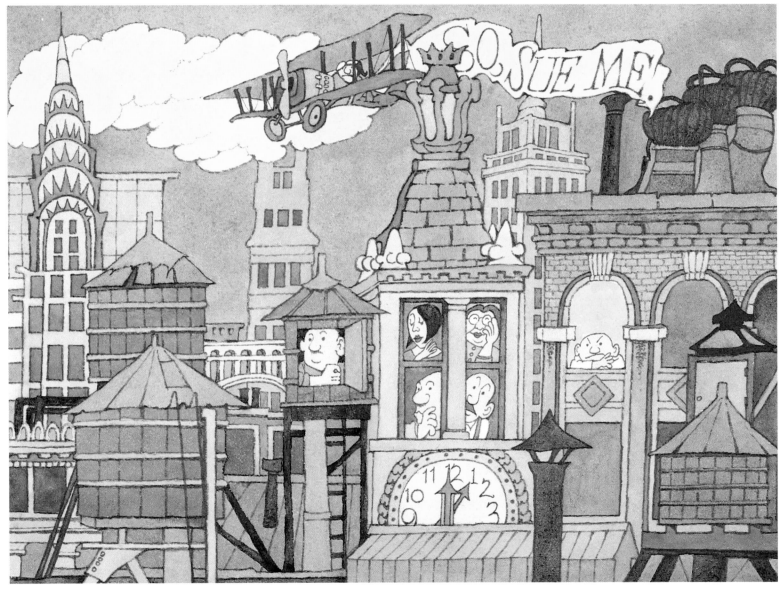

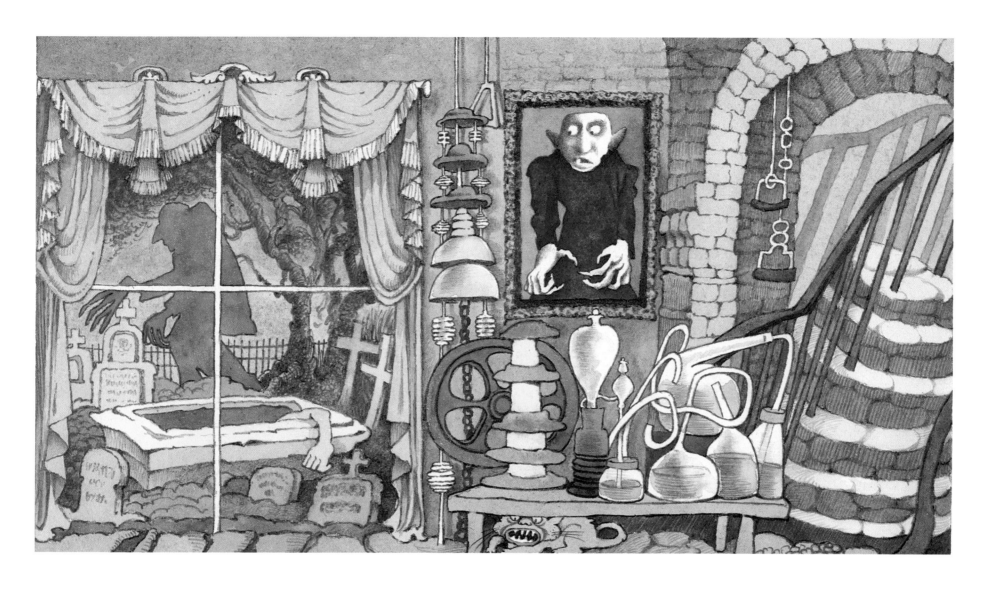

Top: *It's Alive*, play, finished watercolor for set drop; above: The Night Kitchen Theater card; right: *It's Alive*, play, costume studies; opposite top: *It's Alive*, play, costume study; opposite below: *So, Sue Me*, play, finished watercolor for set drop

On May 8, 1997, after years of practice practice practice, Sendak got to Carnegie Hall. In collaboration with the violinist Midori, the composer Pierre Jalbert, and the actor-writer-director Bob Jaffe, Sendak and Night Kitchen Theater presented a performance called *Were You There When the Sugar Beets Got Married?* Sendak wrote a short narrative text, Jalbert wrote music for violin and piano, actors were hired, a complex slide and performance interplay was planned—and time ran out. "There was no time to do original pictures for the tiny Midori project," Sendak says.

I re-used the ten watercolors I had painted some years previous for a

Were You There When the Sugar Beets Got Married?, performance, opposite: finished watercolors (projected on stage); below: finished watercolors (projected on stage)

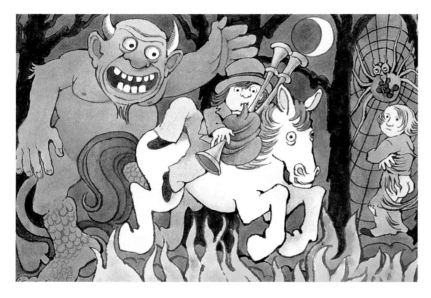

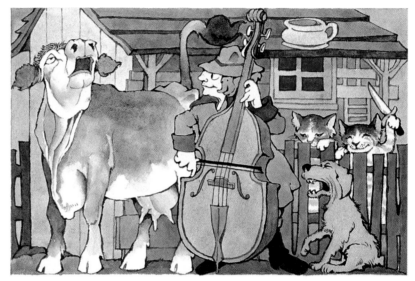

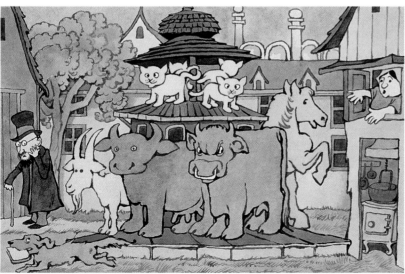

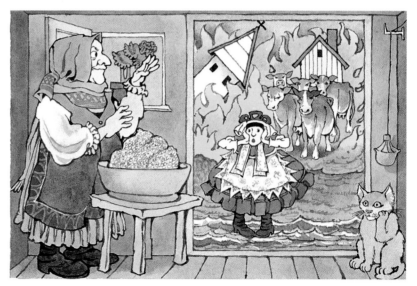

production at the Barbican Theatre in London. A concert performance of the opera of *Where the Wild Things Are* [in 1984] had been preceded by a collection of children's songs, by Janáček. I did watercolors and these were projected on to a screen. Michael Tilson Thomas conducted. These "Janáček pictures" were the basis of the little Midori script.

The *Mitteleuropa* pastoral magic Sendak called forth for Janáček's *Vixen* produced these comically quizzical, jolly illustrations. Given the drawings' considerable charms and Midori's

playing, everything worked out in the end—like a Ruby Keeler movie!

Corsaro and Sendak reunited after seven years to work on a production of Engelbert Humperdinck's *Hänsel und Gretel*, which opened on October 24, 1997, at the Houston Grand Opera. "*Hänsel* was intended to be our swan song," Sendak says, "Frank and I had decided that." It was subsequently filmed in New York at The Juilliard School and broadcast on PBS's "Live From Lincoln Center" on December 17, 1997.

Sendak was reluctant to do *Hänsel und Gretel*; like *Nutcracker,* it seemed too appropriate.

Who needs Sendak doing a kiddie opera? But I fell intensely in love with our *Hänsel und Gretel* production. It was the best organization of collaborators. All our work together came to a burnish on this piece. Both Frank and I fell in love with it.

The designs for *Hänsel und Gretel* are obviously a kind of valedictory, incorporating figures from some of Sendak's best work. The witch made her first appearance in *The Juniper Tree,* while the terrifying forest looks like the one in which that other Grimm child, Mili, gets lost. There are hooded goblins from *Outside,* and aerodynamic, Michelangelean angels from Sendak-via-Blake.

Hänsel und Gretel, opera, poster

The story is for kids, but it's not precisely fair to call it a "kiddie opera." The librettist, Adelheid Wette, Humperdinck's sister, had softened the tale, but not all that much; it's still an impressively Grimm bit of business, with desperate poverty and parental cruelty, drunkenness, incompetence, and indifference among its more memorable features. There's also the threat of cannibalism and a little *auto-da-fe*, after which dead children are resurrected from their gingerbread limbo. And the music lofts everything up to truly Wagnerian heights; what was intended to be a little *Märchenspiel* becomes simultaneously a miracle play and a gentle

Hänsel und Gretel,
opera, storyboard

176

threnody for children sacrificed to the harshness of life. How could Sendak *not* do this opera?

Together with Corsaro, all the stops were pulled, every register sounded: fairytale playfulness, fear, genuine malevolence. There's great theatrical hokum, which reaches its apogee in the witch's animate house. And there's much occasion for naturalist rapture, for Blakean/Wagnerian mysticism.

On the occasion of the opera's television broadcast, Sendak gave an on-camera interview to producer John Goberman. Since it offers perfect commentary on his designs for the opera, as well as other insights into his process and his mind, I've chosen to reprint it in its entirety.

MAURICE SENDAK: I'm basically an illustrator, but I've been working in the theater since 1979, so I've had to learn how to think ahead in three dimensional terms. I have apprenticed myself over the years, so by now I know how to leave a door open so a soprano can enter and get off stage again. I've had to learn.

QUESTION: Is there anything in particular that you think is an extraordinary construct in this set?

MS: What surprises me is you are reliving your *mishigass*—how do you translate

that?—your phantasmagoria—as you're drawing, you say, "Oh my goodness, a fish house" or, "Oh, my goodness, a mushroom house." You wonder, "Well, it's the witch's landscape, she would have strange architecture." But then we actually see that people have gone to the trouble to construct these things and put your *mishigass* on stage. It's weird, but I've experienced this on every production I've done, because every bit of it is always a bit of private business coming out of my imagination. And you're drawing it, first rough sketches, and then onto watercolor paper, and after that, craftsmen are making a three-dimensional fish! Strange, strange to see it. And all you hope is that it's going to mean something, that when it's all on stage, and when the production is going, when that scene comes on, you're going to get the audience reaction that you want.

The kids have been hungry from act one. In act two, they are very hungry. At the end of the act they are pathetically starving. So when they see the witch's house, they are hallucinating food. Stylistically, everything changes from the dense "Grimmsy" wood color, forest color—to come to a fantastical, almost psychedelic place—an enticing, dangerous place to eat. Then the fish and

Hänsel und Gretel,
opera, costume studies

177

Hänsel und Gretel, opera, costume and prop studies; opposite: pencil studies for set drops

everything become succulent stuff. It made sense to me. I got hungry as I was doing the piece. I must have gained 10 pounds. I was eating for those two kids.

Q: Why is there always a fish around?

MS: "Sendak" means "fish," in the language of the vanished, old world my parents came from, so I've used it emblematically, especially to give my father pleasure [remember, please, the fish in *In Grandpa's House*]. When he saw my books, he would look for the fish. It was always a little present to him. Something's always fishy in every production.

Q: What do you do about the music? Is what you've done reflecting the music?

MS: You know that I am a passionate music lover. To me, the best of all art forms is music and perhaps opera is my favorite, and the best best best of all that is Mozart. There is some kind of strange connection that occurs between me and music; I don't understand it, but when I'm drawing—say, pictures just for myself—I will play musical selections. I was just working on a book, and I played only Schubert piano sonatas with per-

formances by Richter and Schnabel, not because I planned it or I had a program in mind, but somehow the sounds of late Schubert had something to do with what I was doing on the paper. Nothing else would suit, not even Mozart. It sounds artsy, but it's really a kind of unconscious determination that I make about what music I'll listen to while painting. When I'm listening to *Hänsel und Gretel*, there is a color in the music, there is a quality in the music that I have to find the right line for, the right color for. You're inventing a solution. You're inventing Humperdinck color with a little Wagner mixed in. And you just go by your instincts.

Q: Did you play the opera while you were working on the drawings?

MS: *Hänsel und Gretel* is an old favorite. I listened to the opera a good deal with Frank Corsaro, timing out, working out sequences and solving dramatic problems. When I'm actually painting it, I do not listen to the opera, because at that point the music becomes a kind of peculiar obstruction to the graphic rendering of what I'm doing. At that point I'm listening to other music— don't ask me why. Lots of Haydn trios.

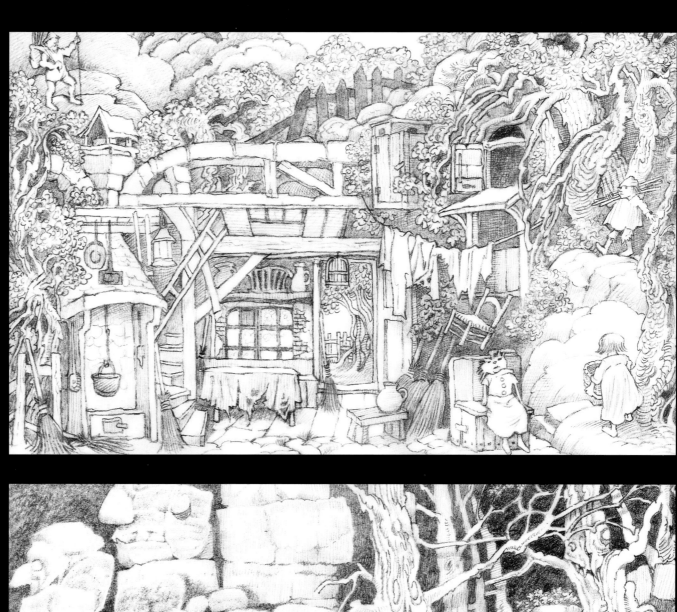

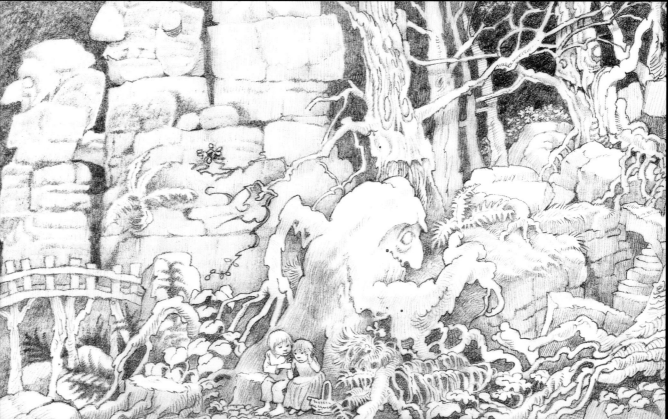

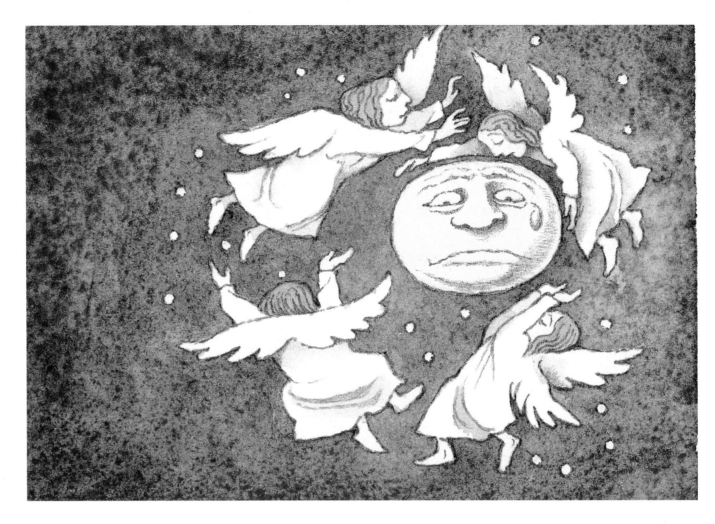

Hänsel und Gretel, opera,
below: costume study; right:
finished watercolor for set drop;
opposite: finished watercolors
(and pencil) for set drops

Contrasting color, contrasting mood. I adore Haydn, and he led me into and out of the opera, pace Humperdinck. I know this makes no sense, but when you get right down to the painting of it, you don't want to hear the opera.

Q: When you look at the end result of having listened to Haydn while you're designing for Humperdinck, can you describe what the sense is?

MS: When I look at all this, I see Humperdinck. I don't see Haydn. Haydn was the ignition key to get to Humperdinck.

Q: What would be the relationship between all of this, the performers on stage in Europe, and your concept?

MS: I'm not sure I'm answering this directly, but *Hansel and Gretel* is the most profound of all Grimm fairy tales. Generally speaking, most of Grimm is about heroic children. Hansel and Gretel

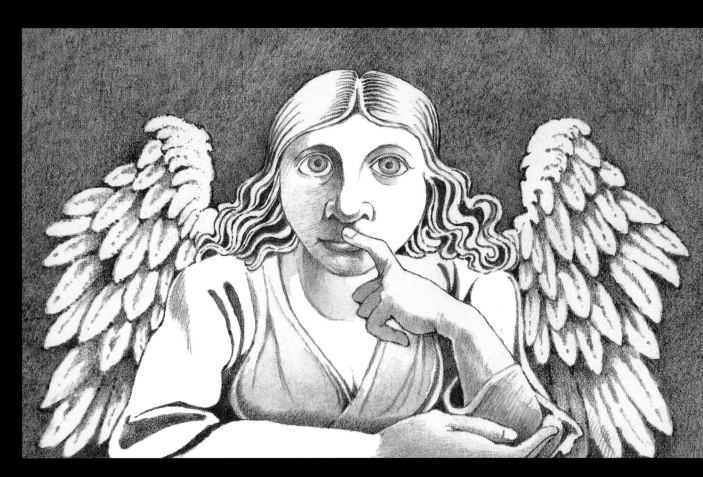

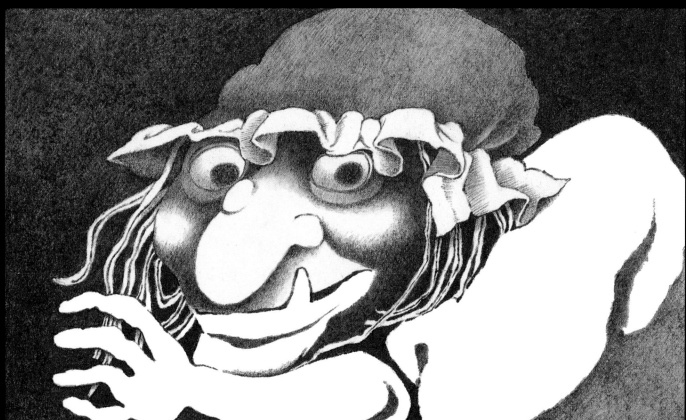

are the most heroic of them all. These are two children in the most harrowing situation—much more harrowing in the fairy tale than in the opera. Fraulein Humperdinck, Engelbert's sister, wrote the libretto for this entertainment. It was originally an entertainment. She took most of the dark parts out of the tale and quite softened it. The story is maybe four pages long in the actual telling and it's like a fist right in the face. It's the toughest story in the world and people are afraid of it, yet it's famous because it's so truthful. This opera is really about Gretel because she is the strong one. She is the cool-headed one. She figures out how to save herself and her brother. The subject of all my work from the beginning, my

books and everything I've done is—to put it simply—the extraordinary heroism of children in the face of having to live in a mostly indifferent adult world. Generally speaking, people don't understand what's going on in the heads of small people. I side with the kids all the time.

Hänsel und Gretel was Sendak's seventeenth stage production in as many years, and the work took its toll. "I experienced great fatigue after *Hänsel und Gretel*," he told me.

Everything in opera now is done in co-productions, and these are always exhausting, but we had to include other opera companies, had to get other producers, otherwise we couldn't afford

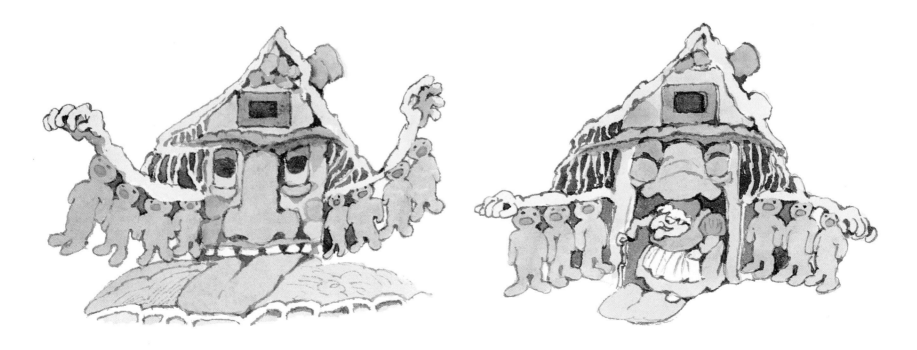

to do it. Houston couldn't do it alone— and that was the kiss of death for me, not being able to work for one opera company. It seemed as good a time as any to get out.

Sendak is currently working on another opera double bill, Hans Krása's *Brundibár* and Bohuslav Martinů's *Comedy on the Bridge*. But with *Hänsel und Gretel*, he feels that a chapter in his life came to an end. Continuing our conversation about why he wanted to stop designing opera, at least for a time, he explained,

Opera is as fragile as a butterfly's wing. Maybe that's why I was attracted to it. It wasn't a book. It's ephemera; how many people see opera? It was just for me and Mozart and Janáček. I had my musical life. I had a good time, I have no regrets, I took 15 years out of my publishing life and I have no regrets.

The Humperdinck opera was, as of this writing, Sendak's last project with Corsaro, just as they'd planned. Though they might work together again, it makes sense to see *Hänsel und Gretel* as the conclusion of a remarkable, sustained achievement. Sendak, in his *Nutcracker* introduction, called Corsaro an "ingenious stage director, my collaborator and teacher." As for Corsaro, he wrote in his *Oranges* book, "Let me state categorically that I would never have attempted mounting these mastodons without him. For besides Maurice, who is there?"

Hänsel und Gretel, opera, below and opposite: watercolor studies for set design; overleaf: finished watercolor for set design

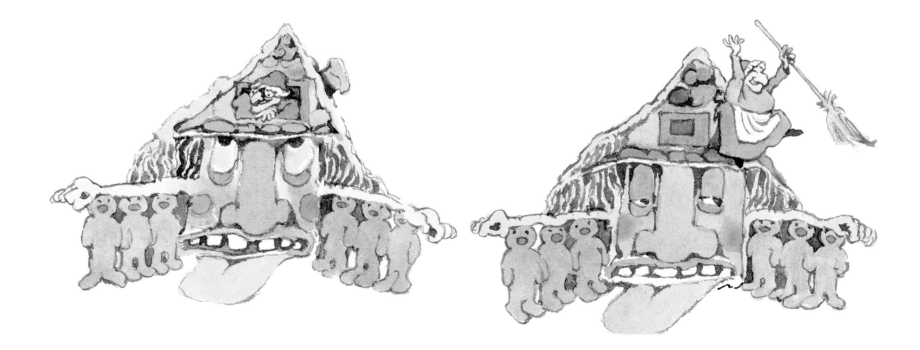

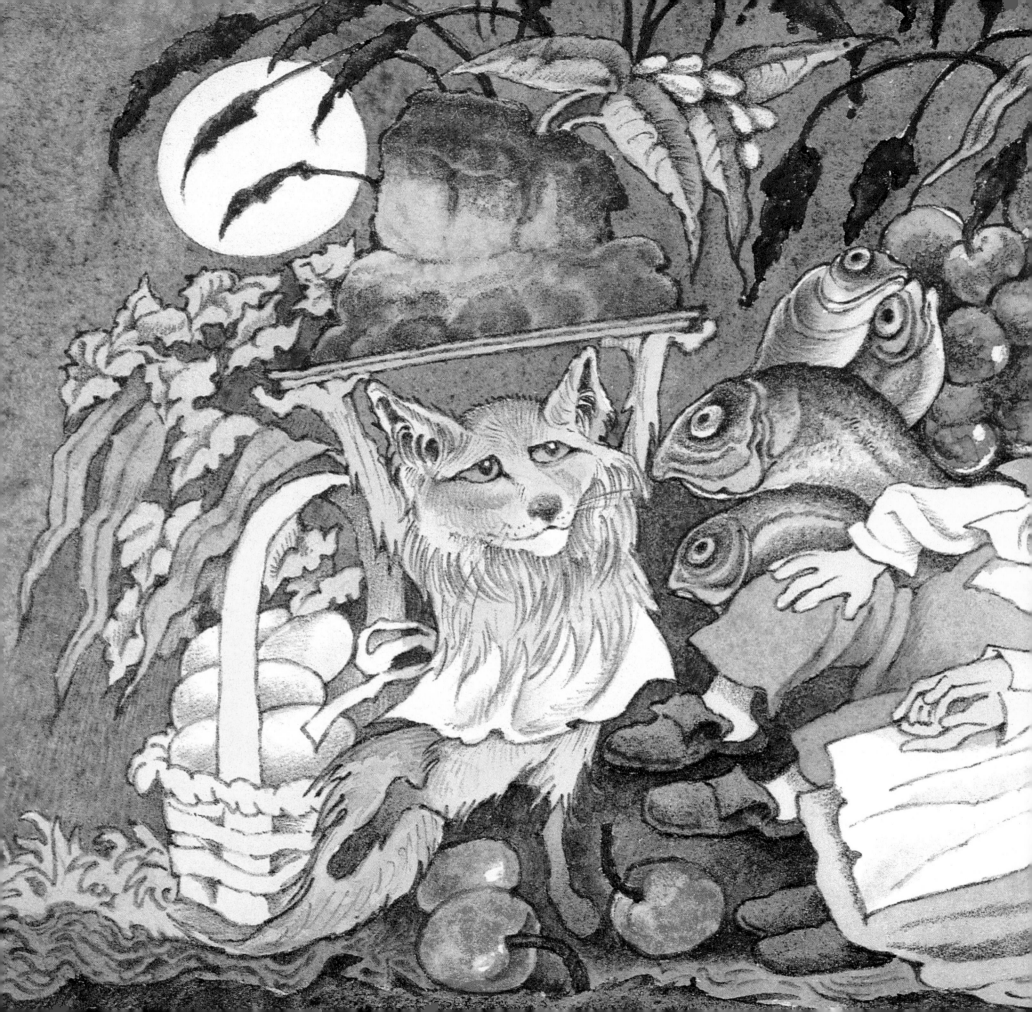

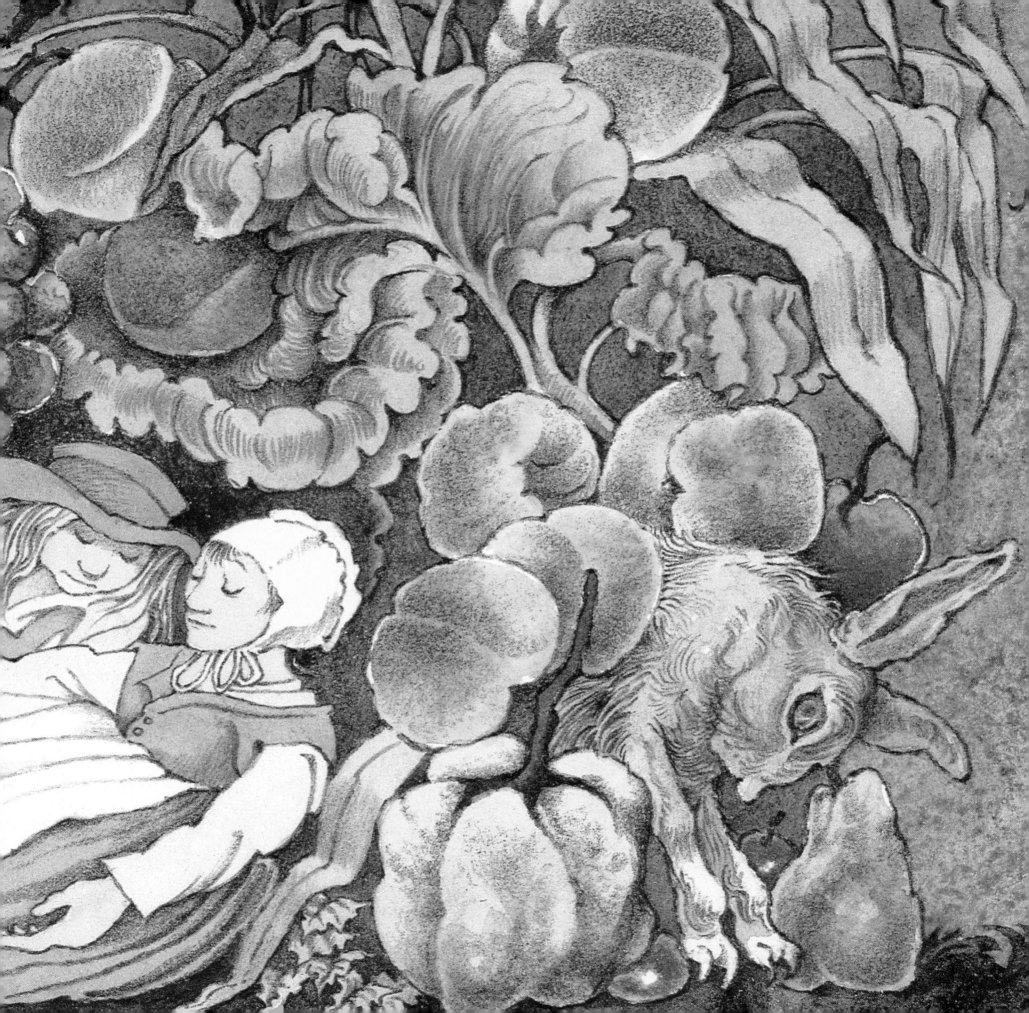

Book illustration and opera design define this second phase of Sendak's long career. But there have been other, extracurricular activities. The wide world beckons, and sometimes Sendak responds.

June 16, 1999, was the opening day of a *Wild Things* fun house that Sendak created on a floor of the Sony Corporation's Metreon building in San Francisco. The immense playroom is reverberant with disembodied voices hurling taunts, jibes and smart-aleck remarks, and crammed with palm trees, jungle vines, toadstool whoopee cushions, a witch's cauldron, a trick telescope (when you look into it you see your own butt), mazes and scrambles and colossal wild-thing puppets. Every corner of the space is controlled by its peripatetic kid customers, with no instructions or directions provided, no warning signs posted. It's a great inviting puzzle of a place eliciting misbehavior, every kid encouraged to release his or her inner Max. Some law of spiritual thermodynamics dictates that so much freedom unleashed in one arena must necessitate its concomitant quotient of rigor elsewhere. Sendak's desire to control every aspect of the design of the *Wild Things* Sony project, the unyielding meticulousness which has made him the (mostly beloved) terror of production staffs in publishing houses and theaters alike, his insistence on stocking the gift shop at the *Wild Things*

A Selection,
dance performance,
costume studies

ride with only handmade merchandise, with toys of real craft and ingenuity, inevitably put him at loggerheads with the Sony Corporation.

Sendak has played protracted footsie with Hollywood. Studios, screenwriters and stars have hungrily circled *Where the Wild Things Are*. The rights for the book have passed from one company to another, but Sendak's contract gives him final approval of the adaptation, and the author has yet to approve a script. He is determined to spare his monsters the cynical "updating," the death-in-marshmallow-goo big screen traducing suffered by *Charlie and the Chocolate Factory, Stuart Little, The Borrowers,* or *How The Grinch Stole Christmas*. The film and television projects with which Sendak has been involved, usually as a designer or acting in an advisory capacity, are few: a graceful and charming animated video series based on *Little Bear*; the *Rosie* special; and broadcast recordings of *Magic Flute, The Love For Three Oranges, The Cunning Little Vixen*, the two Ravel operas, the two Knussen operas and *Hansel and Gretel*. The "American Masters" series on PBS aired a short documentary about Sendak, focusing on Mozart's influence on his work, entitled *Maurice Sendak: Mon Cher Papa*. *The Last Dance*, a documentary by Mirra Bank, is an illuminating chronicle of Sendak's bumpy *Selections* collaboration with the Pilobolus dance troupe.

Carroll Ballard provided Sendak with his

best experience working in film, when Ballard directed an adaptation of *Nutcracker* in 1986.

Carroll fell in love with the project. We filmed in Seattle; we had no money to produce, and it's a very uncommercial film. But this was one of the best of my collaborations. I was working with a master who let me learn on the set; Carroll was teaching me. He had such an extraordinary eye. His way of shooting dancing was considered off the wall. He didn't shoot the whole figure all the time, he had a special camera so that you followed the dancer—he wanted to do anything but a dance movie. The film was fantastic. It got terrible reviews. Totally unconventional. Carroll used my sets in a wonderful way. In other films the sets are just there, they're not used. Carroll really worked the sets into the film, they were integral to it. He's a real artist. Period. I feel such a very personal affection and respect for him. We have remained friends forever. It's shown every Christmas, with Tony Randall introducing it. It's a work of art, faulty but extremely important.

Sendak adores film, as has been evident in his illustrations since the beginning of his career. He's an avid movie watcher and, when the mood strikes him, a talented imitator of stars in big scenes, specializing in tragediennes of an earlier era. His most accomplished impersonation is Luise Rainer waiting for William Powell in *The Great Ziegfeld*: "Flo, Flo, why don't you call me, Flo?" A movie sometimes plays in the background on his studio VCR when he's drawing late at night. Sendak himself is briefly visible in a crowd scene in Fellini's *Amarcord*; and he appears in the HBO television film of *Angels in America*, playing a rabbi in a scene with Meryl Streep.

Despite the mutual attraction between Sendak and the film industry, which is after all run by people who grew up on Sendak books, his work has proved so far resistant to mass-media and corporate expectation.

Naturally he's spent time receiving homages: honorary doctorates, speaking invitations, and a National Medal of Arts in 1996 from Bill Clinton. At the reception following the medaling ceremony, President Clinton wistfully asked him, "Maurice, what becomes of the dreams of childhood?" Apparently the president as a boy had dreamt of growing up to become a doorman in a fancy apartment building, wearing a uniform with epaulets and a hat. Sendak, in a panic to respond with appropriate grace to this confession, tried to make a joke: "Don't worry, Mr. President, your second term is almost up, and after you leave the White House I'm sure you can get a job as a doorman." For which witticism

Sendak, lifelong Democrat and Clinton supporter, is still biting his tongue.

The world and Maurice Sendak: it's a jagged fit. He's most at ease, to the extent he's ever at ease, in realms of literature, painting, music. He's an artist, and his true home is the work of making art. He labors with a concentrated industry, responsible for the vast amount he's produced and for its invariably high quality.

He has produced numerous drawings for the jackets of other people's books. Among these are the two loving portraits of Melville, as a young man and in oppressive late middle age, that Sendak provided for Hershel Parker's giant two-volume biography. Sendak promised the portraits at the Melville conference at which he met Parker, in May 1991, five years before the first volume and eleven years before the second were ready for publication; when the books were ready, Sendak delivered. "A man of his word," says Parker. Other book jackets include a Fuseli homage for the cover of *Sleep Demons*, Bill Hayes's brilliant contemplation of the meaning of insomnia (something

Herman Melville: A Biography, Volume 1, 1819-1851, book cover illustration; far right: *Herman Melville: A Biography, Volume 2, 1851-1891,* book cover illustration

Sendak knows something about); an exquisite black-and-white drawing for Reynolds Price's *A Perfect Friend;* a ravishing portrait of his first editor and dear friend, Ursula Nordstrom, for the collection of her letters entitled *Dear Genius;* and a haunting painting of two Chassid lovers for my version of S. Y. Ansky's Yiddish play, *A Dybbuk.*

He is illustrating a new picture book for children, *Brundibar.* The text, based on the libretto of the opera he's designing, was written by me.

VI.

Sendak and I have been good friends for a decade. I can't keep up this "Sendak" business. I know people who call their close friends by their last names but I never have—it sounds so bluff and buff—so I hope it's OK if I switch to "Maurice" for the rest of this essay, which he has taken to calling "the *kol mincha siddur,* the *ganze megillah*" (Yiddish again, "the whole story.")

A Hole Is to Dig, What Do You Say, Dear?, and *Nutshell Library,* among Maurice's early books, were a central part of my first experience of literature, as they were for many Americans of my generation. Sendak books are still central to American children, though not necessarily the same Sendak books. I grew too old for picture books—or at least I believed I had to pretend I had—a year or two before *Where the*

Wild Things Are was published. In truth I never managed to move far from picture books. In my early adolescence I was an avid consumer of superhero comics. I haven't changed much; I'm still drawn to any attempt to combine word and image, a lifelong addict of the daily funnies, a medieval-studies major in college because I'd seen and couldn't get over *The Lindisfarne Gospels* and *Les Très Riches Heures du Jean Duc de Berry.* It was probably this affinity for the verbal and the visual combined that led to my choice of theater, specifically playwriting, as a career. Over and over again it has led me to Sendak, for no one has combined word and image to better, more delightful effect.

Before we became friends, I'd encountered Maurice, briefly, in 1979. I was working at B. Dalton's Books on Fifth Avenue, my first crummy job after graduation from college. Maurice came to sign copies of his books. Even though I could get an employee's tiny discount, with my tiny tiny paycheck it was hard to scrounge up the money to buy a copy of the slipcased two volumes of *The Juniper Tree,* expensive at twenty-five dollars, but scrounge it I did, and the nerve as well to ask Maurice to sign it. He signed and drew a little cat; he smiled in a friendly fashion, and that was that.

He was unfailingly polite to the long line of people who'd come to the signing. Maurice is rather courtly in his dealings with other people, except when provoked, and even then he merely

bares his teeth and growls, behavior he may have learned from generations of canine companions. His desire for solitude notwithstanding, he is not a hermit. He is in fact gregarious, observant, and curious about people, as I think most artists are inclined to be. The affectionate and sociable impulse in Maurice, however, is countermanded by a self-protective privacy, an inward gazing which has as one of its sources a childhood of illness in an atmosphere of pressurized familial closeness. Immigrants' child, Brooklyn child: such children were loved while at the same time inculcated with ghetto-bred tribal fearfulness and insecurity. Maurice is a child of the Great Depression and of Jewish Depression, if I may generalize. Jewish Depression is that inherited awareness of the arduousness of knowing God, the arduousness of knowing *anything*, an acute awareness of the struggle *to know*, the struggle against not knowing; and it is that enduring sense of displacement, yearning for and not securely possessing a home. It is the conviction, passed through hundreds of generations, that true home is elsewhere, promised but not attained, perhaps not even attainable. Maurice's is a *Yiddische kopf,* a large, brooding, circumspect, and contemplative mind, darkened by both fatalism and faith.

Last winter I learned he never uses his fireplace. I told him, "I use mine every chance I get!" He replied, "You, you're an *emancipated* Jew, you don't know fire will kill you! *I* will *never* unlearn that!"

Being a self, alone, committed to one-ness, whether through predilection or through a conviction of the necessity of the condition of aloneness, is a part of what Harold Bloom has termed Jewish interiority. God is to be found in the world but pursued finally, decisively, only in one's heart, in one's mind, in one's *neshoma*, one's soul. "If we want to be holy," writes Gershom Scholem, the great scholar of Jewish mysticism, in a letter to a friend, "we must bind ourselves together in isolation. Any community that does not arise out of isolation is a fraud." If this is a truth of all religious vocation, it is also true for Maurice's chosen profession. Children's literature may reflect the pleasant booming confusion of the world in a thousand ways; it may describe earthly pleasures; it may be the most profoundly materialist (in the philosophical sense) and the most thoroughly sensual literature. But it is the product of a solitary, and a lonely, pursuit. For the great adult creators of children's books, the work at hand is a reclamation, through the difficult exploration of feelings most people have forgotten, of the past. The search for lost time is as inescapable a task for the children's author and illustrator as it was for Proust; and as it is for any labor of quiet, scrupulous intensity, interiority is an essential faculty and isolation a necessary capacity.

Opposite: New York Is Book Country, poster (1979)

NEW YORK IS BOOK COUNTRY

September 16, 1979

Illustration by MAURICE SENDAK · All net proceeds benefit Children's Services, New York Public Library · Design by Barbara G. Hennessy · Production by Eileen G. Schwartz · Printing and production courtesy of Viking Penguin, Inc.

Distribution courtesy of Harper & Row, Publishers, Inc. · Copyright © 1979 Maurice Sendak

Maurice is not an observant Jew, but he is deeply Jewish. Like most Jews, he is shadowed always by the Holocaust. Relatives of his who didn't make it to America died in the camps. In much of his work, obeisance is made to these ghosts. Memory is enlisted in the name of putting their unhappy souls at peace, in the name of placating the unquiet dead. But Sendak is also *echt* an American Jew. As has been immemorially true of Jews, but especially in countries where Jews have not been subject to oppression and mass murder, American Jews have been hungry and brilliant absorbers, assimilators, students of culture, both American and cosmopolitan. Frequently, in the act of absorbing, Jews are only returning to truths that originated in Jewish minds and were appropriated by dominant cultures. They are always, always transforming what is absorbed. Maurice is representative of his generation in this regard, the autodidact Jewish kid in the public library. He didn't attend college; hungry to succeed, he began his career as an artist immediately after high school. In spite of this, he's encyclopedically conversant with antecedents in poetry, fiction, painting, and music. His parents, remember, met over a book—the Sholom Aleichem Sarah was reading aloud at that long-ago wedding. An ambition towards erudition, towards cultural fluency and sophistication, was bred in the bones of these mid-twentieth-century Jewish American kids.

Even if their parents didn't possess erudition or sophistication themselves, lacking the language and the leisure, the ambition was theirs and subsequently—they made certain of it—it was their children's inheritance.

Maurice didn't need college and doesn't particularly care for formal education, but he's eternally a student. His greatest hunger is to learn, and knowledge intoxicates him, it's an aphrodisiac. It seems likely to me that Maurice's partner of many years, Dr. Eugene Glynn, a psychoanalyst, a man of vast learning as well as fierce opinions, has helped guide him in his study. Maurice has over the years befriended writers, artists, and dancers, including Randall Jarrell, Grace Paley, Coleman Dowell, Philip Roth, Twyla Tharp, Jules Feiffer, and Marianne Moore, who, according to Michael di Capua, said she wished she'd written *Chicken Soup with Rice* (so, apparently, did Randall Jarrell). He is instantly alert at the mention of a new book, a new idea. He is, after all, the grandson of a rabbi.

There's a story about that grandfather, Reb Moishe Schindler. You can hear Maurice tell it while he paints the crotch and backside of a dancer's leotard in *The Last Dance*. It's a story I was told on my first visit to his house in Connecticut.

When he was two years old, Maurice was stricken with a fever, and he nearly died. At the height of the fever, his mother came into his room to find her two-year-old son standing up,

reaching towards the photographic portrait of his maternal grandfather hanging over the crib. Maurice was speaking fluent, fervent Yiddish— a language the Sendak parents had refused to teach their children. He was, Mrs. Sendak decided, trying to join his grandfather in the picture (talk about a portent of things to come!). A neighbor lady in the Sendaks' Brooklyn apartment building, having been apprised of the situation, advised Sarah Sendak that her father's *dybbuk* (the soul of a dead person), through his photograph, was trying to lure his grandson into the *yenne welt*, the spirit world. The dangerous picture had to be destroyed. Ever since the Second Commandment, Jews have had a problematic relationship with graven images. Mrs. Sendak tore up the portrait of her father. Maurice recovered. Thirty-eight years later, after her death, Maurice and his sister Natalie were cleaning out their mother's closet and made a discovery. Mrs. Sendak had saved the fragments of the picture of her father, stuffed in the remotest corner, wrapped in a big piece of tissue paper. "Every scrap of it!" he remembers. "She couldn't *bear* to throw it away. And she kept it all that time." Maurice had the picture reassembled by a specialist from the Metropolitan Museum. Reb Schindler's portrait has been restored, reframed, and is hanging again over his grandson's bed. "He's waiting for me," Maurice says.

Maurice's love of people is great and wide, as is his interest in their doings—heroic, monstrous, and everything in between. His need for their company is more circumscribed. He will invoke one of his favorite poets, Emily Dickinson, tutelary divinity of reclusiveness. "What I learned from her," he told me, "is 'Don't open the door, don't let them in!'" Then he enacts an imagined domestic drama from the Dickinson home in Amherst, doing all the characters: "'Emily, Emily, you promised you'd come for a snow ride with us! What are you doing sulking upstairs?' 'Don't listen don't care don't let them in!' And she stayed upstairs. She didn't listen to them. She kept the world OUT," he concludes, full of admiration.

Yet sociable Mozart and Keats are heroes as well. Sendak in hiding attracts an ever-expanding army of friends. I'm forever meeting people who know him, who have visited him, who have worked or corresponded with him. Time spent with Maurice is invariably recalled in tones of gratitude and bemused wonderment. Complex, contradictory, mercurial, wickedly funny, exasperating, erudite, generous, entirely unique, and the source of so much glorious art, Maurice inspires devotion.

The object of such devotion is frequently a source of concern among the devoted. Maurice's is a bumpy life, with a lion's share of physical difficulty. His tough, sturdy-seeming body, beset since his early coronary—since

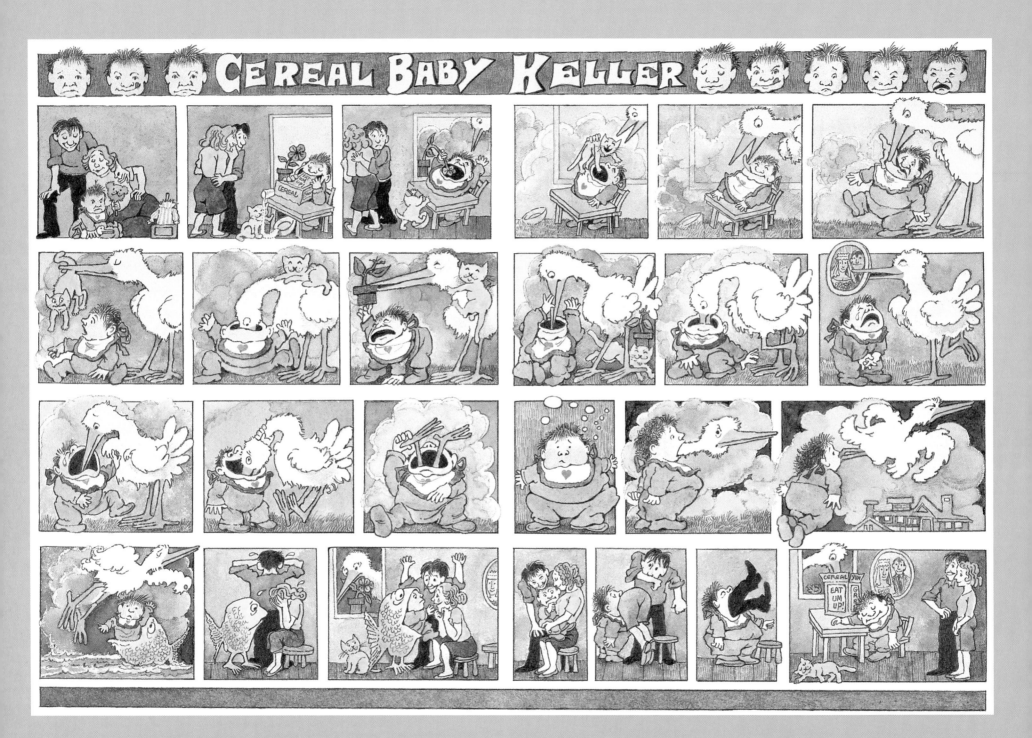

Strange Stories for Strange Kids (Little Lit, Book 2), "Cereal Baby Keller" comic strip;
opposite: clockwise, from top left: *A Dybbuk and Other Tales of the Supernatural,* book cover illustration; "Dracula: A Centennial Exhibition" booklet; *The New York Times* Op-Ed page, pencil drawing

BRAM STOKER'S
DRACULA

A Centennial Exhibition

APRIL 13 *through* NOVEMBER 2, 1997

The
ROSENBACH
MUSEUM & LIBRARY

2010 DeLancey Place . Philadelphia . 215.732.1600

Please note that the museum will be closed from August 1 through September 8.

Bram Stoker's Dracula: A Centennial Exhibition is supported, in part, by grants from the National Endowment for the Humanities; the Institute of Museum and Library Services – a federal agency; the Pennsylvania Historical and Museum Commission; the Pennsylvania Council on the Arts; the Philadelphia Cultural Fund; by a special gift from Andrea M. Baldeck, M.D. and William M. Hollis, Jr.; by the Young Friends of the Rosenbach; and by the Rosenbach trustees and members.

Special thanks to W.W. Norton & Company

early childhood, perhaps—has rarely had a moment's peace, and at times threatens to fall to pieces; he marshals himself back to health and to the drawing board by dint of will and with the help of medication. Septuagenarians confront, day in and day out, the loss of loved ones. This is hard, especially for a man of more than ordinary loyalty and ferocious affection. In the ferocity of his affection you come to understand Maurice's affinity for children; in his loyalty you come to understand his spiritual kinship with dogs. Such fierce feeling exacts a price; it isn't sustainable. Usually, it forces kids to grow up, growing prophylactic neuroses (also known as personalities) in the process. For dogs, lacking humankind's genius for denial, the price is higher even than growing up. In Yevgeny Yevtushenko's novel *Wild Berries*, a Siberian peasant, thinking about his dog's way of grieving terribly each morning when the peasant leaves, and then leaping about in uncontrollable joy each evening when he returns, says to himself "It's no wonder dogs don't live long, they feel too much to have a long life, it wears them out."

And so we worry about Maurice, who feels ferociously and for whom self-protective denial seems largely unmanageable.

Maurice faces his vicissitudes, setbacks, and losses with an angry, fatalistic courage. I sometimes think of him as the unbowed survivor of many a battle, akin to the eponymous Seafarer

in the earliest extant English-language poem— except that Maurice isn't Anglo-Saxon, of course, but a Jew—whose ancestors, after all, probably hailed from some cold *shtetl* on the desolate steppes, from some place as demanding of indomitability as the icebound incubatories that produced those dauntless emigrant warriors whose excursions and invasions produced our mongrel mother tongue.

Maurice is a champion lamenter, which is different from saying he's a *kvetch*. Kvetching is annoying. Lamentation is a kind of poetic indictment; it is a sorrow and a joy to hear. Maurice's lamentation has a recognizable Jewish cadence, spiced with Anglo-Saxon invective. When his wrath (there's no other word for it) is aroused, his vituperation is alliterative and bloody and guttural and as scorching as dragon's breath. It's quite shocking when you first hear America's greatest author of children's books raging like a mad Danish sailor, raging like Nixon, or rather like Nixon would have raged if, instead of that Whittier Booster's Club beer-sodden griping and grumbling, Nixon had possessed Maurice's musicality and well-fed poet's ear.

The shock is intended. Shock, after all, is a way to collect devotees. If you want someone to be your friend for life, you must at some point shock them. How else to fascinate other than by being unpredictable, how else to raze dividing walls other than by blowing a barbarous

yawp or two on your brass or goat-horn trumpet? Shock catalyzes chemical bonding; it forms adherent agents; and this is equally true for chemical compounds, for friends, for readers and fans. Othello hooked Desdemona's attention by telling her soldiers' stories of carnage, travelogues featuring people whose heads are in their bellies. "My story being done," he tells the Duke of Venice,

> She gave me for my pains a world of
> kisses.
> She swore in faith 'twas strange, 'twas
> strange, 'twas passing strange;
> 'Twas pitiful, 'twas wondrous pitiful.
> She wished she had not heard it; yet. . .
> She thanked me
> . . .
> This is the only witchcraft I have used.

An artist should not be a sensationalist, but an artist must shock, or else face indifference. To paraphrase Pier Paolo Pasolini, it's a sensual pleasure and a moral imperative both to shock and to be shocked. Maurice Sendak has always understood this.

He delves in a field in which shock, scandal, even the censor's wrath, was, if anything, too easily come by, children's literature (at least until very recently) being in this regard rather like Hawthorne's New England or some small town in the '50s or like a Stalin-era Eastern European country. The best children's authors and illustrators have always shocked; the temptation is irresistible when the interdiction is so formidable and unreasonable. And good children's authors, like any good authors, must know their audiences. Children like being shocked. To the dark Gothic forest breezes blowing icily through the Brothers Grimm can be attributed, perhaps more than to any other quality, their tales' immortal appeal. Consider Hans Christian Andersen's lavishly suffering children, his predilection for tortured feet— those little girls treading on loaves and knife blades. Think of Lewis Carroll, of Tenniel's rat-fanged Jabberwock; think of the heartbreak and emotional overload you attempted to incorporate over E. B. White's poor dead Charlotte, or Bambi's murdered mother.

Nowadays children's authors often resort to vulgar, unimaginative means for providing the joy of transgression. Offering an abundance of ordure, symphonies of bodily eructation, reading for all the world as if children had written them, sowing in consequence nothing more than seeds of regressive incapacity, of slacker-slobbism, the books these panderers write and illustrate are mere preparatory manuals for future citizenship in the Global Kakatopian Empire. The best children's literature expresses the hope (melancholy though it be) that children won't stay children forever.

Maurice, among the best of the best, shocks

deeply, touching on the mortal, the insupportably sad or unjust, even on the carnal, on the primal rather than the merely primitive. He pitches children, even aged children, out of the familiar and into mystery, and then into understanding, wisdom even. He pitches children through fantasy into human adulthood, that rare, hard-won and, let's face it, tragic condition.

There used to be a handsome reporter on one of the New York television newscasts who always looked badly startled, no matter what he was talking about, his face an attractive rictus of blanched alarm. A friend of mine, a psychoanalytic grad student, watching this guy, remarked "He looks like he's never recovered from his primal scene." I decided at that instant to read any expression of perpetual surprise as evidence of unmended early developmental trauma. I suspect it in Maurice. Don't get me wrong—he has a beautiful face, with wide, pale, almond-shaped eyes. After a lifetime of looking, he wears glasses with thick lenses—maybe they've always been thick, but I choose to think of the thickness as recent, his spectacles a badge of suffering for his art. These magnify his eyes, in which some wondering wildness resides, tough and also furtive. They're startled and startling, his eyes, like saltwater deep-sea pressure-resistant fish, at swim behind dense aquarium glass. They are capped by eyebrows which are more often than not semicircles of astonishment. These lower only when he's faced with a lovely

person or a lovely painting, when listening to great music, when moved by some act of kindness, when feeling sympathy or grief, when he's disarmed. Otherwise they arch, seventy-five years of muscular contraction holding them effortlessly, exclamatorily high. Maurice's broad and bottomless familiarity with the world and its ways, its turbulent history, is, I think, in marked contrast to the expression on his face, which is often that of an innocent taken by surprise.

When he's angry at something, or at someone, when chicanery in the newspaper or a phone call with an adversary or false friend triggers the Norse warrior/shtetl-ghetto Jew in him, he has an impressively wrathful scowl, mostly an eyebrow affair. The inner edge of each eyebrow moves towards the other and dramatically down towards the bridge of his nose. The narrowing-in of eyebrows seems to concentrate his rage. This pushing-down in anger strenuously opposes the raised outer edges of the brows, which maintain astonishment, which salute Maurice's astonished heart—or so it pleases me to believe: a heart which anticipates, which rises to battle against, but which can never quite accept the actual existence of malice.

His sincere despair is forever at war with his fundamental inability to accept the fact that evil exists. Perhaps the primal scene he's perennially startled by isn't parental but moral, global, universal. Perhaps his original trauma is his witnessing the world, human life itself, so wicked

Opposite: "Sendak in Philadelphia" exhibit, poster (1995)

198

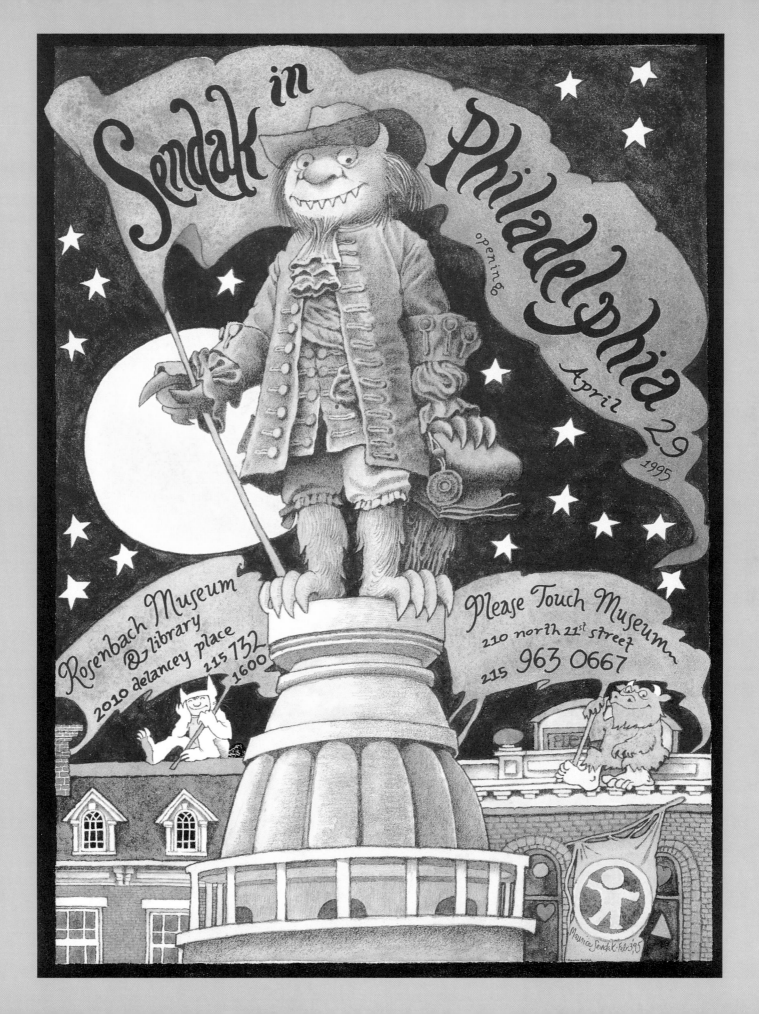

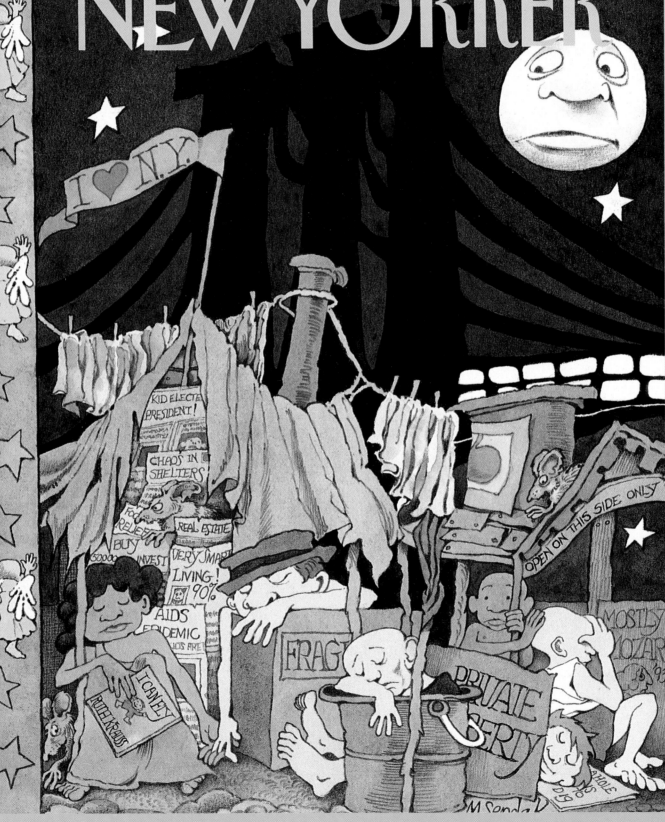

and so lovely, so irreconcilable in its extremes, so fixating it's impossible to leave, and so frightening, its clamor so battering, it's impossible not to *want* to leave, to want to stray, very, very far away.

While I was still an undergraduate, probably in 1975, I'd gone to an exhibition of illustrated books at the main branch of the New York Public Library. I purchased a 1972 Library of Congress pamphlet entitled *Questions to an Artist Who is Also an Author: A Conversation between Maurice Sendak and Virginia Haviland*. One moment in the exchange has always stayed with me, which according to my memory went something like this:

> Miss Haviland: One critic has asked why you changed from the "fine engraved style" of *Higglety Pigglety Pop!* back to what this person calls the "fat style" of your earlier work?
>
> Mr. Sendak: Umm, "fat style." Well . . .

He went on to say, as one would, that it's important for an artist to avoid fetishizing and fossilizing his or her "style," that different subject matter demands differing graphic approaches, "a fine style, a fat style, a fairly slim style, and an extremely stout style." But what sank in my soul was "Umm, 'fat style.'" Why?

One reason, I suppose, is that I heard in his remark that Maurice was receiving a blow and absorbing it. One would wish that a man of such accomplishment had a thicker skin, but in the past ten years or so I've met a number of eminent artists and not one of them, no matter how venerated, is genuinely indifferent to the value of their stock, if you will; none is immune to condescension passed off as pleasant raillery, nor even to clumsy or mean remarks made by patently hostile or just stupid strangers. Another artist of Maurice's generation, equally famous and a rather tough customer, told me that bad reviews had made him cry. Skinlessness comes with the territory; every artist is Marsyas, flayed.

"Um" is a swallowing sound. The speaker makes it when, aware or not, he or she has words to say, a response to make, which must not be spoken, which must be gulped down instead. "Umm," on the other hand, might start out as simple ingestion—the insult is being incorporated. But that rolling "mm" suggests other things: contemplation—the remark is being weighed; degustation—the insult is being savored. It might, as it slips from the ululatory to the guttural, be the beginning of a growl—"Ummmmm" watch it! *Cave canem.*

Whatever it means, I suspect the "umm" is the reason I have always remembered the exchange with Miss Haviland. I'm not the first person writing about Maurice to cite the phoneme he ummed that day in 1972. "Umm" is a Sendakian sound. He has always reckoned with the power of gabble, of the ur-syllables that make up words. At the time of the interview, *In The*

201

Night Kitchen had just been published (and was, in fact, the book that the unnamed critic had declared rendered in a "fat style"), with the "bump" and the "clump" that send Mickey off on his flight. *Higglety Pigglety Pop!* begins with nonsense words and ends with a play, the denouement of which reads as follows:

"Pop!"

"Stop!"

"Clop!"

"Chop!"

THE END

Samuel Beckett couldn't have put it more concisely.

Years before, in *A Hole Is to Dig*, Ruth Krauss gave a few good reasons why houses have rugs and floors. "Rugs are so you don't get splinters in you" and "[a] floor is so you don't fall in the hole your house is in." She also decided it was important to record for posterity a baby's pre-verbal opinion of rugs and floors: "Boodlyboodlyboodly."

Nothing gives kids more pleasure than laughing at baby gibberish. It's a way of marking and securing their great accomplishment, their accession into the world of language; they are horribly delighted to recall the gabble it took such hard work to escape. And they miss terribly the freedom simply to make up words instead of submitting wordless feeling and impulse to that tyrant, the dictionary. The best people refuse to

submit. Mozart, in a letter to his sister, coins the word "Schlumba!" and many others you won't find in a Langenscheidt's. Edward Lear's Mr. And Mrs. Discobolus exclaim, in an access of anguish or delight, "Oh W X Y Z!" Lewis Carroll chortled "Oh frabjous day! Calloo! Callay!" To which colloquium Ruth Krauss and Maurice Sendak have added their two bits: "Boodlyboodlyboodly. . ."

Kids love nonsense words, onomatopoeic phonemes. Immigrants, lacking vocabulary, often resort to the same, the exasperated expression of that for which language cannot be found. Long after the fundamentals of the new language were mastered by the newly arrived, after the American-born generation appeared, that-for-which-language-cannot-be-found did not, and never does, go away; and so the immigrant's rhetorical strategies resurface in her or his children.

As I'd written earlier, one need only read Philip Sendak to understand an important source of Maurice's prose style. Maurice, remembering the sound of English in his immigrant father's time, made use of certain features of this speech in his books: the deliberate "errors" of syntax, the way language flows over its own "mistakes," and flows because of its "mistakes," a kind of thick, chewy, over-explained, careful quality that suggests the newness of English words in immigrant mouths, once *mamaloschen* (Yiddish for "the mother tongue") has been put away in

favor of unimpeded assimilation. Again, from *In Grandpa's House:*

> The doctor put his instruments in a big pot and boiled them. With the tongs he took the little head and turned it, and Maurice came out all by himself.

Ruth Krauss may have taught Maurice the trick of emulating immigrant speech, its juicy improprieties, and gaffes. A selection from *Charlotte and the White Horse* gives an example of Kraussian prose:

> Then a big man comes, who is her father, and says, he won't make a good race horse so we will sell him. Then Nathan can go to college when he is grown.
> —That's the little brother.
> Now just sorrow is coming in.
> Now just sorrow is coming in.

Or, from *Open House for Butterflies:* "A good thing not to be is a plant because someone might think you are a weed and pull you up by the roots."

Maurice takes this rhetorical gesture further and makes a deliberate poetry of it. In Max's bedroom "the walls became the world all around." Or, in *Outside Over There:* "'What a hubbub,' said Ida sly, and she charmed them

with a captivating tune. The goblins, all against their will, danced slowly first, then faster until they couldn't breathe."

Maurice plays with meter, he sets up iambic expectations and breaks them with syncopation. "The goblins, all against their will, danced slowly first" is an Alexandrine, iambic hexameter. The following line is nearly in tetrameter; to regularize it, substitute "till" for "until"—". . . then faster till they couldn't breathe." The "until" deliberately throws the rhythm toward a stumble, a pause, in favor of irregular life. The secret of making metered speech come to life is to make it *almost* regular. "Now Ida in a hurry snatched her mama's yellow rain cloak . . ." "Now I– (*bum-BUM*) -da in (*bum-BUM*) a hu- (*bum-BUM*) -ry snatch'd (*bum-BUM*) her ma- (*bum-BUM*) -ma's yel- (*bum-BUM*) -low rain (*bum-BUM*) cloak (bum)." "To be (*bum-BUM*) or not (*bum-BUM*) to be (*bum-BUM*), that is (*BUM-bum*) the ques- (*bum-BUM*) tion (bum)."

The flow of meter and the bump in the road: it's a blending of the elegant and inelegant, the polished and the crude; besides the inherent drama of the dialectic, of any self-contradictory gesture, this way of writing appealed to Sendak because it's a Jewish trope, a kind of speech perhaps best described in Philip Roth's *The Ghost Writer:*

> What you smell are centuries and what you hear are voices and what you see are

Jews, wild with lament and rippling with amusement, their voices tremulous with rancor, and vibrating with pain, a choral society proclaiming vehemently, "Do you believe it? Can you imagine it?" even as they affirm, with every wizardly trick in the book, by a thousand acoustical fluctuations of tempo, tone, inflection and pitch, "yet this is exactly what happened."

Two of Maurice's most recent projects take him back, in very different ways, to this unbelievable "what happened." With Arthur Yorinks and the Night Kitchen Theater, in collaboration with the Shirim Klezmer Orchestra, Maurice has written a script and provided costume/character drawings for an orchestral suite with narration called *Pincus and the Pig: A Klezmer Tale for Children,* a Yiddishkeit version of Prokofiev's *Peter and the Wolf.* Here's an excerpt from the script, in which Sendak seems not so much to be emulating his father's rhetorical style as channeling (what we imagine to be) the speaking voice of Philip Sendak.

So sweethearts, listen and enjoy! Try, anyway. Did you hear of Boychick Pincus, how he opened wide the gate and hippety hoppityd over the sweet warm meadow? On the branch of a big old tree a little birdie sat, qvetching away. "Oy! Vay! The gate is open! Is

Pincus looking to get killed again! Surely Chozzer, that devil pig, and his gang of shmutsika wilde chiaya will pound poor Pincus into chopped liver." "Oh! Shaah!" quacked a plump cranky duck as he waddled through the gate. "A cry-baby birdie is no better than a dumb bunny. I'm going for a swim in the meadow pond."

Maurice is working, as I've mentioned, on opera designs for *Brundibár,* by Hans Krása. The opera was first brought to Maurice's attention by Bob Jaffe, who sent him a lovely recording sung by children in Czech, which is surely one of the most lyrical of languages. For the upcoming production at Chicago Opera Theater, *Brundibár* will be paired with Martinů's *Comedy On The Bridge,* since it too was written during the terrible middle years of the twentieth century, also by a victim of the Third Reich, in this case a non-Jewish refugee. At Maurice's request, I wrote an English-language adaptation of both Adolf Hoffmeister's *Brundibár* libretto and Martinů's text for *Comedy.* After I'd finished, Maurice asked me to write a text based on the libretto for *Brundibár* for a picture book, which he is now illustrating.

Brundibár, Czech for bumblebee, tells the story of two small children, Pepicek and Aninku, whose mother has fallen ill; the brother and sister travel to a nearby city to bring back milk

Pincus and the Pig, performance, character studies

to make her well. Upon arriving, the children realize that to purchase milk they need money, and their attempt to earn some by singing in the town square is thwarted by the villain of the opera, Brundibár, a teenage hurdy-gurdy player and a bully. Frightened, the two kids hide in an alley; they are rescued by a friendly sparrow, cat, and dog who, along with 300 schoolkids enlisted for the purpose, help Aninku and Pepicek drive the bully away. The kids sing a beautiful choral number, and consequently get plenty of cash from an appreciative audience of grown-ups to buy milk for their mother, who drinks the milk, or *mleko,* as it is called in Czech (say it out loud and you will realize that it's a much better word

than its English equivalent), and is restored to health.

It's a sweet tale, but it has a tragic history.

In 1938, the Czech Ministry of Education and Culture sponsored a competition for a children's opera. I haven't been able to find out whether Hans Krása's and Adolf Hoffmeister's *Brundibár* won the competition, or whether it was excluded from the competition, or whether the competition was ever concluded. A few months after the opera was completed, the German army invaded and occupied Czechoslovakia, and Krása, being Jewish, would have been barred from participation in such a contest, Jewish music having been declared

unperformable before a general audience by Nazi race laws.

Brundibár was not given its premiere until 1942, at the Vinohrady, a Jewish boys' orphanage, which had become a concert and recital hall for the Jews of the Prague ghetto. The piece was given three performances before the Nazis rounded up the opera's designer, conductor, director, and accompanist, all the boys in the Vinohrady orphanage, and the composer,

Hans Krása. All were transported to the concentration camp at Terezin.

In September of 1943 this same group, all inmates of Terezin, staged a new, coed production of *Brundibár* using the camp's imprisoned children. Krása brilliantly orchestrated the piano score for a small ensemble, taking advantage of the fact that some of Czechoslovakia's best musicians were prisoners in Terezin. The opera became a hit among the inmate population.

Brundibar, picture book and opera, illustration and costume study

207

Brundibár is a political allegory, an almost undisguised cry for resistance to Hitler. In photos of the production the boy playing the organ grinder Brundibár is wearing a mustache.

Brundibár was performed fifty-five times at Terezin. Jews sang it for Jews during the *Freizeitgestaltung*, or "free time period" the Nazis permitted the inmates of Terezin. Before long the camp officials recognized the opera's propaganda potential. It was performed for the International Red Cross representative sent to inspect camp conditions, who went away impressed with the kindness of the Nazis and the cultured atmosphere of the camp. Segments of a performance were then filmed for inclusion in the Nazi-produced documentary, *Der Führer schenkt den Juden eine Stadt* ("The Fuhrer gives the Jews a City").

Brundibar, picture book and opera, below and opposite: illustrations and costume studies

208

Nearly all the children who performed it were eventually sent to Auschwitz, where they were murdered. Hans Krása was killed there in October 1944.

Maurice, Michael di Capua, and I have struggled to make a children's book out of *Brundibár*, one which honors the martyred dead. Our discussions have raised the question that has become a recurrent theme in this essay: In a world of trouble and woe and worse, what are children to be told? How much knowledge should they be spared? How much do they need to know so that they are prepared to meet the world? How much can they handle, and at what point does truth, when it is terrible, faith-destroying, hope-destroying, unassimilable truth, become unsuitable for children, with their still undeveloped capacities to sustain its reception?

I've been moved and have felt privileged to observe firsthand how deeply Maurice *suffers* a picture book. He has drawn *Brundibar* twice now; he produced an entire set of sketches, and then, losing faith in the approach he had taken, considered abandoning the book. Jules Feiffer, having heard what a rough time his old friend was having, called Maurice to tell him about some new watercolor pens he'd just bought. He wanted Maurice to try them. It was intended, Jules told me, as "a kick in the ass." It worked. Maurice began again, with remarkable results.

One of our discussions has centered around the character of Brundibar, played onstage by a boy, but intended to represent Hitler himself. Maurice's first impulse was to draw the organ grinder as Hitler. We agonized over the results. It was too horrible, and it raised all the old questions. When you are reading this book to a child, are you meant to stop and explain to the kid who this scary-looking man was, or what he'd done? I felt the choice we'd made was unfair to parents, and inappropriate to the tale, to the impulse to present an allegory. So we turned Brundibar to Hitler in a clown costume. Still it seemed wrong; in the opera, Brundibar is a boy, bigger than the two protagonists but not as formidable a foe as an adult would be; and again, was it right to play hide-and-seek with Hilter's visage, an icon of human evil? Maurice went back to work, and made the decision to turn Brundibar back into a boy; to give him Napoleon's hat; to festoon his upper lip with a moustache that threatens to become rat's whiskers; and finally, to put into the boy's head staring eyes of psychopathic blue.

As a way of addressing our concerns about the tale and its history, Maurice has evolved a narrative strategy for *Brundibar*. He explained to me that the story's first part—Aninku and Pepicek going to fetch milk for their mother, their inability to get it, their terrified retreat from Brundibar and the police into the litter-strewn alley in which they spend the night—is to be taken at face value. Our readers are meant to understand that this part relates the story

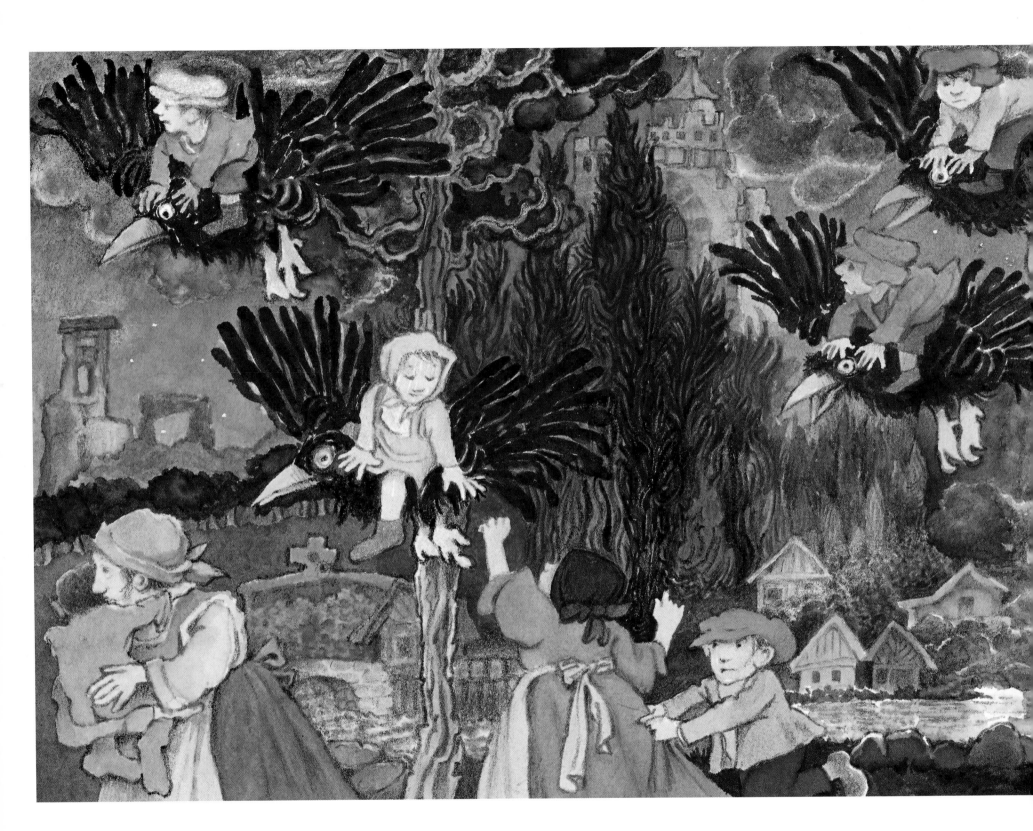

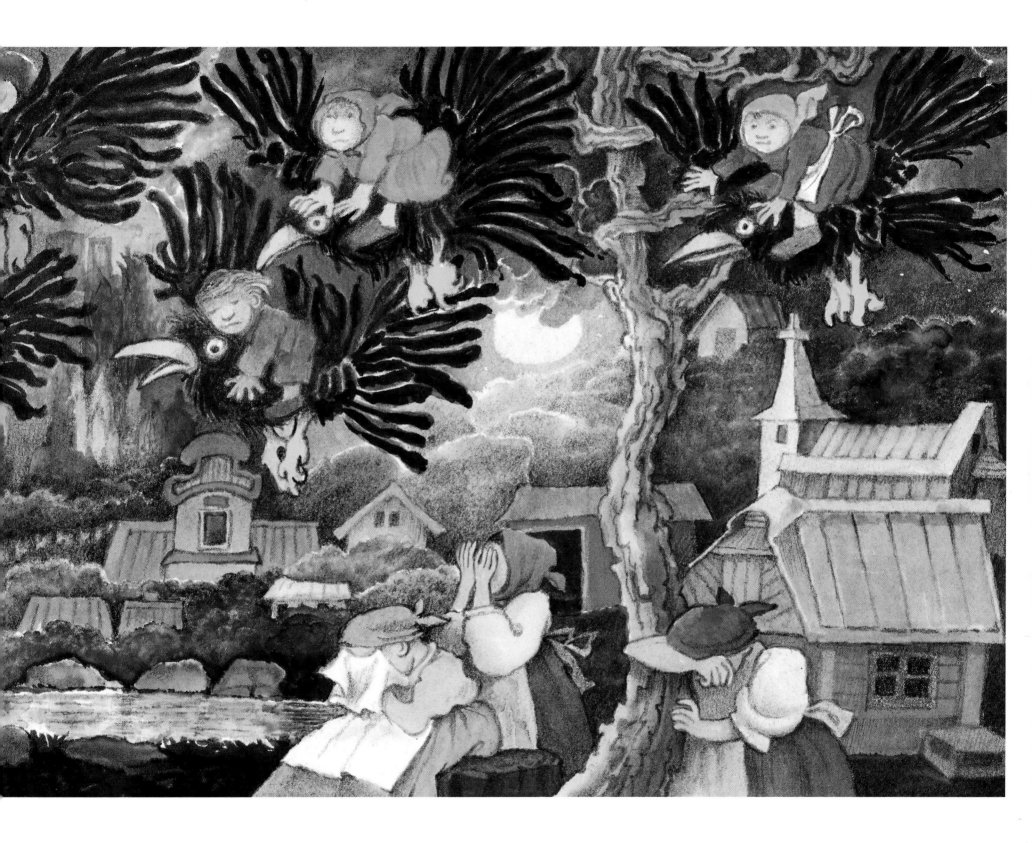

exactly as it happened. The story's second part—the children's rescue, their triumph—is possibly real, or possibly it's merely a victory dreamt by two cold, homeless kids for whom the morning will bring no good news. Possibly it's our wish that everything will work out for them, even as we know that often it doesn't.

But his *Brundibar* illustrations seem to describe a path that diverges from his own strategy. The first images, those in the "real" part of the book, are simple, brightly colored. They're folk drawings, almost—God forbid I should say they're done in a "fat" style! After the kids hide in the alley and meet their animal rescuers, after our fantasy or their dream has begun to take over, Maurice's drawings assume a greater degree of elaboration, historical specificity, of gritty reality. The triumph, which he grievingly reads as an improbable wish, appears paradoxically to be more real, more substantial than the "reality" it flies away from. The paradox is, it seems to me, a way for Maurice to find hope, to find what the philosopher Ernst Bloch called "concrete-knowing hope"—tough hope that emerges from a refusal to deny the darkness around you. I don't think that Maurice devised this schematic in advance—he seemed rather surprised to notice he'd done it. It's an instinct for hope he has, a reflex for hope. It comes from his bones, or flows from his beleaguered heart, down to the fingertips of his soft, pale, subtle hands.

"I have to learn to live life, just enjoy it,"

he tells me on the telephone during a recent conversation. "I'm *screaming* at my enlarged prostate (*and here he screams in a really unearthly voice*) 'JUST SHUT THE FUCK UP!!!!'" Impressed by the sound he's made, he pauses. "I never heard *that* voice before." Then he concludes, "Anyway. That's what I have to learn. I must learn to unlearn appetite."

"So you think you can?" I ask. "That sounds difficult, and you're a hungry sort of person." "I have to try," he says. "I should be ready to try. I've had a fat full life."

We make plans to see one another. He's not coming into the city! He *hates* New York at Christmas. The Rockefeller Center tree summons up in him an empathic rage: "You've survived 500 years in the forest, you're the tallest most beautiful thing in the whole forest, so our way of rewarding you for this? We cut you down and fly you to concrete and stick you in a pot and wrap ten thousand miles of electric bulbs around you!" I tell him I will come visit him in Connecticut. "Great," he says, "we can dance a kazatzkah!" "What kind of a dance is that?" I ask. "A kazatzkah is the Dance of Death," he tells me. "Sounds good. Do you know the steps?" I ask. "DO I KNOW THEM?" he says with glee, making a kazatzkah sound like the most fun imaginable, "I know those steps in every notch every noodle every nerve cell! Of course I know them! I've been rehearsing them all my life!"

A CHRONOLOGY OF SELECTED PROJECTS

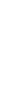

1979—New York Is Book Country, poster

1979, '83—*Where the Wild Things Are,* opera (Oliver Knussen, composer); sets, costumes, and libretto

1980, '92—*Really Rosie,* musical (Carole King, composer); sets, costumes, and lyrics

1980—*The Magic Flute,* opera (Wolfgang Amadeus Mozart, composer); sets and costumes

1980—*The Magic Flute,* poster

1981—*Outside Over There,* picture book

1981, '83, '98—*The Cunning Little Vixen,* opera (Leoš Janáček, composer); sets and costumes

1981—*The Cunning Little Vixen,* poster

1982—*The Love for Three Oranges,* opera (Sergey Prokofiev, composer); sets and costumes

1983—*Kleist: A Biography* (Joachim Maass, author), cover art

1983—*The Nutcracker,* ballet (Piotr Ilyich Tchaikovsky, composer); sets and costumes

1984—*Higglety Pigglety Pop!,* opera (Oliver Knussen, composer); sets, costumes, and libretto

1985—*The Horn Book,* cover and poster

1985—*In Grandpa's House,* picture book (Philip Sendak, author)

1986—*Nutcracker: The Motion Picture,* film poster

1986—*L'Enfant et les Sortileges,* opera (Maurice Ravel, composer); sets and costumes

1986—*L'Heure Espagnole,* opera (Maurice Ravel, composer); sets and costumes

1986—*Renard,* opera (Igor Stravinsky, composer); sets and costumes

1986—*The Goose from Cairo,* opera (Wolfgang Amadeus Mozart, composer); sets and costumes

1988—*Dear Mili,* picture book (Wilhelm Grimm, author)

1988—American Express advertisements

1988—New York Is Book Country, poster

1989—*Idomeneo,* opera (Wolfgang Amadeus Mozart, composer); sets and costumes

1990—*La Clemenza di Tito,* opera (never produced—Wolfgang Amadeus Mozart, composer); sets and costumes

1989—*So Sue Me,* play (Night Kitchen Theater Company); set and costumes

1990—Ibby Congress, poster

1990—Care poster (baby and sunflower)

1990—The New Advocate, cover art

1991—*The New York Times* Books section, Melville illustration

1992—*I Saw Esau,* picture book (Iona and Peter Opie, editors)

1993—*We Are All in the Dumps With Jack and Guy,* picture book

1993—*The New Yorker,* cover art

1994—*It's Alive,* play (Night Kitchen Theater Company); set and costumes

1995—"Sendak in Philadelphia," exhibit and poster (Please Touch Museum and the Rosenbach Museum & Library)

1995—*Pierre, Or, The Ambiguities,* novel (Herman Melville, author)

1995—*The Miami Giant,* picture book (Arthur Yorinks, author)

1995, '96—Recordings of Shakespeare's plays, CD covers (Caedmon Records)

1995—*Frank & Joey,* play (Night Kitchen Theater Company); set and costumes

1996—Houston Grand Opera, program

1996—*Stravinsky,* CD cover

1996—*Herman Melville: A Biography, Volume 1, 1819–1851,* (Hershel Parker, author); cover art

1996—*Frank & Joey,* board books (Arthur Yorinks, author)

1996, '97—*Hänsel und Gretel,* opera (Engelbert Humperdinck, composer); sets and costumes

1997—"Bram Stoker's Dracula: A Centennial Exhibition," poster and brochure (The Rosenbach Museum & Library)

1997—*Were You There When the Sugar Beets Got Married?,* concert piece (Pierre Jalbert, composer); pictures commissioned by Midori

1997—*What Can You Do With a Shoe?,* picture book (new full-color edition)

1998—Brooklyn Children's Museum; poster

1998—*Penthesilea,* novel (Heinrich von Kleist, author)

1998—*Swine Lake,* picture book (James Marshall, author)

1998—*A Dybbuk and Other Tales of the Supernatural* (S. Ansky, author; adapted and translated by Tony Kushner and Joachim Neugroshel), cover art

1998—*Dear Genius: The Letters of Ursula Nordstrom* (Leonard S. Marcus, editor), cover art

1998—New York Is Book Country, poster

2001—*Strange Stories for Strange Kids (Little Lit, Book 2),* "Cereal Baby Keller" (Art Spiegelman and Françoise Mouly, editors), comic strip

2001—*A Selection,* dance performance (Pilobolus Dance Company); set and costumes

2003—*Brundibàr,* opera (Hans Krása, composer); sets and costumes

2003—*Brundibar,* picture book (Tony Kushner, author)

BIBLIOGRAPHY

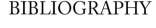

"American Masters: Maurice Sendak." American Masters, PBS, September 5, 1987.

Banks, Mirra. *The Last Dance*. USA, video, 84 minutes, 2002.

Corsaro, Frank. *The Love for Three Oranges: The Glyndebourne Version*. New York: Farrar, Straus & Giroux, 1984.

Cott, Jonathan. *Pipers at the Gates of Dawn: The Wisdom of Children's Literature*. New York: Random House, 1981.

Edson, Margaret. *Wit: A Play*. New York: Farrar, Straus & Giroux, 1999.

Hentoff, Nat. Edited by Sheila Egoff, G.T. Stubbs, and L.F. Ashley. "Among The Wild Things" from *Only Connect: Readings on Children's Literature*. New York: Oxford University Press, 1969. 323-356.

"Interview with Maurice Sendak" from *Hänsel ünd Gretel Backstage/Lincoln Center #405*. Lincoln Center Live, PBS, December 17, 1997.

Lanes, Selma G. *The Art of Maurice Sendak*. New York: Harry N. Abrams, Inc., 1980.

Roiphe, Anne. *For Rabbit, with Love and Squalor: An American Read*. New York: Free Press, 2002.

Roth, Philip. *The Ghost Writer*. Boston: G.K. Hall, 1980.

Scholem, Gershom. *A Life in Letters, 1914–1982*. Cambridge: Harvard University Press, 2002.

Sendak, Maurice. *Caldecott & Co.: Notes on Books and Fiction*. New York: Farrar, Straus & Giroux, 1989.

Sendak, Maurice. *Questions to an Artist Who is Also an Artist: A Conversation Between Maurice Sendak and Virginia Haviland*. Library of Congress, 1972.

Snow, Edward A. *Inside Breugel: The Play of Images in Children's Games*. New York: North Point Press, 1997.

Spaethling, Robert. *Mozart's Letters, Mozart's Life*. New York: W.W. Norton & Co., 2000.

Spufford, Francis. *The Child that Books Built*. London: Faber and Faber Limited, 2002.

Willett, John, Ed. *The Theatre of Bertolt Brecht*. London: Methuen, 1974.

Winnicott, Donald Woods. *Human Nature*. New York: Brunner/Mazel, 1988.

Yevtushenko, Yevgeny. *Wild Berries*. New York: William Morrow, 1984.

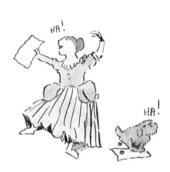

ACKNOWLEDGMENTS

The author, who had the good sense to marry a fantastic editor, wishes to thank his husband, Mark Harris, for his careful reading of the text and his invariably excellent suggestions. Michael di Capua also provided a smart edit and contributed his personal knowledge of Maurice Sendak's work to the essay, and I am very grateful.

INDEX

(Page numbers in *italics* refer to illustrations.)

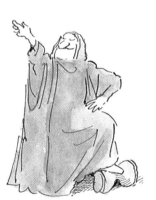

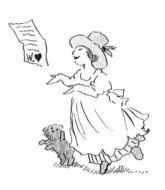

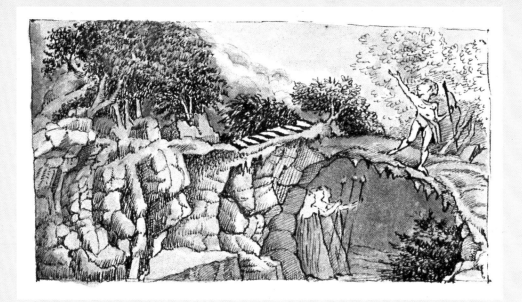